THE QUALITY INSTINCT

SEEING ART THROUGH A MUSEUM DIRECTOR'S EYE

Published by The AAM Press of the American Association of Museums, 1575 Eye St. NW,
Suite 400, Washington, DC 20005
www.aam-us.org
John Strand, Publisher.
Cover design: Abbott Miller and Kim Walker, Pentagram
Interior page design: Susan v Levine, art director, AAM.

The opinions expressed in this book are those of the author and do not necessarily
reflect the opinions or positions of the American Association of Museums or its Board of
Directors.

Anderson, Maxwell Lincoln.
 The quality instinct : seeing art through a museum director's eye / by Maxwell Anderson.
 p. cm.
 Includes index.
 ISBN 978-1-933253-67-1 (alk. paper)
 1. Art appreciation. 2. Quality (Aesthetics) I. Title. II. Title: Seeing art through a museum
director's eye.
 N7477.A53 2012
 701'.1—dc23
 2011042867

THE QUALITY INSTINCT
SEEING ART THROUGH A MUSEUM DIRECTOR'S EYE

Maxwell L. Anderson

The AAM PRESS *of the* AMERICAN ASSOCIATION OF MUSEUMS

About the Cover.

Statue of a Young Woman, Italic, 3rd century BC

The Metropolitan Museum of Art, Rogers Fund, 1916 (16.141)

Purchased by The Metropolitan Museum of Art in 1916, this statue was reclassified as a forgery in 1926 and remained in storage for 60 years. The author uncovered it in the museum's basement, recognized it as a masterpiece, and published it in 1987 in a monograph on the Greek and Roman collections of the Metropolitan. Today it is on prominent display at the Met, and has achieved the enviable status of being reproduced on a postcard, a distinction reserved for the museum's finest works.

TABLE OF CONTENTS

ACKNOWLEDGMENTS .. vii

INTRODUCTION : *How I See It* 1

CHAPTER I : *An Apprenticeship in Seeing* 9

CHAPTER II : *Defining Quality in Art* 33

CHAPTER III : *How to See: The Detective's Reflex* 55

CHAPTER IV : *On Originality* 85

CHAPTER V : *Crafted with Skill* 107

CHAPTER VI : *Confident in Subject or Theme* 131

CHAPTER VII : *Compositional Coherence* 151

CHAPTER VIII : *Memorable for the Viewer* 171

CHAPTER IX : *Finding Quality in the Art of Our Time* ... 193

CHAPTER X : *Art and Muscle* 213

INDEX .. 220

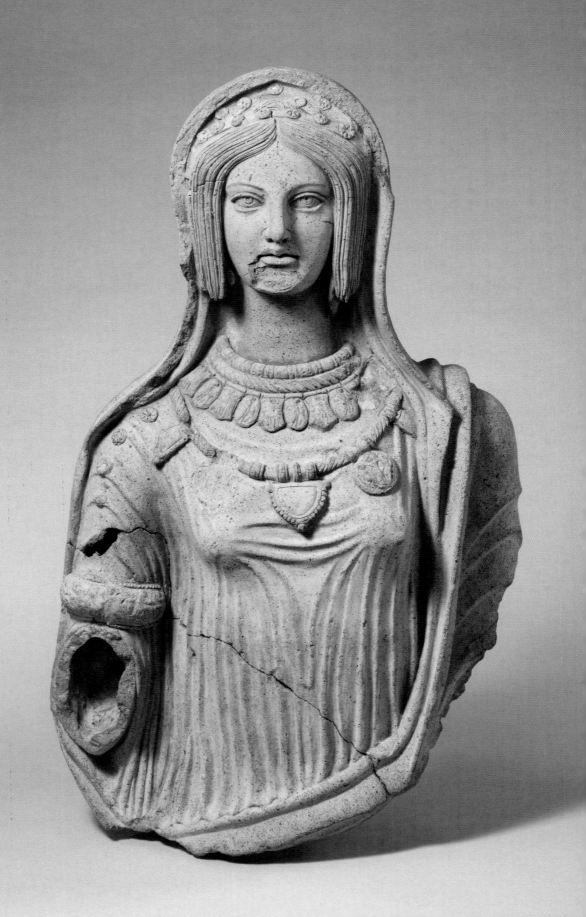

ACKNOWLEDGMENTS

I began the winding path to arrive at this book thanks to my devoted parents, Quentin and Thelma, who served up experiences that formed the basis for my love of art and museums. They spirited my brother Brom, me, and our sticker-clad steamer trunks across the Atlantic four times, afforded us an enviable education, and magically cleared the journey of obstacles. Brom has always been the best possible sounding board by virtue of his free-ranging brilliance and unfailingly selfless character. He enriches the lives of all he meets, and I am ever proud to be his brother.

Along the way I have benefited greatly from teachers, professors, trustees, one director, Philippe de Montebello, and one curator, Dietrich von Bothmer, who looked upon me with benevolence and bemused generosity, and other relatives, friends and colleagues who have kept my emotional provisions stocked through the first three decades of a life in museums. Many fellow directors, kindred spirits with whom I have ridden the rapids of this rarefied profession, have provided unstinting camaraderie when needed most. The staff members of the four museums I've led over 25 years have supported their director in myriad ways and kept my spirits high.

Almost a decade ago, media guru Michael Wolf introduced me to the talented literary agent Mark Reiter, who helped me with a first stab at this book. Mark was a discerning coach, but it became clear that the manuscript needed more time and

focus than I could then afford. It was AAM's publisher John Strand who reignited my interest in writing about the quest for art knowledge in 2011. Over a six-month marathon from the day he extended the invitation, I cranked out 70,000 words, which he cut and polished with acuity, encouragement, and good humor.

For my son Chase and daughter Devon, this book may help explain why our family has made homes in multiple postal codes from coast to coast. They are, singly and together, admirable and beautiful souls with boundless imagination, sweetness, and potential, who inspired me to give them something lasting about their dad's chosen profession and its effect on the first chapters of their lives.

Jacqueline, the *sventola* I am blessed to call my wife, was an exacting editor of the first rough draft, excising gratuitous name-dropping passages, long-winded anecdotes wholly irrelevant to the task at hand, and non-sequiturs born of a pack-rat's disposition. This she did lovingly, quickly, and unerringly, accompanied by a mischievous laugh, all the while following her own creative pursuits as a gifted actress, CEO of a successful company, mother, and inspiration to other women, far and wide. I thank her for graciously closing the study door with me at the keyboard, and for opening that door to fill my cup in countless rewarding ways. She is my best editor and my best guide, in life as in writing.

—*Maxwell L. Anderson*

To Jacqueline, the woman of my dreams.

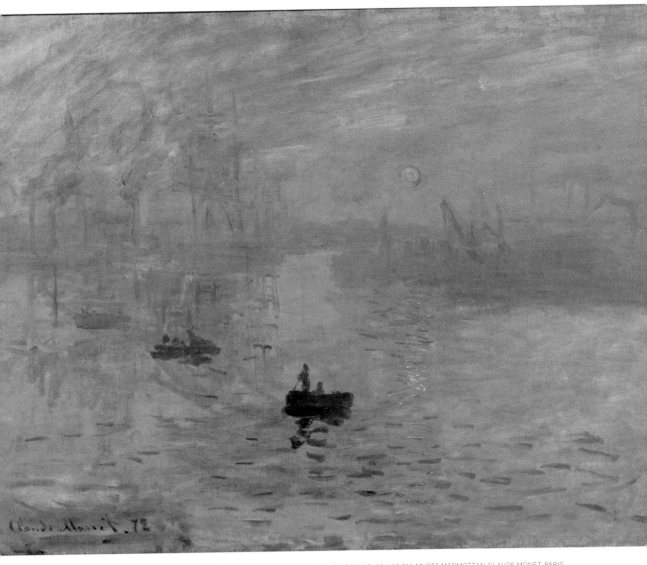

CLAUDE MONET (1840-1926). *IMPRESSION, SUNRISE.* 1872. OIL ON CANVAS. 48 X 63 CM. MUSÉE MARMOTTAN-CLAUDE MONET, PARIS. PHOTO BY ERICH LESSING / ART RESOURCE, NY

INTRODUCTION : How I See It

The first group exhibition of the artists who would come to be called the Impressionists was held in April 1874 in the Paris studio of the photographer Gaspard-Félix Tournachon. Critical reaction was scathing. Referring to Monet's painting *Impression, Sunrise*, critic Louis Leroy wrote: "Wallpaper in its embryonic state is more finished than that seascape."

Within a few years, Monet's paintings were recognized as pivotal accomplishments that changed art forever. *Impression, Sunrise* today hangs in a Paris museum that bears the artist's name, Musée Marmottan Claude Monet.

We have a conflict here.

Judging quality in art is not an easy skill to master. Judging the art of one's own time is especially daunting. To make the whole process even harder, there is a current of thought prevalent in academia that would dismiss such opinions as meaningless. Judgments on art, this line of reasoning goes, are hopelessly subjective. Based on this logic, both the early condemnation of Monet and his later apotheosis are legitimate.

Legitimate they may be, but I maintain that only one is right.

How can we come to recognize quality in art without relying on a museum docent, wall label, or sale price—or even more perilous, a critic? How can we hone what is, for lack of a better phrase, visual literacy? How can we learn to "see" with the confidence that we are seeing the artist's intention?

Divining artistic intention and separating artistic wheat from chaff have preoccupied me throughout my career. In *The Quality Instinct* I want to share some of what I have learned. My goal is to offer you some practical help on your next museum visit, whether you are a knowledgeable dévoté or a first-timer, whether you are learning to see or re-dedicating yourself to the task. And, if I am successful, you may gain some insight about the visual creativity found all around you in everyday life.

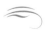

There are days when the ambition of judging art seems sadly superficial in a world beset by tragedy at the hand of man or from natural disasters. But if we can't aspire to overcome privation and loss, and find commonality in the human condition through our creativity, we will have an even rougher road in life.

I'd like to help retire the most entry-level response to art: "I don't know much about art, but I know what I like." Humorist James Thurber turned this oft-used phrase upside down in a *New Yorker* cartoon caption to parody self-conscious art experts who lack for pleasure in art: "He knows all about art, but he doesn't know what he likes." (*The New Yorker*, November 4, 1939).

Thurber was right: amateurs *and* experts have trouble sorting out artworks. But if you limit yourself to responding to things you know you like, you'll be in a rut. The discovery of something remarkable in a person, experience or thing that *initially put you off* is where a more fulfilling life begins. Children don't start out liking coffee or spicy food. And many adults don't start off liking Picasso. But this book might help you abandon the reflex to seek out familiar or comfortable artworks, and make you curious about artworks of all kinds. Even if you don't end up *liking* them, you may end up understanding why they matter so much to others. And, at the very least, you can avoid ever being intimidated by experts, whether self-appointed or real.

PAPERS, PLEASE: YOUR AUTHOR'S CREDENTIALS

To start with, I have some confessions to make. I'm a zealot about art—a fetishist. I can't imagine life without it. But it's much worse than that. Almost every visual encounter I have results in unpacking creative intention. I can be meeting someone in

a dull office in downtown Manhattan, and the façade across the street will catch my eye. For the person working in that office day after day, year after year, the building across the street may be simply a vacant blue screen behind the day's weather. But for me its creativity is still alive. I can almost hear the scraping sounds made by a stoneworker in the 1920s. I try to guess the exact inspiration for the design architect who derived his window mullion from an English Gothic choir screen—when I am startled back into the conversation I had tuned out of. It's that bad sometimes. I'm constantly engaged in seeing visual connections that otherwise go unnoticed—and I enjoy it. Although I admit it is sometimes disconcerting to my interlocutor.

Here's another factor to consider. I'm well trained at my profession. At 24, I finished the requirements for a Ph.D. in art history from Harvard University, having studied with some of the world's leading scholars of ancient, medieval, Renaissance, baroque, nineteenth-century, and modern art. Doctorate in hand, I was said to be the youngest art history Ph.D. from Harvard in the school's history. I went straight to work for six years as a curator at The Metropolitan Museum of Art. At 31, I became a museum director, overseeing great art collections dating from remote antiquity to the last few months.

I am grateful for the privilege of that education and experience, and I have used them every day for the past 30 years, studying thousands of artworks in hundreds of museums across dozens of countries. I've published dozens of articles and monographs, lectured everywhere from the Louvre to Abu Dhabi, from Berlin to Los Angeles, and taught on the faculties of Princeton University and the University of Rome.

My point is this: I know the art world, warts and all. That's important because in this book I'll grab the rope on one side of a tug of war. It's the debate that separates people like me, who love objects because they are precious and worthy of our affection and attention, from those who care first about the objects' monetary value or the prestige attached to owning them.

THE QUALITY TUG-OF-WAR

Apart from artists, there are, we can say simplistically, four factions in the art world.

1. The critics and academics, whose job is to interpret.
2. The dealers, whose job is to buy and sell art.

3. The collectors, who surround themselves with art to have its grandeur enrich their lives.
4. And then there are museum people. Our job is to make a safe place for works of art to be seen and enjoyed by a broad audience.

I don't want to oversimplify. Many of the residents of these worlds share my belief that visual literacy, an understanding of quality, starts with values innate in the object, unattached to schools of thought or money or personal possession. But in *The Quality Instinct*, if it's not already obvious, I am unswervingly for the thing itself, the *ding an sich*, as Immanuel Kant called it. I believe that to appreciate quality you have to care about artworks almost as much as a parent cares for a child. You can love the child without reservation, but it sure helps to know a few things about parenting.

Does an art historian like me suffer from self-doubt when embarking on a quest like that of writing this book? Of course. After all, we don't make the things we write and talk about. There are lots of people who do what we do, and each of them supposes that his opinion deserves at least as much credence as ours. We are on balance as irascible and unforgiving a bunch as any other professional class.

But unlike investment bankers, who can parade their net worth, or policemen, who can tout arrest records, or dry cleaners, who can take pride in repeat business, art historians are more akin to meteorologists. We get things right much of the time, but we don't make the weather, aren't in charge of it if things go wrong, and even if we prefer crisp winter mornings to hot summer afternoons, that's ultimately just a personal preference. The big difference between us and meteorologists is that members of our field study things that usually endure longer than a summer squall and will have a greater impact on the quality of our lives in the long haul.

But it's also against our nature to reveal too much in a world awash in skepticism. It comes naturally to be self-effacing when the stakes are high. I believe in my antennae when it comes to artistic achievement, but there is no judge or jury to render a simple verdict on what this book contributes to the ongoing conversation about art's place in life. If you the reader end up feeling more at ease with art world jargon, ready to connect with almost any artwork, and better able to draw from your life experience to appreciate what you see, then this book will have been worth it for me to write and you to read.

HONORÉ DAUMIER (1808-1879). *THE ART CRITIC.* LITHOGRAPH.

PREPARING FOR THE SEARCH FOR QUALITY

I don't know about you, but I like a plot line for a story. A protagonist and a theme. I benefit also from knowing about the author's life and inspirations, his or her social circumstances and political convictions, family life and the background against which he or she wrote something. Not knowing of F. Scott Fitzgerald's complex relation to affluent New York does not improve a first-time reader's appreciation of

his work. That isn't to say that a work of art without a clear plot—like so much art made since the advent of pure abstraction—is any less deserving of our attention. Its plot is less evident but by no means less present, and we will spend some time delving into works of art that may have left you cold before.

That, at least, is the perspective of a museum person. But the vantage point of academics and critics is not always aligned with the perspective of a curator or director—someone who revels in the quality of great art for its own sake. According to many art history professors, the particulars surrounding the creation of a work of art are beside the point. The objects, it is argued, have meaning independent of these particulars. Artworks, many other academics and archaeologists feel, are less interesting in and of themselves than as ciphers of a movement, time, or place. And as we mentioned, the adjudication of quality is thought by many academics to be a pointless exercise, because judgments of quality are seen as completely subjective and personal. Connoisseurship—expertise in appreciating artistic quality—has become a discredited word.

That gets us to the root of the problem with so much art historical scholarship since the 1960s. The worldview of many academics is inherently out of most people's reach. Their playbook is written in arcane language inherited from the discipline of semiotics, the study of signs and signification. The layperson seeking knowledge about artistic achievement is made to feel simpleminded for lacking the requisite vocabulary, let alone for concerning himself with outmoded concepts like quality.

At the opposite end of the spectrum are art dealers. In the art marketplace, nothing matters more than the evaluation of quality and rarity, since these are the attributes that drive the assessment of value. Auction houses and dealers spend their energies building variable pricing models that are as sensitive as the stock market. They even have a form of market history to gauge against: the Mei Moses Art Index. A comment by an expert can promote or demote an object to greater or lesser value, and the zealous bidding of a wealthy collector can skew the pricing of an artist's entire oeuvre.

Between these two extremes—the subtle relativism of the academy and the absolutism of the art market—sits the art museum establishment. For most museum curators and directors (most of us started out as curators), "semiotic" interpretations of art history are only occasionally engaging, at best. And the value-price

matrices of the art market are the beginning of the story of artworks, not the end. The end is complete knowledge about, stewardship of, and thoughtful care, interpretation, and display of great artworks for the public's benefit.

If I do my job well in this book, you will feel more confident about appreciating art—not as the illustration of a theory, nor as a commodity, but as a part of our collective creative history, with importance that is both inherent in the act of making it, and contingent upon factors beyond the artist's control. I hope to impart some of what I have learned in appreciating art, and to help you consider how to identify the right questions and where to go for answers.

One result I hope for is this: on your next visit to an art museum, instead of limiting yourself to the art you feel most at home with, you will be tempted to strike out upon a quest for surprises. Seeing, studying, and having an experience you can savor and take with you. In *The Quality Instinct*, I'll show how it's done.

NOTE
Louis Leroy, "The Exhibition of the Impressionists," *Le Charivari* (1874)

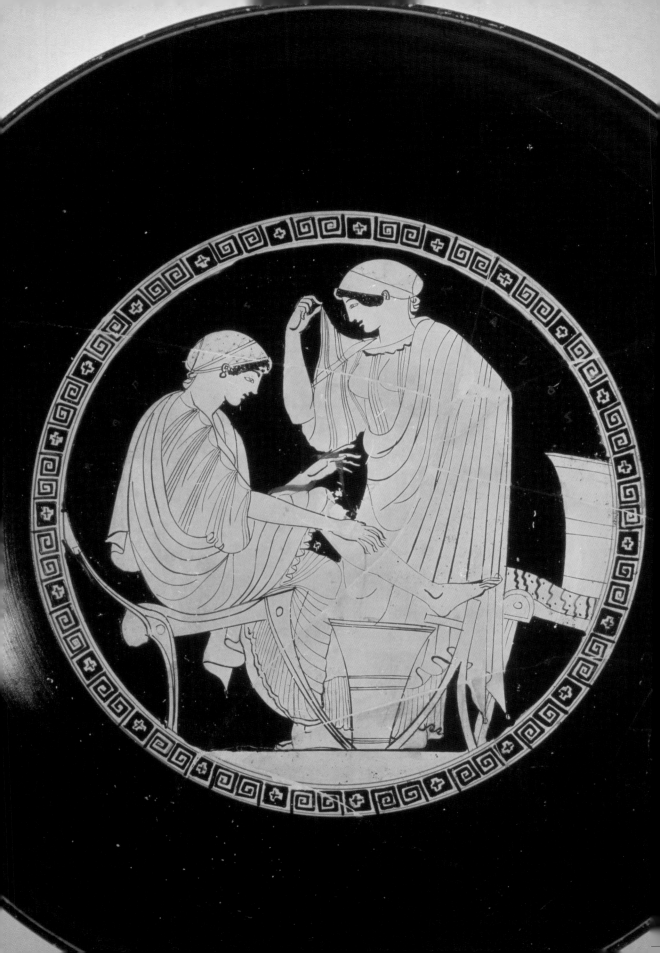

CHAPTER I : An Apprenticeship in Seeing

"Please don't get your hopes up. He's a very difficult man."

My heart sank. Instead of meeting America's greatest expert in Greek art, it sounded like I was about to spend the summer shuffling papers. It was 1977 and I was one of 12 students who had beaten the odds to be admitted to The Metropolitan Museum of Art's prestigious internship program. I was hoping to interview for a placement in the Department of Greek and Roman Art. Liz Childs, the head of the program, sat before the phone in her windowless office to schedule an appointment three floors up with Dr. Dietrich von Bothmer, the formidable chairman of the department.

"Are you going to call him anyway?" I asked, as she hesitated.

"Yes." She paused. I couldn't tell if she was deliberate or worried. "It's just that Dr. von Bothmer doesn't usually accept students from this program."

Having been rejected by the Met's program the year before as a junior at Dartmouth College, I had just graduated and was on my way to grad school in the fall, determined to have a career in museums. I had come to the Met to learn the ropes as a curator, and the very man who could make or break that effort and my career was apparently predisposed to reject me. After a brief phone call with no indication of what was being said on the other end, she hung up and looked at me in apparent wonderment.

"He'll see you tomorrow."

LEFT: DOURIS PAINTER (5TH CENTURY B.C.). *WOMEN WOOLWORKING*. TONDO OF AN ATTIC RED FIGURE KYLIX (DRINKING CUP), FROM VULCI, 33 CM. ANTIKENSAMMLUNG, STAATLICHE MUSEEN, BERLIN. PHOTO BY INGRID GESKE / ART RESOURCE NY

All day I kept replaying that one side of the phone call in my head to guess Bothmer's frame of mind. The next morning, back at the Met, I mounted the stairs to the Greek and Roman Department offices in the museum's attic. The gray linoleum tile, the narrow, claustrophobic corridor, the odors from the Fountain Restaurant below all seemed out of place in this bastion of precious things.

The energetic department secretary, Mrs. Springer, greeted me at the top of the stairs and told me to walk one door down the hall.

"You're early," she said. I was suddenly nervous. A year and a half of anticipation was now over.

Arriving at the threshold of this legendary office, I felt like I was watching a movie with me in it.

"Come in, come in," barked the chairman in a Prussian accent, with evident impatience.

I scanned the surroundings. A modestly sized, low-ceilinged space with a skylight was lined with books, file cabinets, and crammed document boxes. Two massive tables pushed together in the center of the office left little room to navigate. Placed on them was a selection of antiquities: a terracotta statuette, a drinking cup, and some fragments of pottery.

"And what do you want?" he asked, as if my arrival was unanticipated. I answered that I was hoping for a placement in the department as an intern. He barely seemed to listen to my response, instead directing me to sit down as he lit a pipe.

"I read your honors thesis," he began. "Highly speculative. I trust you'll never do anything like it again."

These words are still etched in my memory. I had toiled for months at my 90-page undergraduate thesis on the origins of pictorial space in Attic black-figure vase painting. My college advisor had been altogether enthusiastic about the results. And with not one or two but three Ph.D.s, Professor Matthew Wiencke seemed credentialed to make that judgment. But here I was, seated before the world's leading expert in Greek vase painting, and my first instructions were to forget everything I had written.

"No, I won't," I answered unthinkingly. My pride was wounded, my curiosity aroused (what did he mean?), but self-preservation dictated that I follow his brisk lead. It was getting warmer. Light pouring in from the skylight above

wasn't the reason.

"What is she wearing?" he asked abruptly, pointing at a draped statuette in front of me.

So this was to be a test. Tests are rarely my finest hour.

The fragmentary figure of a woman was in baked clay, about eighteen inches high, and headless. I thought it to be Etruscan or Italic but had never seen anything similar that wasn't close to life-size. Open at the arms, the drapery hung heavily from the shoulders. It looked like a fluted column but one contoured to the curving forms of a woman.

"It's not a peplos, is it?" I asked, feeling any confidence I brought into the interview slipping away fast.

"Yes it is. You got that one wrong."

I couldn't tell if he was joking but on the whole it seemed better to assume otherwise. My double negative had revealed my unease. He was quick to exploit it. I resolved to toughen up for what I assumed was the next round.

"Date it," he said gruffly, gesturing at a Greek drinking cup.

I had this one nailed. Despite his disparagement of my collegiate scholarship on vase-painting, the vessel had a familiar lively scene painted in the red-figure technique, encircling the exterior wall of a nearly foot-wide stemmed cup with handles on either side. A banquet was portrayed in a continuous frieze interrupted only by the handles, with revelers reclining on couches and drinking from cups very much like the one on which they were painted.

"About 470 B.C.," I ventured.

"Entirely wrong: 480 B.C.," he said, leaving my head spinning. I wanted to protest. What difference can ten years make? But eminent scholars like Bothmer take a missing decade seriously, even if a vase was 2,500 years old. This was his entire life, after all. I now wondered if it could ever be mine.

As the exchange came to an end, I realized it wouldn't be. His standards were impossibly high, and my limited training had left me with little choice but to slink off to the Education Department in search of another placement. My brain was underwater. I can't recall the rest of the truncated interview. I was awakened from a reverie of self-doubt when he ended our time together with these unforgettable words:

"Mrs. Springer will show you your office. I will see you Monday at 8:30 a.m."

I stammered some kind of thanks and made my way out. I would have the same office from that summer in 1977 until I left the Met in 1987.

I regard that decade as the time when I acquired visual literacy. It was the beginning of my career, and set me on a quest to learn how to discern quality in art—how to become what was known then, less disparagingly than today, a connoisseur. As I developed from an intern to an apprentice to a visiting professor at Princeton, I began to learn how to see, slowly acquiring the tools to recognize the gradations of achievement in art.

LESSONS FROM FORGERIES

Arriving at quick but informed judgments about artworks has always given me a surge of pleasure. Yet the process, like learning to hit an overhead smash in tennis, was halting, with plenty of trial and error. During that first summer with Bothmer, I was overwhelmed by stimuli, in large part because I was in constant proximity to masterworks. I had little to compare with the best. When you don't know mediocre, you can't fully judge what is great. It didn't help that Dr. von Bothmer was a grudging teacher. At times I felt like I was a huge disappointment to him, and at times he took on a more avuncular manner. He would constantly quiz me when new works were brought in for inspection or purchase.

One day I was in the front office with Mrs. Springer when the phone rang. It was the jovial Bob Bethea at the information desk in the Great Hall. Bothmer came striding in.

"Who is it, then?" he barked.

"The Information Desk. A lady has brought in a Greek vase and would like someone to look at it."

"Send her up," he ordered.

This was a startling development. A few days earlier, when someone had called to ask about our coin collection, he had told Mrs. Springer without missing a beat, "Just hang up on him."

Within a few minutes, the lady with her vase had climbed the stairs and faced the three of us, lined up along the office-length table as the sun beat down from the skylight. From a large shopping bag she carefully withdrew a hatbox-sized parcel

wrapped in brown paper and tied with string.

"Just put it down," Bothmer commanded brusquely. "Is it wrapped only in tissue?"

She nodded but looked bewildered.

"Don't you want me to open it?" she asked, unaware of the peculiar social conventions in our airless scholarly retreat.

Bothmer picked up the unwrapped package for an instant, then just as quickly set it down on the table.

"It's a fake," he pronounced.

"But you didn't even open it," sputtered our visitor.

"I don't have to. Mrs. Springer, make out a package pass for the lady."

As our visitor began to protest this apparent miscarriage of justice, he interrupted her with a hearty "Goodbye, goodbye," then turned on his heel and padded back to his lair. I was left with the stupefied woman and her parcel. After shrugging my shoulders empathetically, and muttering an encouraging phrase or two, I made my way out too, musing on what was apparently a frequent parlor trick for Dr. von Bothmer.

It turned out that he had to be right. Like a wine connoisseur telling you the year, the grape, the vineyard, and the hillside the grapes grew on, Bothmer could spot a fake instantly. This one betrayed its origins by being too heavy. Forgers of Greek archaic and classical vases have never mastered the light touch of sixth- and fifth-century potters. To this day, my first impulse is to heft a would-be antiquity.

GETTING TO KNOW ARTISTS AFTER THEY'RE DEAD

There were dozens of other such encounters over that decade, some more instructive than others. I'll never forget when another visitor accompanied a vase—this one genuine—that she had purchased. She was already acquainted with Dr. von Bothmer, and they had the following exchange.

"I don't know," she said. "It's just that the figures aren't very vigorous."

"Vigorous?" He chortled in mock amazement. "Of course not! This is by Douris. He painted delicate love scenes. If you want vigor, go find a battle by Makron!"

For Dr. von Bothmer, these usually unsigned masterworks were not simply objects. They were the living embodiment of artists' personalities. He lived in their

heads and was completely fluent in their visual language. He was even able to iden-tify disparate fragments from six different collections as parts of a single vase—all from his encyclopedic memory.

I suspect a lot of us want to develop that depth of understanding in any endeav-or we truly care about. To live vicariously in the imagination of those who have created the contents and settings of the best art the world has to offer seemed to me a wondrous talent. I wanted to have Bothmer's antennae. I wanted and still want to have such fluid connectivity to artworks that the personalities, quirks, tastes, idio-syncrasies of these distant masters would be as familiar to me as the moods of my wife, son, and daughter. Just as I can see in my children resemblances to relatives and forebears that are invisible to strangers, I wanted to have that intense power of observation with art, too.

But before we can think about developing such acute antennae, it is best to know something about how art objects originally functioned and what they meant to their makers. This is part of acquiring a refined visual sense that is essential to connoisseurship. We can begin, for example, by learning to decode humble product design, or perhaps deciphering the colorful medals and ribbons on a soldier's chest. There are symbols and metaphors that we can learn to see and understand, and they can tell us why something was created. We'll get to these soon.

A FACULTY BRAT'S ADVANTAGES

Much of what I have learned about seeing has been subliminal, prompted by a privi-leged childhood. I use "privileged" loosely and advisedly. My family wasn't wealthy. My privilege, such as it was, took the form of (a) access to creative people, and (b) travel abroad.

During most of my school years, I grew up in a rent-controlled, university-owned apartment on the Upper West Side of Manhattan. It was filled with some 7,000 books and the aroma of pipe smoke. At home the primary currency was "the life of the mind." My dad was a professor of English literature at Columbia University, and my mom was an advertising executive. We were middle class, but my classmates at school were for the most part the children of the super-wealthy in Manhattan. Dinner conversation in our apartment was more likely to center on debates about the Cold War, or fine distinctions of literary theory, or the

pertinence of eighteenth- and nineteenth-century authors to our time—which helps explain why my brother Brom went on to become a scholar of Immanuel Kant.

I, however, was ill suited to the metaphysical. I preferred concrete expressions of human potential. I liked objects. In shorts and knee socks in 1966, I collected a bottle of water from the Roman Baths in Bath, England, imagining that this was the very same water used by the ancients. (I still have the water.) I marched through fortresses in southwestern France pretending to be a knight preparing for battle. I stood in St. Peter's, ogling the bounty of the Crusades, noting that these marvels were unavailable back home on the concrete island of Manhattan except behind glass at the Metropolitan.

AMERICAN PLAYWRIGHT MAXWELL ANDERSON (1888–1959). THE AUTHOR'S GRANDFATHER. PHOTO COURTESY OF WIKIPEDIA.

MY GRANDFATHER'S MAGICAL HOUSE

My grandfather was the playwright Maxwell Anderson. In the 1920s he acquired a couple of dozen acres along South Mountain Road near New City, New York, ultimately dividing these up in equivalent parcels for his three sons, my father being the eldest.

We spent the summers when I was young in a prefab house that my parents bought from the ninth floor of Macy's department store. When we were little, my brother and I used an outhouse a few dozen steps from the front door, until my parents finally got around to adding a working toilet in our little house. My dad, it seemed to me, got the short end of the stick because we lived in the city during the school year, while his two brothers had proper year-round homes there in the countryside. Born in North Dakota in 1912, he was a cerebral literary expert in the company of New York's leading intellectuals during the week, and on weekends a

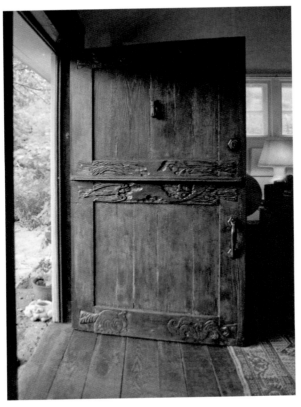

mountain man inculcating his sons in the laws of nature.

In this enclave I spent childhood summers and weekends, surrounded by a fascinating crop of neighbors. A few houses down from us lived the composer Kurt Weill and his actress wife Lotte Lenya. Another actor, Burgess Meredith, was close by, as was John Houseman. The sculptor Hugo Robus, the painters Morris Kantor, Martha Ryther, Annie Poor and her husband the ceramist and painter Henry Varnum Poor. They all moved there when my grandfather did, in 1921 and 1922. It was a renowned artists' colony. Musicians, artists, actors, and writers, the people around us were all creative souls and ran the gamut from insightful to eccentric.

The most important neighbor to me was the artisan Carroll French, who made many of the fine pieces of furniture in our homes.

As a boy I took for granted the exquisite artisanal surroundings in my grandfather's house in Rockland County, where my ad exec uncle Alan and his wife Nancy lived. Everything was handcrafted—from the original music scores, to the fireplace andirons, to the tile work, to the hardwood railings. Unbeknownst to me, I was acquiring antennae about quality, with little or no effort at my end, and my greatest influence was Carroll French. Asked to enlarge my grandfather's nineteenth-century farmhouse to accommodate a family of five, French took it upon himself to carve the existing beams in the ceiling as if they were living creatures.

French's imaginative marks begin outside the house. To start with, you enter

through a carved Dutch door that today opens to a sweeping lawn. The Dutch door—really two separately hinged doors, one on top of the other, that swing independently—was invented to keep children in and pigs out while allowing light and air to bathe the interior. It was the most solid door one could conceive of, made of Philippine mahogany and other hardwoods. The door's dovetailing was highlighted by carvings of doves, and incised on the inside was the Latin expression Exeunt omnes—a fancy way of saying "This Way Out."

Once entering through the front door, you encounter a wide chestnut stair on the right, with no banister. It leads to the upper floor, where French fashioned an open balcony railing supported by a series of upright spindles, each animated by a different plant or animal. He topped off the stairs with a huge carved chestnut leaf, inviting a caress on the way up or down, that is folded over and grows up from a modestly sized chestnut tree emanating from the floor. Other animals disport themselves upstairs—deer, rabbits, squirrels, red foxes, and turtles, all of which could be found live just outside the door. My childhood imagination took them in as if they were from the pages of a fairy tale.

The ceiling beams on the entrance floor were awash with water nymphs and other mythical creatures, perhaps as French's sly nod to the waterfall and pond within earshot of the house. The original beam over the living room fireplace was longer than needed, so French carved the excess end of it in a spray of chestnut leaves projecting

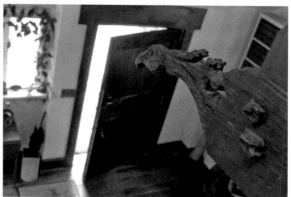

TOP: ANDERSON FAMILY HOUSE, SOUTH MOUNTAIN ROAD, NEW CITY, NEW YORK. BELOW: DEER'S HEAD CARVING BY CARROLL FRENCH. PHOTOS COURTESY THE ANDERSON FAMILY.

eastward into the room. The beam from the fireplace south to the dining area was also too long, so French carved the excess, which, it should be noted, hung over a hand-carved sideboard, with a roast pig, its mouth open to hold an apple. These accents were magical to my young eyes, and I never tired of gazing at these quirky features. They all hung together to create a personality for the house itself—playful but sophisticated, suited to the surrounding countryside, and slightly wild. They reflected my worldly, rustic, free-range grandfather perfectly.

A HUMBLE TABLE TELLS A TALE

In my parents' Manhattan apartment was, among other pieces, French's oak side table inscribed "for MA 1934 by CF." The inscription instilled in me the naïve assumption that everyone was entitled to personalized furniture. After all, it was just carved wood, and therefore affordable.

As I compose this on the wooden writing table Carroll French carved for my grandmother, its fine craftsmanship prompts a flood of visual associations—and also the childhood memory of seeing it not as a table but as a masterwork. Made of cherry wood, it is modestly proportioned, about five feet long and only three feet deep. Around the front and sides are low-relief carvings, one including a mouse reading a book with the title "You Who," an inside joke on *You Who Have Dreams*, a book of my grandfather's poetry published in 1925. Along with other less bookish mice, leafy plants grow up the length of the table legs.

My eye never tires drinking in the details of the table, and family memories are only part of the reward. Running my fingers across the bas-relief, I can imagine the original blows with mallet and chisel that transformed the unfinished surface into an imaginative playground.

As an antique, it bears the subtle markings and distress of an object that has endured the touch of three owners. Each bruise carries an echo of lives lived. But the relief carvings are so vital and playful that they stand in as a kind of perpetual conversation between the maker and the original owner. As a witness to this conversation, it matters less to me that the table is in my possession than that I can eavesdrop at any time. That has been my great privilege: I knew the man who made it. Although it probably wouldn't fetch more than a thousand dollars on the open market, it is priceless to me for its personal associations—and its very high quality in the arts and crafts genre.

The other privilege in my formative years was travel. When I was six, my father took a year-long sabbatical in France. My mother, brother and I took pretty well to being expatriates. We spent the fall of 1961 in the south, in Toulouse, in a humble, coal-heated apartment on a noisy street. Americans abroad were somewhat exotic there, and the feeling was mutual. Seeing a shop sign with a horse head painted on it, I was staggered to find out that people made a living selling horsemeat and even more amazed that others ate it. But there was also Carcassonne, the twelfth-century medieval castle, and cobblestone streets with the hornet buzz of Vélo motorbikes, coal fires, and flea markets. Baguettes with butter and jambon that taught my palette a whole new world apart from a "ham sandwich." There were toy soldiers made of lead with meticulous detailing of every feature.

During the winter and spring of 1962 we were in Montmorency, a northern suburb of Paris. Its flea markets were far bigger than those in the south. I marveled at how baubles from the distant past could be purchased right from a table under a tent. My parents fretted over a pair of late eighteenth-century flintlock pistols, but ultimately decided they were too costly. Even so, they are as vivid to me today as if they had made it to a shelf in our home because I had handled them. The electrifying realization that we were living in history was constant. Sitting on actual cannons was more exciting than any American child could have imagined in the abstract. To be in the presence of authentic pieces of long-lost history that were out and available for touching. Resting on the real, blood-soaked soil of millennia of Western history.

The daily ritual of public school écoliers included writing the alphabet in cursive on tablet-sized blackboards and dipping pens in inkwells to try out our penmanship on graph paper. The French know quality in penmanship, and deviations from the ideal were discouraged by means of a ruler rapping your knuckles. At night my father obligingly read and simultaneously translated the cartoon-book adventures of Tintin, the young Belgian reporter. When our spare Toulouse apartment grew colder with the winter months, my brother and I reveled by the little fireplace in the imagined worlds of this wily sleuth and his older companion, the retired sea captain Haddock. We had already traveled farther than most American

children did at the time, but the adventures of Le Capitaine Haddock excited me yet more through our shared absorption in his ship models. I was inexorably drawn to actual models on display in the Musée de la Marine, then in the Palais de Chaillot. These seventeenth- and eighteenth-century masterworks with their ivory and ebony inlays were marvels to a six-year old. Our modern lead soldiers seemed more animated, armed as I was with a newfound knowledge of intricate tributes to warfare from centuries earlier.

SAILING HOME WITH A FRESH PERSPECTIVE

When we sailed across the Atlantic back to New York in the summer of 1963, having missed little except grilled cheese sandwiches, the world was a somewhat different place for us. We had tasted European sophistication and American cultural isolationism was found wanting. Whereas in the U.S., one obligingly visited museums for enrichment, I realized that in Europe, the whole continent was a museum, and culture was in the water and the air. The Arms & Armor Wing of the Metropolitan Museum now had a different resonance for me, since I'd walked through medieval sites in southwestern France. The flintlocks at the Met had one signal disadvantage with respect to those we passed up in the flea market: I couldn't touch them. Exquisite as the museum displays were, they lacked a visceral connection to the place that spawned them.

I also realized that my American grade school, founded by the Dutch in 1628, was no longer the oldest place I could imagine. I had wandered alongside

the Roman aqueduct in Nimes, seen the sanctuary of the Neolithic goddess on Mont Ste. Odile in Alsace, visited Roman amphitheaters, medieval abbeys, and Renaissance chateaux.

BACK ACROSS THE POND

Four years later, in 1966, we were off again, this time sailing on the Queen Elizabeth II for a year in England. My dad had another leave from teaching, and was invited to lecture at the brand-new University of Sussex. We rented a house, packed enough peanut butter to smooth over our homesickness, and ventured back across the Atlantic in wave-tossed, affordable lower-deck berths for my brother and me and our parents.

I didn't have an eye yet, but I was beginning to look and occasionally see. I also didn't have to learn the language—apart from a slew of unfamiliar expressions. Most of all, I visited places that I had read about, from the Baths in Bath, to the Tower of London, The British Museum, and most memorably, Stonehenge. Back then, before today's protective fence, I sat on a collapsed stone pier from remote antiquity and communed with the spirits of Druids. The plain materiality of that site, with its 56 paving stones surrounding it, was achingly beautiful, mysterious, and powerful. I also enjoyed having it all to ourselves on a damp, overcast, wind-swept afternoon. Nothing like that experience awaited us Stateside. The closest I've ever come was a day among the Sequoias in Eureka, California.

We lived in the tiny town of Ditchling in Sussex, next to a gentle soul named George Knott and his wife Pam. Childless, George and Pam would take tea with my family and share anecdotes about his life in the military. Every couple of weeks he would remind me to look for change behind the sofa cushions in our overstuffed parlor—I was unaware that he would palm some coins and pretend to root around in the sofa while dropping shillings for me to find. I finally figured it out because the money was warm.

BENEATH THE DECORATIVE SURFACE

One day when he came to visit us, he seemed subdued. In a small box he ceremoniously presented me with what appeared to be yet another shiny metal coin. Actually

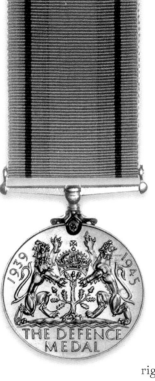

it was his Defence Medal, awarded during his service in the British Army in the 1940s. He had no one else to pass it on to, and even with a child's dim appreciation of the costs of war, I understood how a precious object had more value when accompanied by knowledge of its origins, function, and meaning.

Made of nickel-plated copper, the medal is not, in metallurgical terms, a precious object. The obverse (front) shows the bare-headed effigy of King George VI, facing left, and bears the legend GEORGIVS VI D: G: BR: OMN: REX F: D: IND: IMP. On the reverse, the Royal Crown rests on the stump of an oak tree, flanked by a lion and a lioness. At the top left is the date 1939, and at the top right, the date 1945. In the exergue (the bottom below a baseline) is the wording: THE DEFENCE/MEDAL. It is mounted on a plain, straight, non-swiveling suspender with a single-toe claw. Its light green ribbon is 1.25" wide with a central stripe of orange (0.5" wide) and a narrow black stripe in the middle of each green stripe.

The most important feature of this decoration, I assumed, was the shiny medallion. But Mr. Knott explained that the orange or flame-colored stripe of the ribbon represents enemy attacks on the green land of England, and the black stripe represents the blackouts during bombardments. The study of medals is a field unto itself, and the iconography of ribbons is not something a person without a military background knows. Instead we might fairly assume that a ribbon is simply decorative, with random color choices. It was his account of the colors that I remember most vividly, about why they signified the defense of freedom on British soil in the face of the enemy's assaults.

I treasure the medal to this day. It functions as a remembrance of George Knott, of his heroism, and of his fondness for me. The associations it creates every time I look at it are rich and recurring. It's like hearing a favorite melody—you never tire of it and the feelings it produces. But it was also the moment when I first made the connection between an object and its history.

Since that day I have always sought signification in objects that at first appear

only decorative. That was the day when, however imperfectly, I articulated it in my 10-year-old brain. I realized that context added value and significance to every object. It meant something by itself. But it meant so much more——it seeped its way into my memory and my heart—because I knew how, where, when, and by whom it was made or given.

I don't mean to present myself as a highly attuned aesthete at the tender age of ten. The truth is, I was largely unaware of my good fortune as a boy. So many privileged schoolmates had East Side town houses with servants rather than a rent-controlled Columbia apartment. But in time I came to notice that their furniture was not personalized. Their paintings were not by people they knew and whose homes they had visited. Their simulated Beaux-Arts surroundings were pale imitations of the palaces that inspired them. Arts and letters were things they coveted and displayed, not things they lived among in their natural habitats, from South Mountain Road to southwestern France.

OFF TO COLLEGE

Translating this wellspring of visual experience into the study of art history came about eventually, but it took some time. I had a sullen and unremarkable adolescence in Manhattan, and along with my more privileged classmates, was perpetually and unforgivably bored. At that age, hanging around with your friends on Park Avenue is no more exciting than doing the same thing in suburbia.

My first milestone in discerning quality came when I was a sophomore at Dartmouth. The first professor who took an interest in me, Franklin W. Robinson, is a renowned scholar of seventeenth-century Dutch painting. He generously arranged for my first publication, an article about the collection of a slightly eccentric Polish woman who had put down roots in New Hampshire, and owned America's most remarkable collection of eighteenth-century Polish and Russian prints. My job was to describe the collection, which was piled up in stacks in a large house dominated by about a dozen cats. Between cups of strong Russian tea, I pored over the etchings and engravings, and eventually managed to crank out a respectable summary of her holdings for Print Review magazine, later published when I was a senior. Once I had proven myself to Professor Robinson, he saw to it that my sophomore summer was spent back in Manhattan, as an intern with the legendary dealer David Tunick.

David Tunick had begun in the field as a young man, a member of the so-called "Williams Mafia." These were the graduates of a program in art history at Williams College in Williamstown, Massachusetts, taught by Lane Faison. A notable number of his students went on to become great scholars, curators, and museum directors. David is a quiet, commanding presence in a room. His tortoise-shell glasses and sandy-colored hair and beard give him a professorial air from afar, but his sardonic humor, very New York, can be intimidating. His voice is raspy and matter-of-fact, while he has a near-constant grin that seems not put-on but a function of how much pleasure his work provides. He dresses impeccably, but is not fussy about his appearance. At the same time, he leaves nothing to chance. When stopping in his booths at art fairs today, you are conscious of a man who needs no more potent illustration of his eye than the staggering quality of the art with which he surrounds himself.

But he had to start somewhere. I was there in 1975, closer to the beginning of his career, when he was specializing in prints—not drawings, and not photographs. When it came to prints, Tunick was the man to beat. By the late '70s he had cemented his reputation as the boldest dealer in the field by buying the most expensive print in history—$1 million for a pastel by Edgar Degas. To call it a print was a bit of a stretch—it is a monotype, meaning a one-of-a-kind print with features added in pastel by hand, making it a hybrid print and colored drawing. But a print it was, and his swaggering purchase made the whole art world sit up and take notice. In 2002, the Museum of Modern Art turned to Tunick to help deaccession an important group of photographs. While he had no track record in selling photography, he has one of the most enviable stables of clients in the art world.

In those early days in the mid '70s, he had to stretch to put together the right trappings for an outwardly successful gallery. He found a luxurious four-story town house situated between 5th and Madison Avenues in the low 80s, one short block from The Metropolitan Museum of Art. No sign announced the gallery within, save a discreet plaque whispering "By Appointment." The marble lobby reeked of the right pedigree, and a spiral stair led one up through successive floors with book-lined breakfronts, Persian carpets, chandeliers, ornate molding, and antique furniture. The high-ceilinged second floor, or piano nobile, was David's office. Oak tables were kept clear for viewing works under consideration, with sunlight pouring in from lead-glazed windows facing south.

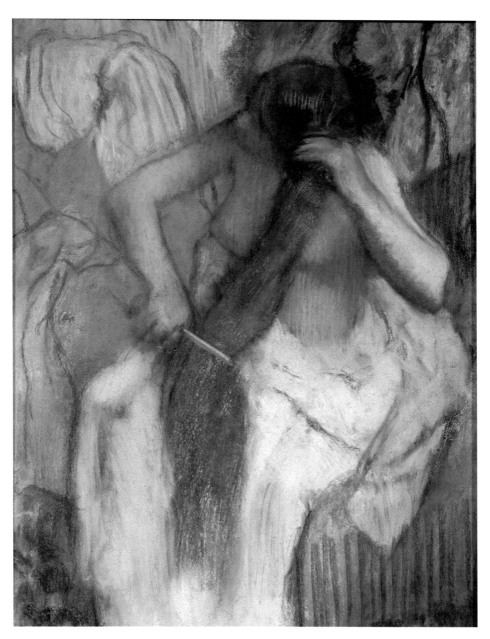

EDGAR DEGAS (1834-1917), *WOMAN COMBING HER HAIR*, 1890-92. PASTEL. MUSÉE D'ORSAY, PARIS. PHOTO BY ERICH LESSING / ART RESOURCE NY

It was a preserve apart from the overt commercialism along Madison Avenue on the Upper East Side, where the street-front galleries to this day offer the best works of second-tier artists and the lesser work of top-tier artists. In Tunick's baronial townhouse, you could be sure of one thing: he simply didn't show anything but the most brilliant impressions of a print in the best condition.

MY BAPTISM AS A CONNOISSEUR

I was an intern that summer, doing what interns have done forever: fetching meals, running to the post office, and chasing references. But Tunick had meticulously constructed a summer tutorial for me. On Mondays, he would take me across the street into the Prints and Photographs Department of The Metropolitan Museum of Art. There he would request solander boxes filled with Old Master prints, and we methodically examined every Dürer, Rembrandt, and Callot in the collection. He would slide the mat out of the box, gently remove the glassine sheet covering it, and quiz me about the subject, composition, sources, quality of line, freshness of the burr, type of paper, collectors' stamps on the recto (back), and every other feature of the master prints in this unfathomably great collection.

"Where's the block broken?" he asked with a wink.

I scanned the rich black lines on the woodcut by Ugo da Carpi, searching for a tiny gap in the middle of a passage. This would signify that after repeated impressions, the wood block was fatigued and had begun to wear down. It would prove that this was not an early impression but later in the life of the wood block—and therefore less valuable, both as a record of the artist's intentions and as a work of art. The scene was of *Hercules Chasing Avarice from the Temple of the Muses*, and the print dated to about 1518. I lifted the mat it was mounted on and held it up to raking light.

"Here—in the clouds behind the arch!"

Tunick grinned. "Actually the print is almost flawless. What you're seeing is the effect of a second block to add tonal variation."

He had been leading the witness. I was so eager, I saw something that wasn't there. I learned not to rush to judgment again, or at least to keep it to myself until I was sure.

It wasn't all connoisseurship. I was sent out for sandwiches, and knew that I had a long way to climb before I could lay claim to anything remotely like "an

eye"—that combination of visual experience and instincts that govern the recognition of quality.

But David Tunick taught me to look at art. He would rasp out questions I couldn't possibly answer. But like a great teacher, intent on inspiring rather than deflating a passion for the subject, he did not keep me waiting too long for the answer. His evident pleasure in teaching made the summer fly by, and there couldn't have been a better experience for a young pup seeking to soak up everything possible about the work of Europe's greatest artists.

The act of connoisseurship, I discovered, required deep commitment, and was only achieved through intensive study and intensive looking. Tiny clues couldn't be overlooked in the search for the hand of the artist, the state of a print, or the quality of an impression. Over the previous century, unscrupulous dealers had learned to fill in lines with ink by hand when woodblocks had cracked, or to bleach paper to give otherwise fainter ink a starker contrast.

Two years later, in 1977, I had my A.B. from Dartmouth, admission to the Ph.D. program at Harvard, and that precious internship with Dr. von Bothmer. My dreams were within reach. I believed myself to be launched on a museum career.

WHAT I LEARNED AT HARVARD

The art of connoisseurship—of learning to distinguish the treasure from the fake and the fine from the fair—is learned by concentrated examination of works of art, and by developing a sense of relative quality through comparative examination. The field of classical art is ideal for this learning curve, for two reasons.

First, most of the history of Western art derives its visual vocabulary, and its inspiration, from the ancient world. It's certainly true in literature, philosophy, and politics. No one has had a completely original thought, the adage goes, since Homer, Herodotus, Aristotle, Plato, and Aeschylus. And second, variations in quality are easier to spot when there are numerous examples of the same subject—as with nude athletes, draped women, horses, battle scenes, and other familiar typologies that consumed so much creative energy for over a thousand years of the classical tradition. The more examples of good, great, and greatest, the easier it is to establish quality.

Greek and Roman art was held up as the wellspring of quality for 2,000 years, specifically up until the moment in 1870 when the Impressionists toppled the past as

MUSE. MARBLE STATUE. IMPERIAL ROMAN COPY OF 130 B.C. GREEK ORIGINAL. RECONSTRUCTED IN ROME IN 1812 BY BERTEL THORVALDSEN. GLYPTOTHEK, STAATLICHE ANTIKENSAMMLUNG. MUNICH. GERMANY. PHOTO BY VANNI / ART RESOURCE

the ultimate source and began to celebrate the present. We can trace the influence of classical forms in the Early Christian art of Western Europe, to the first stirrings of the Renaissance, to the exuberant forms of the Baroque, and to the academic set-pieces of the nineteenth century. I always try to be conscious of what sources these painters, sculptors, and architects turned to, with varying degrees of success. I was lucky enough to have had an opportunity to master the basics of Greek and Roman art while still in college.

After college and that summer internship, I went on to graduate school in art history at Harvard, and finished the requirements for my doctoral dissertation in a hurry, at age 24. I noted down the day my thesis was formally submitted to the Registrar: April 21, 1981. I remember it well because it was the birthday of Rome— the day Romulus and Remus were believed to have founded the city in 753 B.C. Superstition played a part in the date I chose to submit it.

Dr. von Bothmer offered me a full-time job that summer, and I stayed on at the Met as an assistant curator until I left to become a museum director at 31. After three decades in museums, I have never abandoned the larger discipline of art history. It allows me to concentrate on the joys of art again, and to communicate that pleasure to others.

Two formative years in Europe during my childhood launched me on the quest I was to take up after college. For Americans, though, living in Europe is a luxury. Regardless of where we live, or how much we travel, we all have a desire to recognize and appreciate quality. The search for beauty and talent in a work of art is really a search for what separates the commonplace from the extraordinary. But our efforts need not be confined to art. Everyone is a connoisseur of something—it could be speedboats, trading cards, or chili. The refinement of the senses is a pursuit that gives pleasure to all of us. Through observation and experience anyone can learn the basics of that pursuit. And the effort rewards us in many different aspects of our lives, in ways we do not always foresee.

FINDING BEAUTY IN THE RUINS

The untrained eye can lose its way in the pursuit of quality for any number of reasons.

The producers of Sesame Street came to the Metropolitan in the early '80s to

film an episode there. The Met's young television producer Caroline Kennedy asked me to watch over the shoot in the Greek and Roman galleries. It was riotously funny to see Big Bird standing on a vacant statue base on the museum's ornate facade. But as he sang a song titled "Broken but Beautiful," it was a revelation to me that most visitors to museums have trouble admiring works that have endured damage. Having spent time among ruins in Europe, I took it for granted that wonderful treasures can be manhandled or suffer from the elements. The condition of a work of art can influence our estimation of its place in art history, but it shouldn't deter us from imagining what it must have been like in its pristine, finished state in an artist's studio.

In fact, art history itself is filled with regular acknowledgments of the importance of the state of ruin. Seventeenth-century Dutch still life paintings show flowers not only in full bloom but in their decadence, as well. Fruit has turned, attracting flies. Eighteenth-century German park architecture turns to the classical ruin as a romantic stage set, with "fallen" entablatures carefully placed on the ground next to half-height columns. And mid-nineteenth century landscape painting more often than not portrays events from classical mythology and the Old Testament in ruined settings, with classical temples in the foreground and background.

It is only in the last century and a half that we have developed an aversion to states of ruin. We either want it old but intact, or new. No imperfections need apply. You can't blame it on one signal event. It developed after the Grand Tour made it desirable to own and display baubles in treasure houses. The early nineteenth-century Danish sculptor Bertel Thorvaldsen made short work of Greek antiquities in Copenhagen's Ny Carlsberg Glyptothek, adding fanciful restorations that became all the rage by the 1880s. The industrial revolution made it de rigueur to build with repetitive casts of mechanical elements, revealing the structure of buildings with iron, steel, and glass, rather than occluding it with carved limestone or marble that tended to chip and weather. And the rejection of aging surroundings took flight over a half century, from the Impressionist movement in 1870 to the birth of a middle class seeking contemporary comfort rather than Old World opulence, to the embrace of the pristine trappings of the machine-age Bauhaus style by the 1930s.

As I settle into middle age, I am well aware of the march of time, in ways that would have surprised the student who found himself apprenticing at the

Metropolitan Museum 35 years ago. But while I've learned much in the intervening decades, I don't believe that developing a quality instinct comes with age. Dedication to looking will do the trick for a person of any age.

Let's move on to some examples of how we can develop better ways of looking at and judging works of art.

CHAPTER II : Defining Quality in Art

N
ow we arrive at the most challenging task in the book: defining what is meant by high quality in art. Many writers better read than I have thrown their hands up at this task. Others have rushed bravely ahead to stake out a position on the topic, only to be beaten back by hordes of adversaries. Yes, "quality" is contested territory. But let's head fearlessly into the fray.

WHAT IS MEANT BY QUALITY

Scientific efforts to measure quality are seductive. And doomed to failure. Since the birth of the expressions "beauty is in the eye of the beholder" and "*chacun à son gout*" (to each his own), there is too much room for disagreement to arrive at precise calibrations of quality. Instead of chasing easy solutions to an age-old challenge, it's best to aim for a kind of fluency in visual language. Just as exams provide only approximate computations of who speaks the best French, we would better devote our energies to learning to speak it as well as our faculties permit, and enjoy the fruits of fluency without assigning a score.

We should begin by noting three competing perspectives about quality.

First, the prevailing academic view that judgments of quality are completely subjective. My quality is just as good as your quality.

Second, the art market's belief that price is the best measurement of quality. The hammer rules.

LEFT: *TABLE FOUNTAIN*. FRANCE, PARIS (?). C. 1300-1350. GILT-SILVER AND TRANSLUCENT ENAMEL. 33.8 X 25.4 X 26.0 CM. CLEVELAND MUSEUM OF ART. GIFT OF J. H. WADE 1924.859

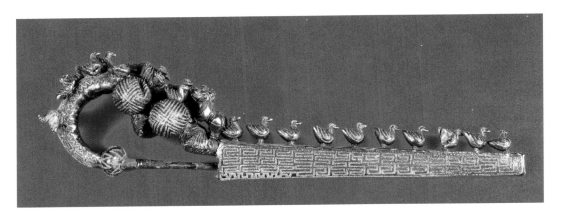

DRAGON-SHAPED CORSINI FIBULA FROM MARSILIANA. ETRUSCAN, SECOND QUARTER OF THE 7TH C. B.C. MUSEO ARCHEOLOGICO, FLORENCE, ITALY. SCALA / ART RESOURCE NY

And third, the dim popular view of most modern and contemporary art: "My kid could make that."

There is one basic thread running throughout this book. It comes from my study of classical art. In antiquity, everything made by human hands was capable of attaining high quality. Even something as quotidian as ancient Greek safety pins (we assign them the impressive Latin word *fibulae*) can be astonishingly detailed and beautiful. The great encyclopedic art museums are filled with utilitarian things made by the Greeks, Etruscans, and Romans that today are considered examples of fine art. That's because many of the makers of these things succeeded in realizing all of the features present in a high-quality example of fine art. And what, you ask, are those features? We're coming to that in a moment. But first…

A QUICK ROMP THROUGH WESTERN ART HISTORY

For a civilization with no shortage of masterpieces to their credit, the ancient Greeks had no word in their vocabulary for what we call art. The closest was *techne*, which means technical skill, or skill at making. For some of us who study the art of antiquity, the most fertile, exciting periods were those from the second millennium, the Bronze Age, through the archaic period to the very end of the sixth century B.C. A watershed divides the late archaic period from the next generation, known as the early classical period. The classical period extended from about 480 B.C. to around

the time of Alexander the Great, in the 330s. This is the phase of Greek antiquity that would later seize the imagination of the Renaissance, and of the nineteenth century.

For me, the pre- and post-classical periods are far more exciting than the flowering of the arts that took place under the sway of Periclean Athens, when the Parthenon was built. That is because these earlier and later periods were filled with restless creative energy, and less of a "canon" to walk in step with. By about 480 B.C. and the advent of what used to be called "The Severe Style," a specific figurative vocabulary emerged that emphasized harmony over exuberance. It was part and parcel of a new orthodoxy espousing the ideal proportions of a human figure alongside other ideals—the balance of mind and body, and devotion to the city-state. A stifling dedication to sameness made itself felt. The faces of gods and goddesses became all but interchangeable, and the physiques of male athletes were systematically copied in a literal canon—meaning a five-to-one ratio of the head to the body. It's an extension of devotion to the Golden Mean, a special ratio of parts to whole by which it was thought beauty could be judged (that seductive but doomed scientific effort to measure quality).

To be sure, there were wondrous accomplishments during the succeeding half-century. But there was also a stultifying attachment to achieving the ideal—and in the process, a stamping out of the feisty individuality of the Ripe Archaic period. The worshipful mimicry of the High Classical period in the sixteenth and nineteenth centuries was, to my mind, a limiting influence.

The École des Beaux-Arts, France's school that set standards for its art pupils, had less interest in what preceded the High Classical period, or in the ferment of the Hellenistic period that came with the death of Alexander the Great in 323 B.C. For me, the most exciting art actually started kicking up its heels again as the stolid predictability of Athens was cast aside and empires began to flower in the Hellenistic period, when warring provinces, freed from Greek domination if not Greek influence, began to find their visual vocabularies, from Alexandria to Bactria to Asia Minor. Among the fruits of this period were sculpture in the round, overt emotion in facial expressions, efforts to document all kinds of physical types in art, from body-builders to dwarfs, the neutral depiction of people of different races, and the first stirrings of psychological portraiture.

The Roman Empire was a fountain of restless innovation, carrying on the

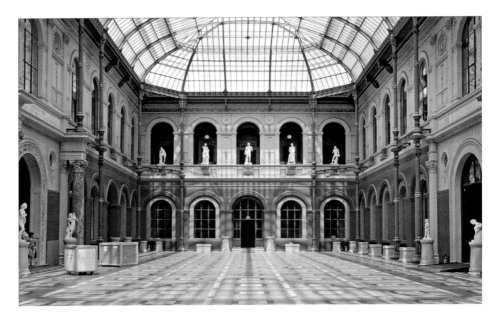

ECOLE DES BEAUX ARTS, PARIS. COUR DE PALAIS DES ÉTUDES. PHOTO BY DALBERA.

experimental temperament of the Hellenistic period before it. Sophisticated portraiture, frescoes, new architectural features, and other media were enriched by the turbulent creativity of the ever-expanding Empire.

Throughout the Middle Ages, guilds and workshops were the centers of artistic production. A rich visual tradition allowed talented craftsmen to make utilitarian, liturgical, and decorative paintings, sculpture, and objects of all kinds with no necessary connection to what would become known by the eighteenth century as fine art.

The Renaissance welcomed the notion that some makers of precious things were more elevated than others. Not only did artists like Michelangelo make such claims for themselves, but treatises affirming this higher station for such artists began to appear. While there were ancient artists like Zeuxis and Praxiteles who were held in high esteem in their time, they were not accorded the social standing of those later masters hired on by the royal courts of Europe.

The concept of *disegno*, or design, was made manifest. At this time architecture, painting and sculpture vaulted above the applied arts and decorative arts for the first time. Simultaneously, narrative art became more highly prized than art

without a story to tell, such as pure landscape painting, portraiture, and decorative arts. This effort to separate kinds of art was the beginning of our current dilemma.

The demise of guilds and workshops posed a problem for those who needed a quality compass. In the absence of a market-related mechanism to regulate the makers of art and craft, it was inevitable that some would come along who arrogated to themselves the definition of quality: the academies.

It all started with the French Academy, founded by Cardinal de Richelieu in 1635. Its founding members saw their role as the purification of the French language (some obsessions die hard). It was this constrictive impulse, now nearly 400 years old, that cyclically returns in Western society, wagging its finger at what is considered beyond the bounds of taste. In 1795 came the formal founding of the Academy of Fine Arts, replacing the Academy of Painting and Sculpture, founded by Louis XIV in 1648. The Academy of Fine Arts lingers on to this day, with 40 members and 20 honorary members.

Today the art world is in a state of despair because, almost four centuries after the founding of the French Academy of Fine Arts, we are returning to the possibility than anything made by human hands—or, for that matter, made through new technologies that were themselves the product of human hands—is eligible for qualitative examination.

There are two ways to cope with this revival of an age-old perspective on creativity. The first is to run from judgment, as many art history professors have for the past generation, while devoting countless pages of rhetoric to why we can no longer make judgments about quality in art.

The second way of coping is to reinvent methods of sorting the wheat from the chaff—reinvent by rekindling the personal impulse to judge quality, an impulse that predates the founding of the French Academy and the self-appointed judges in their wake who presumed to shield us from what they considered sub-par or offensive. To rekindle and refresh that long-lost impulse to judge is what I am attempting to do in this book.

WHY SOME SCHOLARS DISLIKE THE WORD QUALITY

Let's take on some of the obstacles to discussing quality. Most members of the postmodern university world have disavowed the pursuit of quality, rejecting it as

an extension of the self-indulgence of ruling-class collectors. It is assumed by many members of the professoriate that "quality" is a code word for market value, and that a cabal of self-interested parties rules on matters of quality as a means of propping up the exploitative art market. The argument goes that quality cannot be defined, since every viewer imposes her or his biases in defining it, so why bother trying?

This simplistic formulation is in turn decried by the many dealers, collectors, and even museum people as an abandonment of art history in favor of what is lazily indicted as "theory." Most detractors of the academic skeptics leave little room for social commentary about works of art, as practiced by scholars as nimble as former Harvard and Berkeley professor T.J. Clark. Conservative art critics lump theoretical approaches to art history with "political correctness" and dismiss any theoretical models as rigidly ideological, trendy, and removed from reality.

The debate about quality in art has a long history, dating back to remote antiquity, with lots of permutations. Today's battle lines were clear a generation ago. In a 1971 lecture at Bennington College, Clement Greenberg mournfully stated: "…my experience has been…that the question of being able to discriminate quality in art seems to be one that is improper to touch on in public nowadays."

Greenberg has been, for almost two generations, the bête noire of the modern art world. His appreciation of a select group of artists from the 1950s and 60s, and his castigation of others, marked him as a man frozen in time, unable to make room for innovation. He is guilty of that charge. In 1960 he launched a crusade with his essay "Modernist Painting," claiming in effect that representational art was at odds with what art should properly be, drawing a line back to the theories of Immanuel Kant. For Greenberg, painting could only be about painting, could only be about the surface. Representation and narrative were, to his mind, off limits.

While he stumbled in attempting to foreclose certain creative currents, he also raised important questions in the field of aesthetics, a branch of philosophy concerned with the nature of taste, beauty, and art, along with the creation and appreciation of beauty. Other "formalist" critics of modern art, including Clive Bell, Roger Fry, and Harold Rosenberg, also had tackled issues of taste in important ways. Roger Fry, at the beginning of the twentieth century, not only wrote but organized exhibitions of what would become known as non-objective, or non-representational art, and (happily) stirred up a great deal of trouble. He saw no necessary connection

between art and representation, although he did find the art he championed "beautiful" and therefore deserving of our attention.

Fry opened up the definitions of art and quality that have brought us to today's fractious art world. It's a world in which the avant-garde is continually gobbled up by tastemakers, including dealers, curators, critics, and collectors, and instantly sapped of its capacity to evolve. The old dynamic of the downtrodden artist neglected until after his death has been traded in for a hysterical talent search that anoints ingénues, only to trade them in for a newer model within a year or two.

Greenberg remains the immovable obstacle for contemporary criticism. While more recent critics weave their way through subjective pronouncements about what matters and what doesn't, his unapologetic stance continues to be discredited—notwithstanding the altogether subjective pronouncements of his detractors. While his position was untenable, he continues to attract the slings and arrows of his successors, in a backhanded compliment to the power of his claims.

BEAUTY IN ART: A TRAP TO BE AVOIDED

It's not the same as quality, but the problem of how to define beauty is what consumed aesthetics for a couple of millennia. It really wasn't until the 1960s that the worlds of art, literature, and philosophy acknowledged that creativity was no longer primarily in search of beauty. In fact, most avant-garde art by that time was in some way opposed to the ideal of beauty, which was read as vacuous, self-serving, and politically un-evolved.

This book is certainly not about beauty—although works of art of high quality are often beautiful to this day. I don't feel any guilt for appreciating works that happen to be beautiful, which is what separates me and other museum people from many aestheticians and postmodernists.

PLATO'S TAKE ON QUALITY

Western aesthetics has a long history, and finds its primary roots in the writings of Plato (c. 427-347 B.C.). Plato was 28 years old when his teacher Socrates was put to death. While Plato gave life to Socrates's philosophy, he also added much. Plato's *Republic* is the original source for any inquiry about quality in art, and deserves

our attention for setting the stage in debates then and since. He begins with simple questions, such as whether poetry is good for us, and he continues to fashion some of the building blocks of what would become the field of aesthetics. Many of his observations have fallen out of favor, and still others are utterly beside the point in an age of art marked by shark carcasses suspended in formaldehyde.

Plato offers no concerted theory of aesthetics, instead believing from an informed, although misguided point of departure that the arts can be, in Karl Marx's later formulation about religion, the opiate of the people. To Plato, art is powerful and dangerous.

His ambivalence about the power of poetry in the city-state was based on the fear that art can distract one from the proper concerns of an upright citizen—even as he praised its existence.

Plato went too far, arguing that the state should be in a position to exercise control over the arts, using censorship to ensure that the citizenry does not become incompetent at separating the pleasing from the good. His proscription doesn't fly in most of the post-Soviet world because we are too attached to individual liberties—a philosophical tenet that postdated classical Athens.

Odd as Plato's impulse may seem to a modern reader, it has no shortage of adherents today. The culture wars of the 90s and the sanitized National Endowment of the Arts of today presuppose the foundations he laid about how art can be dangerous and divisive. For many, the photographs of Robert Mapplethorpe represented a threat to their version of a Platonic civilization, and needed to be repressed.

Plato and Marx bracket a host of philosophers, including G.W.F. Hegel, for whom Christian orthodoxy needed to be part of the debates about art and philosophy. But Plato's approach is the starting point for all those thinkers who followed. His line of inquiry included many of the questions reviewed in this book: how art is different from other forms of man-made things, how art triggers a set of responses from us, and what effect these responses have on us.

As Plato's teacher Socrates famously put it in *The Apology*, "the unexamined life is not worth living." It is in our best interests to spend some time in self-examination about art and about our relationship to it.

In preparation for our quest, here comes a fast-paced survey of some highlights from the history of aesthetics.

ARISTOTLE'S SPIN ON QUALITY

The writings of Plato's most renowned student, Aristotle (384-322 B.C.), are also fundamental to the study of aesthetics. For Aristotle, there is a critical distinction between what a thing is—its essence—and its *extrinsic* quality—how well a thing lives in other contexts. Essence matters because it's how we can agree on what is art and what isn't—no mean feat these days.

Aristotle's second definition of quality is the one we're primarily concerned with: how well works of art function once we are looking at them. Aristotle believed that you can measure the degrees of this kind of quality in the case of something that has a purpose. Art, he argued, had better have a purpose, even if purely decorative, or purely incendiary. He saw the purpose of tragedy as instilling emotions that would lead to the catharsis of pity and fear. That conviction is in step with the way ancient artists thought and worked, as well.

The minute that art has a purpose, it puts itself in play for the quality detectives. The function of an object, its *ergon*, is what we are measuring. We can update the *ergon* to work in today's wildly expanded definitions of art. If a work of art does its job properly—by inspiring us, for example, or stirring, provoking, or engaging us—then it has a claim to being measured by how well it does one or more of these things. If its maker wanted it to be sublimely beautiful, with no purpose other than to elicit admiration or give pleasure, that too is a legitimate claim in the realm of quality. The only way we can be sure that something has quality is if, at its roots, it aspires to have quality, as do works of art.

Naturally enough, in a world in which there is a shifting definition of art, the simple elicitation of admiration or pleasure is now on more perilous ground. Starting with Marcel Duchamp, some artists actively seek to erase the boundaries of art and non-art. This is an attempt to beg the question and remove too much subjectivity or too much objectivity from the act of looking. For many artists and art world observers, art need have no obvious purpose whatsoever. And beauty, while prized in consumer culture, is hardly the top currency in the visual arts today.

But we're going to work on this. Once you are more familiar with what is being made today, you can feel more comfortable in any space or experience you're tossed into.

CATHOLIC DOCTRINE AND ARTISTIC QUALITY

In the Middle Ages, the philosophical tradition practiced by the Scholastics took Plato's *Timaeus* as its point of departure. St. Augustine (A.D. 354-430) was at the birth of what would become known as the theory of ideas, and the reception of Plato. He grappled with Plato's original proscriptions on art in a new theological context. Medieval theologians in this tradition were quick to embrace art as a proper place for man, since the making of objects could be seen as the fulfillment of divine intention if they served a purpose in the liturgy.

The Renaissance ushered in a wholly new way of seeing art, freed from theological strictures, and exemplified by Bernal Diaz's life-changing encounter with the Aztec capital (*The True History of the Conquest of New Spain*, completed in 1568). It became possible to enjoy "wonder" without guilt—and without fear of retribution from the Church. The implications for art were many, including ushering in depictions of pleasures of the flesh, major works of art that lacked an overt theological or moral message, and the celebration of the human alongside celebration of the divine.

THE QUALITY DEBATE DURING THE ENLIGHTENMENT

Immanuel Kant's *Critique of Judgment* (1790) presented a highly developed approach to sorting out the evaluation of art. He believed that aesthetic judgment was undertaken from four topics named quality, quantity, relation, and modality. His basic premise was that the judgment of taste is disinterested. This meant that he rejected the view of the empiricists, for whom passions are the ways that we apprehend quality and beauty. In opposition to Hume and Burke, Kant differentiated between sensation and feeling. Sensation to him often means a *dispassionate* experience of the senses, while feeling is *wholly subjective*. Taste has no logic, but is driven by feelings triggered by an aesthetic experience. So while it's subjective, it's also incontrovertible.

In fairness to Kant, his doctrine, which rests on this concept of disinterestedness, was centered on the experience of nature, and extended to art. But ultimately his effort to compartmentalize aesthetic experience is destined to fail, because we all import so much of ourselves and the world beyond the object into our calibration of its importance and success. And it is problematic because the materiality of objects intrudes into what might otherwise be a purely cognitive, imaginative experience.

How we define art has changed a great deal since Kant's day. And as contemporary observers of the history of art, we import a tangle of associations that he lived blissfully without in eighteenth-century Königsberg.

Kant's great admirer was G.W.F. Hegel. His *Lectures on Aesthetics* were published after his death in 1831, but remain fundamental to students of the field. As an idealist philosopher, Hegel drew from the traditions set in motion by Plato. He defined reality, or "what is actual," as dependent on the ideal. The ideal, in his formulation, is the synthesis of form and content, which he called the *Idea*. When a human being can take something in through his senses, seeing both form and content, that's real.

The existence of the thing alone, Hegel believed, was less important than how we perceive the thing. He was an expert observer of art, perhaps more than almost any philosopher before him, and he was in some ways a mirror opposite of Clement Greenberg. For Hegel, a work of art could only succeed if it was executed in keeping with Renaissance typologies, including naturalism, proper perspective, and shadow.

Scottish philosopher David Hume's *Enquiry Concerning the Principles of Morals* (1748) proved indispensable in arguing for reason before appreciating art: applying the lessons of the Enlightenment rather than simply giving in to a first rush of enthusiasm for something that appears to be beautiful, or, by extension, of high quality. He also notes that notwithstanding earlier philosophical efforts to prove otherwise, "disinterestedness" is hard to achieve: "In every judgment of beauty, the feelings of the person affected enter into consideration, and communicate to the spectator similar touches of pain or pleasure."

Not everyone loves boundaries in the field of aesthetics. French poet Charles Baudelaire (1821-1867) claimed that "(a) man's idea of the beautiful is imprinted in the way he dresses, it rumples or stiffens his suit, softens or sharpens his gestures [see Plato's *Republic*, Book Three], and in the long run, even subtly marks his facial features. He ultimately resembles the person that he would like to be." Baudelaire's concept of the fashion plate as work of art seems altogether Warholian, and akin to Nietzsche's formulation in *The Birth of Tragedy*: "No longer the artist, he has become a work of art."

A real watershed in assessing quality came not only with Roger Fry, but with the advent of modern art. For Marcel Duchamp and his peers, the First World War represented human loss on an appalling scale, justified by political claims that rang hollow. That moment of artistic rebellion and its critical acceptance set the stage for the 1960s and the rejection of standards, which affects art criticism to this day.

After centuries of philosophical ruminations about artistic quality, the allure of science as the place to find metrics proved too great to resist. In 1960, at the very moment that Greenberg labored to cast off the history of art in favor of a new way of seeing, professor of psychology Daniel E. Berlyne tried to change the sheet music on the piano altogether. In *Conflict, Arousal and Curiosity*, he posited that it is not taste, but human physiology that is at the root of how we gauge quality in art, along with most other phenomenological judgments. Berlyne elaborated on this in writings in the 1970s, most notably in 1971 in *Aesthetics and Psychobiology*. He was later taken to task by Colin Martindale, another professor of psychology and a noted aesthetician, who believed that cognitive psychology, not physiology, is the route we must take to understand how people arrive at likes and dislikes in art. In his interpretation, the meaning of art is the stimulus to such choices, while Berlyne created an elaborate system rooted in the formal properties of artworks to explain how they triggered a reaction in the viewer.

If you're confused by any of this, think how their students must have felt.

In 1988 Martindale retrieved some ideas from Kant's bag of tricks, and tried out this approach:

"Aesthetics has been defined in various ways... We shall define the term as referring to the study of how stimuli defined as being artistic or beautiful induce disinterested pleasure. Philosophical aestheticians... have argued for centuries that aesthetic pleasure is different from other sorts of pleasure in that it is disinterested. By this, they mean that one is not interested in possessing or using the stimulus. Another way of putting this is that aesthetic experience is phenomenologically mild and subtle, and strong emotions and motives are not involved."

Ha! For me, it's hard not to let emotions and motives get involved in choices about art. But the key definition is reasonable—that judging quality in art is usually different from judging quality in something primarily functional, like refrigerators. A Sub-Zero refrigerator has a claim to quality (and, incidentally, isn't hard

on the eyes). Intelligent people disagree about the quality of the Sub-Zero versus a Viking on grounds that are not purely based on how it looks. Intelligent people with too much time on their hands, that is.

MY TAKE ON HOW TO DEFINE ARTISTIC QUALITY

With most art, the argument stands, even if it's functional, we judge it differently from how well it functions. The Cleveland Museum of Art has an exquisite table fountain from early fourteenth-century Paris, acquired in 1924. It is a miracle of craftsmanship, and may be the only such work surviving today (page 32). A medieval prince or princess had it at dinners to astound guests. About a foot tall, and with three tiers like a Gothic wedding cake, it has bent sheet metal with miniature figures and architectural features. Little wheels and nozzles, when they functioned, allowed the play of water to ring bells, only to refill the top tier from the basin below.

So it functioned in a sense—although the function was purely for the amusement of the prince's guests. And it is no less beautiful, ornate, and intricate, now that its foot pump is no longer working. It manages to straddle different worlds.

Similarly, the function of a painting from the Rothko Chapel in Houston is rooted in its setting—a place for private contemplation and/or worship. When Rothko's paintings were removed for treatment in the 1990s, they stood in a Conservation Lab at the Menil Collection. Wrested from their intended function, they were no less magical and subtle under the cold light of the restorer. If anything, their quiet, resonant power seemed to overwhelm the rational trappings of science around them—as can a remarkable man or woman in a hospital bed.

So great art can make it out of its intended *ergon*, or function, and still have legs. That is a major test of quality: can a work be plucked from its intended setting and still have powers of suasion over the onlooker?

Like many people trained in and around museums, I neither embrace the postmodernist argument that assessments of quality are fatally compromised by the viewer's biases, nor the others' rejection of nuanced readings of works of art according to social, historical, or even linguistic criteria. There is room for clear analytical thinking about works of art, along with a primeval fetishism of beautiful things for their own sake. In religion there is room for the nuanced theoretical musings of St. Thomas Aquinas along with the pure devotion of St. Francis of Assisi—both made

ROTHKO CHAPEL, HOUSTON, TEX. INTERIOR VIEW WITH WEST TRIPTYCH-NORTHWEST-NORTH TRIPTYCH PAINTINGS. PHOTO BY HICKEY-ROBERTSON.

a signal contribution to the development of the Christian religion, and each had a wholly different point of departure about his convictions and his reasons for faith.

There are as many ways of reading a work of art as there are readers. Unlike the realm of science, in which something is provable as true or false, the whole point of art is to stimulate a series of responses in the viewer. The viewer who takes away only one interpretation is missing the full, textured potential of art to awaken our senses and our reasoning in manifold ways. This is not a realm for the either/ or, it is a realm for unfettered associations and responses. Art is one place—unlike religion, philosophy, or the social sciences in general—in which the author's intention provides a point of departure, rather than the destination. The *Mona Lisa* has spawned an industry of invention and speculation, from Marcel Duchamp's application of a mustache on a replica of it to the best-selling novel *The DaVinci Code*.

Each of the ways in which the *Mona Lisa* exerts an influence on the human

imagination is simply one more testament of its enduring power. Whether Leonardo saw it as a feminized self-portrait, as some argue, or as an embodiment of female beauty, or as a portrait of his mistress, or as a straightforward image of a wealthy noblewoman, its achievement as a masterful painting cannot be gainsaid. This last matter, the indisputable impact of certain objects as a visual experience, is the subject of this book.

ART AND MONEY

Some assume that monetary value and artistic quality are synonymous. This is demonstrably false. The art market is a very plausible mechanism for judging value, but an imperfect one for judging quality. The intersection of the two attributes is far from constant. A renowned painter's masterpiece that has suffered significant damage will likely have lost monetary value, but will have lost none of its intrinsic quality. A lesser work by a renowned painter will still command a considerable price, but may be lacking in quality. The ultimate purpose of the art market is not to discover quality, but to keep the merchandise moving freely among buyers and sellers while taking a bit off the top with each transaction. Some dealers, those who are the models of the field, are prepared to make personal and financial sacrifices on behalf of their artists. But this is a dwindling number in a very competitive industry.

Ideally this transaction leaves the owner, seller, and buyer happy in equal measures. The person parting with property will receive a sum commensurate with his hopes, the seller will receive a healthy commission, and the buyer will part with a sum that is commensurate with his desire to own a precious thing. Often lost in all of this happiness is an objective assessment of the quality of the bauble. In the transaction, quality is less important than the perception that the value was "fair." The owner could be motivated by a need for money or to buy another work of art he cares more about. The seller sees the work of art as a dispensable part of a commercial transaction. And the buyer may be less interested in quality than in the artwork's investment potential, or as proof of wealth or taste.

Exceptions are many to these three stereotyped intentions of the owner, seller, and buyer. But these are a wholly natural feature of the cycle of art making and art buying and selling.

By stark contrast, when a museum makes a purchase, it sees the monetary part

of the transaction as a necessary evil in safeguarding a work in perpetuity for the public good. There is no joy among curators and directors when the hammer falls at auction with a record price—while most observers in the auction hall applaud, museum people cringe. Reducing a work of art to mere property is to debase it. Presumably if it is of sufficient quality, its high cost can be justified. But it is never a cause for celebration.

CRITICS AND SKEPTICS

While a dwindling number of newspapers assign reviewers to write about special exhibitions (there are as few as four newspapers left in the U.S. with full-time art critics), there is no regular beat in the mainstream media for an informed writer to judge the quality of works of art entering museum collections or on permanent view. Only the commercial features of art are the subject of regular reporting and analysis. The museumgoer has to turn elsewhere for an informed opinion about works of art.

An additional challenge in making room for the study of quality is the skepticism of the average museumgoer. Doubt is cast specifically on the art of the last century, and can be summarized as the "my-kid-could-do-that" reaction.

The problem with this reflex is that most innovations in human history appear obvious in hindsight. But it took someone to think them up. Whether they have lasting power can only be judged over time. Often the simplest innovations are the hardest to arrive at and have the most transformative power. The ancient invention of the spring changed mechanical engineering forever. Electricity, the transistor, the microchip were all discovered or invented as a result of accident or dogged research, but today they are indispensable to our way of life. In works of art, the restless need of artists to express themselves often spawns deceptively simple results, as the first spring may have seemed.

Reflexively mistaking visual economy for laziness is like dismissing Hemingway because he writes in short, unpretentious sentences. There are as many ways to make art as there are individual artistic voices, and I ask you for a suspension of disbelief about contemporary artworks that appear simple to create. We will consider the reasons that they deserve our appreciation.

Here's a problem of recent vintage: the glut of images that bombard us from

the minute we wake up to the last flickering of Jon Stewart at night. From social networks to fast-paced television coverage, to ubiquitous advertising, PowerPoint presentations, the Web, animated avatars and an infinity of other visual stimuli, we can't turn around without seeing representations of reality. The work of art that portrays a version of reality is up against it these days—an overload of our visual systems that seems to make discernment far more difficult.

Like people of every age in recorded history, we assume that our time is unique, that our problems didn't exist a generation ago, and that things were better in the past. So it only seems fair to question whether we are in fact more bombarded with images than people of earlier times. People have had their eyes open for millennia. We used to see more reality and less filtration of reality, but we have always had our eyes open.

A case could be made that the daily tidal wave of electronic and print images that greets us makes it no easier or harder to sort out the good from the not so good. After all, it is fairly easy to trick us into seeing things that aren't there, from trompe l'oeil artworks to sidewalk chalk drawings to three-dimensional simulations using virtual reality and video games. The surfeit of illustration and visual stimuli might for some have a different, salutary effect: the eye may be trained through extensive exposure to print and electronic illustration. The ability to sort out an accomplished photographer's work from an amateur's may only come from repeatedly examining the full spectrum of work being made today.

For most of us, the fact that we make less time to reflect is a matter of choice. It would be hard to argue that people have less time—a day has the same number of hours it has always had. And we don't have to rely on candlelight after dusk. Our responsibilities at work and home have shifted, as commuting time has shifted. But Americans still while away time in front of a screen—increasingly, screens that we take with us wherever we go. As high-definition television evolves, it is to be hoped that the experience of viewing works of art on a screen will materially improve. The encounter with a crystal-clear reproduction may draw more people into galleries, just as music downloads build an appetite to hear a performer live.

Whatever the future holds, will visitors to our museums be well equipped to discern quality in what they see? Here we are, arrived at what I promised earlier. Let's take a look now at some tools we can use to judge quality in art.

THE FIVE FEATURES OF ARTISTIC QUALITY

On a bitter cold afternoon in January 2004 at the inaugural Berkshire Conference in Williamstown, Mass., I slipped out of the festivities to savor the permanent collection galleries of the Sterling and Francine Clark Art Institute. This extraordinary museum boasts some of the greatest works in the United States—an altarpiece by Piero della Francesca, a small panel from 1440-50 by Pesellino showing King Melchior sailing to the Holy Land, superb nineteenth-century oils by Corot, Gérôme, and Delacroix, as well as unrivaled Winslow Homer holdings and robust Impressionist works. The unerring eye of Sterling Clark would be hard to surpass today. As a collector, he made remarkable choices that nearly a century later stand as a testament to his instincts and education. Looking out on the snowy hills of the Berkshires, I was easily transported into *quattrocento* Florence, so exquisitely rendered were the paintings before me.

What I did that memorable afternoon is what I do in most collections, public and private. I look for five features. These five features begin with Plato's warning against *mimesis*, or imitation, and continue with other commonsense considerations.

The five features are the extent to which a work of art is:

1. *Original* in its approach
2. *Crafted* with technical skill
3. *Confident* in its theme
4. *Coherent* in its composition
5. *Memorable* for the viewer

Original, crafted, confident, coherent, memorable. These five features, in my view, can be applied to anything made by human hands. In the following chapters, we will unpack them, one by one.

Before we strap you behind the wheel and send you off to seek out quality in art, let's start with something less daunting.

First try out these five attributes on something utilitarian that you have around you. It could be almost anything: your computer or smartphone, kitchen utensils, sunglasses, a lawnmower, a car. What is original in the object? Is it skillfully crafted? Does it project confidence in how it is designed to do what it is meant to do? Does the whole thing hold together: is it coherent? And is the object worth remembering?

MASERATI GRANTURISMO S. PHOTO © MASERATI.COM

What matters here is the chance to begin exercising that part of our brains and our senses necessary to discern one like thing from another. Walking down a street, let your eyes follow the line of parked cars and test out the five features. In the case of cars, it will come easily to you to separate the best from the least. Cookie-cutter designs, unexciting profiles, fussy details, ugly proportions, or a tinny look and feel are some of the features we don't like about cars.

But if you walk by a fine hotel and a Maserati is parked outside, you pause. Why? Besides the fact that the thing has a six-figure price tag, I mean. It is because:

1. The design is *original*.

2. It's well *crafted*. You can't imagine that they skimped on the materials.

3. Its shape is *confident*—meaning bold and uncompromising.

4. While detailed in execution, nothing seems gratuitous or out of place. It is balanced, elegant, well proportioned—*coherent*.

5. It's *memorable*—you are drawn to it for its distinctive features. Your eye lingers. You're not likely to forget it.

Try this exercise on other familiar (and less opulent) objects within your line of sight. There's no score. The process is about training our eye to pick out the character of an object in line with these five features. If you're not drawn to the object, so note and move on.

Over the next few chapters, try giving these five features the benefit of the doubt. We will exercise our quality instinct as we go.

NOTES

Homemade Esthetics: Observations on Art and Taste, Clement Greenburg, contributor. New York: Oxford University Press, 1999, p. 107.

Charles Baudelaire, *Œuvres complètes*, 2 vols. Bibliothèque de la Pléiade. Paris: Gallimard, 1975, II, 684.

The Foundations of Aesthetics, Art, and Art Education, Frank H. Farley, Ronald W. Neperud, editors. New York: Praeger, 1988.

CHAPTER III : How to See: The Detective's Reflex

B efore we launch into the hunt for quality, we have to limber up. Athletes develop muscle memory. Aesthetes develop a quality instinct. Just as an athlete in training is really encoding reflexes in her or his muscles, we need to train our eye to have reflexive reactions to visual stimuli.

FEELING INADEQUATE IN FRONT OF A PAINTING

For at least three centuries, a basic human ritual has brought on crises of confidence in otherwise intelligent people. All of us have made the effort to stand before a work of art in a museum or home, and end up feeling duped or afraid of exposing our befuddlement. The mid-nineteenth-century French artist Honoré Daumier is this ritual's best chronicler. His cartoons lampooning critics and gallery-goers help inoculate us from feeling alone as rank amateurs. Like cartoons on the same topic in *The New Yorker* to this day, the best of these leave us laughing at the pretense of people with whom, ultimately, we identify.

For some reason, when presented with other comparable challenges in life, thinking people don't feel inadequate. We can be at a car mechanic's mercy but feel no less worthy because we don't know a carburetor from a drive shaft. Being stymied by a work of literature is also different—we can close the book, read a synopsis, and lay claim to knowing enough about its contents to have "read it" or at least skimmed it. We can quote one passage and feel connected with the author's intentions.

LEFT: ALBRECHT DÜRER, *COAT-OF-ARMS WITH A SKULL*, 1503, ENGRAVING. PRIVATE COLLECTION, U.S.A. COURTESY OF DAVID TUNICK, INC., NEW YORK.

VICTORIA AND ALBERT MUSEUM, LONDON. PHOTO BY PIO3 / SHUTTERSTOCK.COM.

But standing in an art museum is a public experience. "Reading" a work of art thoroughly is a slow and mysterious act of revelation with no clear end. Speaking about it is a subjective journey lined with traps—academic jargon, tempting but misplaced comparisons, restorations or settings that distort the artist's original intentions. For those of us who have felt a chill when confronted with this gap between looking and understanding, the good news is the vast company we're in. I have been with educated, affluent people who are literally more fearful of betraying a lack of taste and discernment than they are of losing hundreds of thousands of dollars.

SOME TACTICS FOR ART MUSEUM VISITS

I have vivid memories of a year abroad as a graduate student, approaching each of the dozens of museums I visited as if I were inspecting apartments for rent. My goal was to make the optimal use of time by scouting out the floor plan, calculating the amount of time needed, racing first for a quick inspection of the statue(s) or relief(s) I had come to sketch, photograph, and notate, allowing myself the indulgence of scanning the museum's general contents beyond those specific works, and then wrapping up before closing time or the last bus back to town, whichever came first.

Reciting the ritual today makes it sound like drudgery, a mechanical formula to register the attributes of objects I had traveled a long distance to inspect. And truth be told, much of it was baleful duty, as was writing the doctoral dissertation itself. The encounter with the original object was bound to be fleeting, and there was a chance that my single-lens reflex camera would fail, leaving me with only a quick sketch and summary notes. It would be easy enough today to email the museum and request a jpeg. But in those days there was no email, and since there were no illustrated databases, a snail mail request might take months to fulfill.

So while there is in one sense little to learn today from the rigor of the break-neck visits I had to orchestrate over 30 years ago, in another it set in motion a formative and lasting suspicion that photography could not be relied upon to convey the appearance, dimensions, function, condition, and quality of an artwork. All of that was up to me to absorb, record, and enjoy on the spot.

Today's museum visit requires none of the work I put into it then. A camera phone can do the work, and a sidelong glance is sufficient to decide whether to

linger for three seconds or a luxurious five. Like sampling music on a handheld device, taking in an artwork can be a very casual matter, apart from those we are inexplicably drawn to, or those few famous artworks that likely prompted the visit to start with.

"Suspension of disbelief" is a great phrase, in that it captures how we often fall into a trap of our own making by failing to employ critical faculties. Looking at art demands on the one hand that we suspend our instinctual disbelief in what the artist is asking us to believe, and on the other hand that we be analytical about how the artist approached his assignment.

Keeping two competing ideas in our heads at once is essential: we have to allow ourselves to be seduced into seeing the seated statue of a Buddha as he might have been seen by a sixth-century worshiper. But we also have to question how this Buddha stacks up against other examples that the worshiper or artist might never have seen. In this way the act of looking at art is most rewarding when it doesn't stop with mere recognition, but moves on to some combination of free association and comparative analysis.

SEEING ART OUTSIDE MUSEUMS

Entering the living room of a collector, I am always conscious of the game about to be played. It's like a day at the county fair with a toy rifle in hand, aiming at the duck targets ambling by. Each correct attribution of a work of art gets you closer to the stuffed animal. Each missed one brings you closer to the empty end game, even to humiliation. I have had the experience countless times. Once this happened in the home of an established noble family in Italy. I was ushered into an overstuffed space filled with eighteenth-century tributes to the Italian countryside. I recognized a Canaletto, and drew closer to it. Even in the dim afternoon light, I could see that it was very heavily retouched—that losses to the original surface had been filled in by a restorer, and none too expertly. The sky, instead of radiating its typical clarity and brilliance, was almost opaque and flat. Some of the figures by the canal were clearly built up with thicker paint than others, and one of the gondolas had no depth or tonal subtlety to it.

"*Ti piace?*" (Do you like it?), asked my host. The ethical challenge was before me. Should I share my misgivings or dodge them? In a split second I opted for the latter.

What was to be gained by bursting his bubble? Were he thinking of buying or selling it, that would be a different story. But this had probably been in his family for a century or more, and little stood to be gained from a conditional response other than disbelief or rancor. So I let it pass, and with that I opened myself to the criticism of the next art historian who answered that question with his boxing gloves off.

It is my view that a work of art has many lives, and the dormant one in a private collection is the safest, if not the most edifying for the rest of us. Removed from the public eye and from most tastemakers, it can give pleasure without the risk of being downgraded a notch. I've always found it hard to run down an object in someone's home—it would feel like dismissing their cooking—but the minute someone asks my opinion about putting a work of art in play, the game changes. Then either you say you can't comment or you had better be sure of what you are saying. Many a lawsuit has been born of a stray comment that depressed a sale price. For the time being, that Italian nobleman hadn't crossed the line into soliciting a comment that might have had unintended consequences.

TASTEMAKERS AND TASTEFAKERS

Fear of mistakes prods many well-to-do people to hire tastemakers—dealers, curators, designers, or "art advisors"—who can help prevent embarrassment at having bought the wrong painting, sculpture or photograph. The problem is that such reliance only serves to shield the buyer from the work and the learning of the true collector, a breed that is all but gone.

During the course of my career I have met dozens of people who have a fully developed quality instinct. They are anointed as experts in various fields—antiquities, medieval art, Renaissance and baroque paintings, nineteenth-century landscapes, twentieth-century masters, and the very sharpest of cutting-edge contemporary art. Each has come to an appreciation of quality in his or her own way. And yet there are familiar themes.

There are a fortunate few who are born into circumstances that make taste an automatic response, like breathing. They are raised in surroundings that exude self-confidence. This may be connected to inherited wealth and privilege, as when a child of European aristocrats is reared in a setting that has been vetted for centuries.

But being awash in finery can have the opposite effect for some people, allowing them to switch off their internal quality radar in those luxurious settings they take for granted. When they are launched into young adulthood, they're lost. We see children of privilege today parading on reality television shows, completely unencumbered by taste or good judgment of any kind.

There are others instinctually born with taste. You may be such a person, or you may have them in your life. They're much more fun to be with than those without.

For others of us, taste is acquired through hard work. It is instinctive to search for quality—we do it countless ways every day, in choosing what to eat, how to dress, where to shop, and how to spend our time. To the frustration of *arrivistes* seeking to display their unerring taste to the world, taste has no necessary connection to money.

I vividly remember in the early '80s visiting the tiny studio apartment of an aspiring Italian designer. His Manhattan apartment was no bigger than a walk-in closet in some of the palatial homes I've known. But every inch of his nest revealed a flawless visual compass. This was years before popular design solutions could be bought through the Internet, long before people could choose what prefabricated setting suited them best—Ralph Lauren or IKEA—and simply order it up.

This aspiring designer had an internal quality compass that led him to the right fabrics, clothing, and décor, and he reveled in his conquests. He was of a piece: playful, with a love of life, and an insatiable curiosity about how to surround himself with the beautiful. His taste seemed innate, at least to a West Side faculty brat like me. He could find cast-offs and make them his own. He collected original objects from various walks of life that were not available at the fine stores frequented by society's doyennes, and he managed to present them in a modest, uncluttered way. He made his own style. To some it might have seemed affected. But his tiny lair was more authentic than the multimillion-dollar homes he aspired to design for those of lesser visual sophistication. And the satisfaction he derived from it was palpable.

BASIC TRAINING FOR YOUR EYES

Here's a first step in developing a quality instinct: begin a series of exercises to train the eye. A scholar looks at a painting with a rapid-fire, almost instinctive checklist of criteria: the surface condition, arrived at through natural wear and tear, neglect,

or damage; the evidence of restoration; how the composition is balanced; evidence of a signature or maker's mark; the brushwork of passages in the foreground and background to see if they are by the same hand; whether the formula of the iconography (subject matter) is clearly derived from someone else's precedent or seems original; and a host of other questions.

We can develop our own checklist in our homes. Open your kitchen cabinets and scan the products arrayed before you. Everyday objects and man-made places are loaded with signification, and much of it is far subtler than what is found on soup cans and store signs. But if we learn to decode both the apparent and the hidden meaning of everyday objects, we will be better equipped for that next visit to an art museum.

Examine the graphic look of some product packaging. Separate four or five cans or boxes on the counter and study their various attributes. Does the primary typeface match the character of the contents—fancy or hearty? How many competing fonts are there, and do they work together or clash? How effectively can the product's identity be spotted from a distance? Is the shape of the container elegant, nondescript, or clunky? Does it reflect the contents? Is the printing of the ink completely in register, or does it bleed somewhat? If the packaging design hasn't changed in decades, has it passed from being new to old to campy to classic, or is it stuck at old? Is a consistent story being told through the design, or does it read like the clumsy work of a committee?

A walk in a commercial district of your hometown can provide another useful exercise in studying store logos. What is the subtext conveyed by the sign—is it a contemplative design or mass-produced? Is there any editorial judgment at work, or is this just a piling on of information? What does the logo or graphic identity convey about the culture of the purveyor of products and services—sophisticated or matter-of-fact? Are the materials used more costly or more rudimentary?

By learning to look at everyday things with this level of attention, we can begin to train our eye to look at precious things the same way. These simple exercises involving cans, boxes, and store signs can be transferred to works of art. Substitute brushwork for printing, color for fonts, meaning for product identity, harmony for packaging design, and we are on our way to separating the features and intentions of a work of art.

ANTIQUES AND FLEA MARKET. ITALY. PHOTO © GRETASPLACE.

MY FIRST CONCERTED QUALITY QUESTS

In 1979 I received a $5,000 university travel fellowship. With travelers cheques in hand, I spent nine months overseas on one tight budget. While in Europe, I returned to flea markets, where my parents had taken me as a child. This time I was in search of quality, rather than taxonomies. I made a practice of buying seventeenth- and eighteenth-century engravings with classical scenes. Not at art galleries, not from established sources. From street merchants. Properly framed back home, these works by Piranesi and his peers take on a timeless character that I recognized in the flea market, but that others might have passed over.

Learning to differentiate reproductions from original prints is a skill that can be learned, in part by studying the paper. In the seventeenth century, printmakers used thin paper with so-called chain and laid lines, impressions made by the mesh of racks on which the paper dried. Nineteenth century and later reproductions are on cheaper paper that is machine made, thicker, and without the delicacy of paper from the baroque era. If you can get the print in strong raking sunlight, you can make out whether there are such imperfections from being handmade, or an overall sameness from being machine-made.

MAN SELLING METAL ORNAMENTS. PHOTO © J. HELGASON.

Another habit I developed in grad school was to stop at antique stores in Europe and find a single example of silver—usually late nineteenth century and silver-plate—that connoted a time of elegance. Victorian inkwells, picture frames, spoons, and other keepsakes gave me a sense of connection to the past, and helped me train my eye when looking at eighteenth-century silver in museum collections. The silver-smith's mark became a talisman of quality, and my affection for the artisanal and handmade has only grown in time. Spying the difference between a twentieth-century knockoff and an original work became a game for me, and has served me well in navigating the spectrum from forgery to genius in works of fine art.

Why is appreciating quality in art so demanding? In part because this is a field in which the experts routinely disagree. With fine wines, we may not be able to distinguish "floral" from "fruity," but we know it tastes good going down. With art, however, we are really imprinting our own taste on an object of another's making. Unless our ability to discern quality becomes instinctive, we run the risk at every turn of making a gaffe in judgment, sliding past a masterpiece to ogle a minor derivative work.

All of which reveals something basic about my bias in looking at art. I thirst for knowledge about the social circumstances of artists, the psychological disposition of the sitter and/or artist, and the political climate in which a work of art found its first flowering. I believe these add immeasurably both to our appreciation and understanding of a work of art.

BOOK LEARNING VERSUS ART LEARNING

Had I not studied Roman portraiture, the odds are that an extraordinary marble lady once in my study (you'll meet her later) would have been a purely decorative object to me—nothing more than a testament to the enduring traditions of Western art, a skillfully carved rendering of some anonymous woman of the past. That she can be identified as a specific person through the act of connoisseurship—bringing research, experience, and "an eye" to bear—is what makes my pleasure in her particulars so considerable. Would she afford as much visual stimulation were she an anonymous woman?

I don't think so, but that's where the arguments begin in the art world. Numerous scholars and curators feel that her identity shouldn't matter—she is,

after all, the same subject whether we know it or not, and the quality of her carving is innate in the marble, not contingent on knowing her identity. So what is gained and lost by recognizing her?

There is an arrogance among some art professionals who think *they* need to be educated but museum-goers do not. But the fact is, the millions who dutifully troop through exhibitions annually are often being ministered to by experts who are impatient with any obligation to share their knowledge. This impatience is tangentially connected to trends in university circles dating back to the 1960s in Paris, touched on earlier. Michel Foucault and subsequent observers of contemporary culture came to argue that everything is relative, including knowledge, and that no knowledge is absolute. Structuralism and its offspring Deconstructionism have helped ensure that a new generation of university student knows less about world history and literature than any other generation in recent history. I believe all of us must restore our curiosity in learning about art from as many approaches as possible, rather than to use one approach in isolation.

Art museum culture is a hybrid of the products of the academy and the moneyed classes, for whom knowledge can be just another consumable to help stave off existential despair. If you doubt that people are prepared to collect purely for the cachet of owning trophies, absent any true passion for art, think again. There are many for whom art is simply a currency like any other, save that it connects them with the possibility of immortality in the fashion of legendary collectors past.

TROPHY HUNTING

Taste is the ultimate elixir for the aspiring collector. Without it, every decision is internally questioned, and every step forward could lead to disaster—the *wrong* Monet, a garish wall color instead of a bold one, and so on. Growth in the cottage industry of taste-purveyors is directly proportionate to the insecurities of those who inherit nothing and must invent everything, along with their new wealth. I don't find satisfaction in assuaging the fears of trophy hunters with no curiosity about art.

But trophy hunting is a human instinct that I have encountered quite often, with all kinds of results.

In 1988 the phone rang in my Atlanta office with a mysterious request. On the

line was the cultural attaché to then-Ambassador Petrignani in Washington, Rome's top emissary. I was asked to send my *curriculum vitae* to the Embassy, with no further information volunteered.

From several years of working alongside bureaucrats, archaeologists, art historians, museum administrators, and others throughout Italy, I realized that it would be unseemly to pry, and so obliged without any questions in return. I assumed the Embassy was keeping tabs on me, given my extensive work with museums there over the years. As the months went by, I forgot about the phone call, until fully two years later, when the Italian government resurfaced, this time in the person of Atlanta's honorary consul, John Munna. He informed me that I was to be decorated that fall as a Commendatore dell'Ordine al Merito della Repubblica Italiana—Commander of the Order of Merit, presented for outstanding service to the state. At 34, I was hardly ready for retirement into a presidential cadre of war veterans and civil servants. On hearing the title, most think of the Commendatore slain by Don Giovanni in Mozart's opera. For me, it recalled the only other Commendatore I knew, a New York scion of contemporary art, Leo Castelli—the eminent dealer who built the careers of Jasper Johns and Robert Rauschenberg, among countless others.

I then remembered the earlier call from the Embassy, and the pieces fit together. The wheels for this honor were in fact put in motion four years before, in a New York apartment. On a dismal afternoon in the fall, I was invited to the home of a collector to see his newest purchase: a marble head of a man. This was not an infrequent event in the life of a curator, and while I was looking forward to seeing a new object, there was nothing to suggest that this would begin a web of intrigue.

As I entered the plush Manhattan apartment, I was surrounded by familiar works of art purchased over the years. The maid took my coat in the front hall, and there I spied the newest addition to this private museum, standing on a tall pedestal, brightly lit from a pin spot above. It was slightly over life-size, the head of a male deity from the Hellenistic world, copied by a Roman sculptor in the first century A.D. Damaged only in parts of the hair and beard, it was superbly carved, and very imposing.

Just then my host padded into the hall.

"What do you think, Max?"

"Magnificent," I said. "Some variant of Jupiter."

"It's Roman, isn't it?" he asked.

"Yes, first century A.D. The marble looks to be Parian, and it's from an over-life-sized statue. He must have cut quite a figure."

"Glad you like it," the proud new owner beamed.

And that was it. A glass of sherry and I was on my way. Another one of countless meetings with a silent survivor of the ancient world and his modern steward. But there was something gnawing at me this time. The nicks in the hair and beard were awfully fresh. That could mean a lot of things. It could mean that it had been dug up recently, and then vigorously cleaned so as to be presentable for sale.

The fall turned to winter, and I was looking forward to my customary spring trip to Rome. There I would bunk with the then-director of the Capitoline Museums, Eugenio La Rocca, who, with his archaeologist-wife Luisa Musso, cut quite a pair in the Eternal City. They have a splendid duplex with a roof garden in the heart of ancient Rome, a stone's throw from the via dei Coronari, home to the city's leading galleries of fine art and furniture. Luisa taught at the University of Rome and excavated each spring in a site in Libya. Eugenio was the prodigy who had, at the age of 35, become the director of Rome's oldest art museum, built by none other than Michelangelo. The seat of a sixteenth-century noble collection, the Capitoline and Conservatori Palaces flank each other, separated by an oval pavement Michelangelo designed with an elaborate radiating pattern emanating from the base of an over life-size equestrian statue of the Emperor Marcus Aurelius. Within the twin palaces are some of the world's greatest treasures—*The Dying Gaul*, the colossal head of Emperor Constantine, the twin Centaurs of Hadrian's Villa, and hundreds more of the world's finest antiquities.

Eugenio, like most denizens of Rome's archaeological establishment, frequented two libraries in particular: that of the American Academy in Rome, and the one within the German Archeological Institute, known in shorthand as the Germanico. Situated a few blocks from the Via Veneto and the American Embassy, the Germanico was a polished but forbidding place. A fortress-like modern building, it had a wide gate at the entrance, with a buzzer. With proper identification, a scholar not affiliated with the Institute could be admitted for a limited period of time to do research in its unparalleled facilities.

In an era before computer searches, this austere setting housed two remarkable

ISTITUTO ARCHEOLOGICO GERMANICO, ROME.

resources: a library and a *Fototeca*, or photographic archive. Each reflected centuries of Teutonic rigor, starting with the father of archaeology, Johann Joachim Winckelmann. He arrived in Rome in 1755 and almost single-handedly invented a new discipline speculating about the artistic traditions of the ancients, with abundant engravings of monuments and artworks in pursuit of a taxonomy of Greek antiquity. While he looked down on the art of the Romans, it was his legacy that ultimately spawned one of the world's greatest research facilities in the heart of Rome, inheritor of the classical mantle.

Books I had plenty of back at the Met. My pilgrimage to the Germanico was always for the *Fototeca*. There, in thousands of vertical boxes in metal stacks, were dry mounted, 8 x 10 black-and-white photographs of every important monument and sculpture of classical antiquity, and most minor ones as well. Long before the invention of the Web, I could while away hours pulling each box down, resting it on a nearby carrel, and methodically making my way through a category like "Portraits, Roman, first century, from Merida, Spain," or "Sarcophagi, Roman, second century, England." The diligence required to create this resource was over-whelming. As a graduate student I realized that Americans would always be playing catch-up with German students. Our access to information was very limited, and visits to the American Academy library or the Germanico were like reaching an oasis during a lengthy trek through the desert.

On one of my first spring afternoons in 1986, I arrived at the Germanico a few minutes before 2:30 pm, and so prepared to wait outside the gates. German though they were, the administrators observed the very Roman ritual of closing during the lunch hour, obliging *stranieri* like me to go get a proper lunch. Gradually my vigil had company, several severe-looking students and scholars biding their time. The

women, few in number, were a welcome sight among the sea of competitive and seemingly humorless male colleagues.

The click of a lock released was the sound signaling that we could pass through the first gate. Once through the opaque, glazed double doors, I presented my treasured Germanico reading card, checked a battered briefcase, and went up to the hushed *Fototeca*.

Today I had a few self-administered assignments. There was a relief sculpture I was researching in the Met's collections, along with the frescoes from the Pompeian suburb of Boscotrecase—and the head I had seen in that Manhattan apartment. I hungrily set about poring through box after box in search of parallels, noting inventory numbers on index cards, so that if need be, I could begin the tortuous process of ordering black-and-white photographs that would arrive months later on my desk in New York.

As dusk approached, and closing time with it, I turned to the search for *comparanda* for the bearded head. I had a snapshot of it in front of me. By then I had spent fully three hours flipping through boxes, and was thinking about meeting up with friends at the Piazza Navona for a drink before dinner. On a hunch, I started with a box of idealized heads in the collections of Italian museums. By now, I was cutting corners and speeding up, conscious of the rituals of the librarians in preparing to close down. Lights were being switched off in empty aisles, boxes replaced on shelves. And then I saw it. I drew in a breath. There, before me, on a cardboard backing, was a large, clear photograph of the very head I had seen in New York. And it had the inventory number of an Italian museum.

I instantly recognized the damages in the hair and beard, and my eyes flicked back and forth between the snapshot and the glossy photograph. There was no mistaking it.

My heart was racing. This was not a problem that could be solved easily. I was now in effect a witness to a crime. And that afternoon began an eighteen-month adventure that ended with as many questions left open as solved.

I carefully noted the information on the front and back of the photograph's mount, photocopied it, and packed up quickly to head out to a cool April evening. I knew that the art market was full of objects that had made their way out of the ground through the work of tomb-robbers. But this was the first time I had become

implicated in the propagation of a crime tied to a specific state museum.

This wasn't something I could share with Eugenio; he was an official of the archaeological establishment. My concerns were many: how to get the head back to its rightful owner, how to do so without incriminating a good-faith buyer, how to keep the Metropolitan free of any implication of collusion, and how to control the situation so that the dealer responsible did the right thing by reimbursing the collector.

The remaining days of my trip were marked by occasional pangs of guilt and concern, and there was no clear way forward. I didn't even know whom to turn to for advice. As soon as I arrived back at my desk at the Met, I picked up the phone and called the collector to find a time to see him. He was, unfortunately, away for a few more days, and so my next step had to wait.

Finally the appointed day came. I had, folded in my pocket, the waxy photocopy of the Germanico's photograph on thermal paper. This time we started with sherry. He sensed that I was not myself.

"What's wrong, Max? You seemed a bit abrupt on the phone."

"It's this," I said, pulling the paper from my pocket.

Noting the museum's name and inventory number on an image of the head a few feet away, he looked up, ashen.

"Where did you find this?" he asked, clearly shaken.

I explained how I had stumbled onto the picture, and that I hadn't wanted to alarm him over the phone.

"What do we do now?" he asked, imploringly.

I felt a fresh surge of concern, noting that there was indeed a "we" in this equation.

By then I had thought through an approach that, while risky, might resolve the situation with minimal collateral damage. I proposed moving the head to the Metropolitan's vault, calling the Italian Consul General in New York, explaining that we had come across a work that we knew to be missing from a museum in the south of Italy, and asking that he see to its restitution.

The collector readily agreed. I noted that it would be up to him to confront the person who sold the head to him, since my plan only involved getting the work back to Italy. He seemed genuinely unconcerned about the possibility of losing a

prodigious sum of money, and primarily concerned about getting the work out of his home and back to its rightful place.

So I began an elaborate dance, including clearing this scheme with the Met's administration. To my relief, both the Met and the Consul General were obliging. The head made its way to the possession of the Carabinieri, who sequestered it at their lockdown at JFK airport, pending its safe return.

I had dodged a bullet, I thought, and did the right thing. A couple of months later I saw the Consul General at a function and asked if everything had worked out. He was cryptic. And I was suddenly worried all over again. The next morning I called a contact in the Ministry of Culture in Rome to find out what had happened. A couple of weeks passed before I received a fax asking me to call back.

It turned out that the head was still at JFK. Why? The answer was that the museum from which it had been stolen had never reported it as stolen. So technically, it couldn't be returned.

I was flabbergasted. I had risked my reputation and my relationship with a collector and at least one major dealer for what? I pressed my case, and called a director of a neighboring museum in southern Italy to see if she could get to the bottom of things. It was clear that the bureaucratic route would lead to more wrong turns and inadequate information.

This time, given the rhythms of life in the *Mezzogiorno*, or the Italian south, I had to wait fully five months for an explanation, and I had to go to Italy to get it. A full year had passed since that fateful afternoon at the Germanico. On arriving in Naples I called the superintendent who oversaw the director of the affected museum, and he took me into his confidence over a coffee. It developed that the reason the work had never been reported stolen was that a guard in the museum had "averted his gaze" so that the work could be spirited away. Were it to be returned, the guard would be subject to a vendetta from the rapacious *Camorra*—the Neapolitan version of the Mafia. The director could be endangering someone's life.

And so would I. By setting this return in motion, I was jeopardizing a man's wellbeing. All of a sudden, the perspective of many American archaeologists—for whom the illicit trade in antiquities was a simple affair of black hats and white hats—seemed painfully naïve. And I learned a lesson about being a do-gooder. It can have a price. Eventually a deal was struck—well out of my view—according to

which the head made its way back into an Italian museum. But not the one from which it had been stolen.

What tipped me off in the first place about the origins of this head? It was the nicks in the hair and beard. Had these accidental traces of modern discovery not been so visible, I might have seen the head in the photograph as extremely similar, not identical, and been pleased with myself but unperturbed. And the head would have stayed in New York. With the passage of time, its provenance would become less and less of interest, and it might ultimately have passed into a public collection in the United States.

FINDING MEANING IN FLAWS

All of which goes to show that close observation of the condition of a work can be pivotal to our understanding of it. Imperfections are where we may find the most pertinent information. Works of art that appear perfect are very often restored to look that way. And if stripped of their infill, or in-painting, they reveal the battle scars of time that mark everything.

When you look at a work of art, you have to search for flaws in its condition. In a painting, this is best done in raking light—light passing from the side—that can show differences in the direction of brushwork, the thickness of the paint, the extent of its *craqueleure*, or craggy varnish surface. Of course ultraviolet light can reveal a lot more—but that's assuming you have access to at least a UV penlight and enough darkness to examine the surface. For a sculpture, plaster infill can be subtly painted to resemble the stone surface, and traces of restoration can be telling about the real condition beneath.

Do such flaws compromise the quality of the work of art? Absolutely not. That is inviolate—much as Leonardo's *Last Supper* is no less a masterpiece because its experimental technique and its placement in a humid dining hall at a monastery gradually sapped it of the brilliance and clarity it once boasted. But you have to work harder as an observer when a work is in a compromised condition. You have to overlook the damage and its subsequent treatment, both of which end up occluding the original intent of the maker.

SPEED BUMPS IN UNDERSTANDING ART

What other features of the art world can unintentionally end up making it harder to read the artist's intention?

In today's art exhibitions around the world, an obligatory prelude to the experience often comes in the form of an orientation video, earnestly setting the stage for what is about to unfold. I'm leery of providing light entertainment before allowing the viewer to look at works of art. My reservations began long after my conversion to the proposition that the digital revolution would improve our experience of original works of art. It was during an improvised trip to Memphis, Tennessee to take in the exhibition "Catherine the Great" at the Convention Center. It took place in May of 1991. I joined Ambassador Anne Cox Chambers, along with John Russell, the former chief art critic of *The New York Times*, and his wife, art historian Rosamond Bernier. We took off from Atlanta for a visit of just an hour or so in Memphis. After a brief, jovial flight, we made our way to the less than imperial convention center. While approaching we noticed lamp posts festooned with promotional materials for the exhibition, which had become a sensation in a city not accustomed to major art loans, let alone from the Hermitage in St. Petersburg. The banners looked identical to those promoting major studio films.

The exhibition had been organized not by an art museum, but by "The Wonders Series," christened "The Memphis International Cultural Series." The exhibitions, heralding great moments in world culture and history, have presented works from imperial Russia, ancient Egypt, Napoleonic France, the Ottomans, ancient China, Etruria, and that latter-day time capsule of the rich and famous, the *Titanic*.

The projects are consistent in several respects. They all include highly dramatic recreations of the original *milieux* of the works on view. Their lighting involves dramatic pin spots rather than the more subtle wash that typically illuminates works of art in museums—and not coincidentally helps preserve them for posterity. The quality of the objects in the display is erratic. There is next to no new scholarship resulting from any of these enterprises. And all of them assume that visitors hunger for theme-park-style experiences rather than unvarnished, individual encounters with works of art.

The Memphis series and its ilk sell easily summed-up experiences and not complex encounters with individual creative acts. For John Russell, the red scarves

PORTRAIT OF CATHERINE II, RUSSIAN SCHOOL, COPY AFTER ALEXANDER ROSLIN.
C. 1796, OIL ON CANVAS, TSARSKOE SELO, RUSSIA.

of the "Catherine" volunteers were a remarkably maladroit Soviet fashion statement. But more problematic still was the obligatory orientation video before the exhibition entrance. It took my best negotiating skills to persuade the earnest staffer past the ticket booth that we most emphatically did *not* want to sit through the 12-minute video. She was baffled, since it had been conceived as an integral part of "the Catherine experience." I made my best efforts to explain that we hadn't come for that experience—we just wanted to see the works of art. Before things became confrontational, I resorted to a fib, telling her that one of our party was hard of hearing and I didn't want to embarrass her. We were finally escorted through a side door into the middle of the exhibition, causing great consternation among the guards and the representative of the organizers, who shook her head at our intentional subversion of a meticulously scripted faux journey to an age of opulence.

Our aversion to the repackaging of imperial Russia in an overtly commercial, oversimplified stroll past "wonders" was not born of snobbery. Works of art are hard to understand. Smoothing over the rough edges is, to an art historian or critic, like turning an alabaster vase into soap. Steve Masler, then chief curator for Wonders, had a simple explanation for the theatrics of his displays: "All of these incredible works are just neat stuff if we don't tell the story… you need a thread that holds the whole exhibition together." That "thread" is the Medici family, he said, who are "collectors and sponsors of all the great artists of the Renaissance."

There were scores of great artists in the Renaissance—in Venice and Rome, many of whom were out of reach for the Florentine Medici, but that pesky fact

gets in the way of effective marketing. What harm does it do to claim that all Renaissance masters were in the Medici family's grasp, even if it's false? I'm not in favor of reducing works of art—the "neat stuff"—to storyboards or animation cells in a cartoon. Even if, as with the Wonders Series, the wealth and power of the "sponsors" past and present is the real thread of the story. Sensing the aura is what these commercial ventures promise. When most art museums present monographic exhibitions about one artist, the goal is not to leave you with an overall impression, but to have you remember specific works as exemplars of a time or a single creative voice. *Reader's Digest* provides a useful service, but it is not a substitute for reading a book in the original.

It's hard to state all this without sounding curmudgeonly. One analogy is this: the Boston Pops is a subset of the Boston Philharmonic; in Memphis, we were offered only the Pops.

FROM LEARNING TO LOOK TO LEARNING TO SEE

Learning to see works of art takes effort. And all the videos, audio guides and red-scarved tour guides in the world don't relieve the viewer of the burden of learning to see on his own. So let's dig further into how we develop the faculty of learning to see—not just look.

Learning to see precious things is an acquired skill. It starts with the realization that what may at first be apparent is not necessarily so. A garden statue of a nymph in a front yard is, by virtue of its context, assumed to be a modern reproduction of an older work, or a new interpretation of one. We discount its importance automatically, without resorting to critical faculties that might be applied elsewhere, such as on eBay or in any situation where it is wiser to be skeptical about claims.

On the other hand, a modest work of art elevated to undeserved prominence also causes a kind of cognitive dissonance—something is instantly wrong. A non-expert, though, may have trouble putting his finger on it. Learning to see works of art demands that we take the time to slow down and use all of our faculties. We devote much of our time to recognizing objects but little to assessing them. Our forebears in antiquity had an easier time in this regard, since humble surroundings were the norm, and without the continual bombardment of television, the Web, advertising, and other media, we might be in better shape to separate the fine from

the passable. As modern consumers we are accustomed to deferring to other authorities to judge quality for us, whereas people in the past lived by the phrase "caveat emptor"—buyer beware. Today that wariness has been dulled by the advent of government regulation, the Better Business Bureau, comparative pricing, *Consumer Reports*, amazon.com, and dozens of other filters that allow us to drop our guard.

Selectively raising our guard is great practice for life in general. Orwell's vision of a world in which we passively receive manipulative messages seems primeval compared with today's interactive reality. Cookies from our Internet addresses allow anyone to follow our viewing and purchasing habits. Amazon.com intuits our preferences as we shop. Every swipe of a credit card fills in more of a paint-by-numbers picture of our identity to a credit bureau. Our behavior is monitored in ways that we cannot even fathom. For decades, car manufacturers have installed the equivalent of cockpit "black boxes" that determine whether the driver was wearing a seat belt during an accident. The Institute for Applied Autonomy playfully keeps up to date with "the market of tools of repression," from surveillance cameras to advanced robotics. The New York Surveillance Camera Players are a performance art group that monitors, outs, and sends up various manifestations of Big Brother, performing for the cameras rather than being unwittingly recorded.

At home, TiVo makes assumptions about what television programs we are likely to enjoy and records them for us. Hundreds of ways of tracking and encoding our activities are leading us to a society in which individual choice will itself become a choice, as opposed to letting artificial intelligence resources smooth the path for us in advance. Twitter is an ocean engulfing communication and washing over nuance and deliberation. American society in particular has undergone a sea change over the last few decades. The hardy Puritans who presided over the first stirrings of the nation would recoil today at the degree to which we have allowed convenience to supersede privacy.

BEING WATCHED WATCHING

Looking at art has changed from a private experience to a public one. In the distant past, works of religious art were set in a chapel for quiet meditation. For the well-to-do, ivory diptychs were held in a worshiper's hands. Old Master prints appeared in books that could be placed on a stand in one's home. Articles of jewelry were

REMBRANDT VAN RIJN, *THE ANGEL APPEARING TO THE SHEPHERDS*, 1634, ETCHING, ENGRAVING, AND DRYPOINT. PRIVATE COLLECTION, U.S.A. COURTESY OF DAVID TUNICK, INC., NEW YORK.

personalized, and households were filled with exquisitely crafted objects that crossed back and forth between functionality and artistic virtuosity. Only a generation ago, art museums were no less full of art, but emptier of people. Reflection was a relatively simple matter.

Today the merger of art museums and mass entertainment has meant that the pace of a visit has taken on the features of a visit to a commercial establishment. There is a declining amount of time left to look at artworks, as parking, waiting in line, checking your coat, buying tickets, shopping at the store, and dining become more time-consuming parts of the visit. Each of these activities is familiar, and each carries with it a feeling of accomplishment that incrementally substitutes for the core of "the museum experience."

The public experience of looking at art has become infected with filters beyond consumerist trappings. Many of these are well intentioned, from explanatory brochures to orientation videos, audio guides, apps, wall texts, chats and blogs that provide a précis of the artist's accomplishments. The American Association of Museums has estimated, based on market research, that the typical visitor spends on average about three seconds in front of a work of art.

At best, those three seconds allow for a glance. Few are the objects that elicit a longer pause. These tend to be works around which other visitors congregate, presumably because they recognize something in the object that is deserving. Lemming-like, we behave this way in life with good reason. My parents exercised a similar homing device as we drove through rural France in the early '60s. If a notable number of big rigs was parked outside an *auberge*, that most likely meant that the *potage* within was worth our business, as well.

While in Atlanta I was invited to be a second reader of a Ph.D. candidate's dissertation. The Georgia Tech student had devoted a large part of his thesis to the proposition that people flock to crowded galleries and avoid empty ones. His conclusion was that architects should build art museums with spaces more conducive to visible traffic. And yet learning to look at art is not improved by making the looking itself a spectator sport. Just as when a pack of people waits at a bus stop to board the bus, those of us in a crowd around a painting or statue are always aware of the people around, more aware sometimes than we are of the art we came to see. We inch forward and finally arrive at the framed picture, like arriving at the bus's fare

box, but always conscious of others waiting behind us.

Bystanders' stray comments about the object can prove at turns irritating, distracting, confusing, or more rarely, helpful. But the lion's share of commentary by others near works of art is beside the point. Apart from certain categories of art, such as performance art, the vast majority of works are better appreciated if we can tune out other stimuli. People accustomed to being surrounded with children can become adept at tuning out the sounds of nonsensical play. If need be, we bring in an iPod and music best suited to our mood that day. It's better to listen to, say, The Black Keys or a Chopin sonata than the details of a sale at the mall while we are striving to connect with a work of art. We need to learn to encapsulate ourselves when we're in a gaggle of spectators.

COPING WITH VOYEURS

How can we connect instead of disengaging when striving to see art in a crowded gallery? Here are some ways of coping.

Train yourself to tune out others' conversation.

Delay reading the label.

Ask yourself who, what, when, where, how, and why?

Score your results and return to carefully examine the telltale features of the works on which you got low scores.

You can start by finding an object that had a crowd around it when you first saw it, and wait for the crowd to thin. Stand slightly to the side of it—the side opposite the label—so that you still have a clear view. If others join you to see what all the fuss is about, you won't have to budge. Having a private conversation with oneself about the work, and thereby learning to look, involves running through a checklist based on the detective's six-part mantra: who, what, when, where, how, why:

Who made this?

What does it represent?

When was it made?

Where was it originally displayed?

How was it made?

Why did the artist make it?

Develop the detective's reflex. Don't look at the label or wall text until *after* you have scanned the work and taken a guess. Make a game of the search for basic information, and score yourself over the course of looking at a set number of works, say five per visit. Give yourself a lot of credit for any score, at first. Some of the answers won't be found on the label, but the museum's bookstore should have a guidebook with what you need. Or there is always the online search.

For some of us, it is better not to get too hung up at first on artists and dates. Instead devote more energy to figuring out what the work represents, how it was made, where it might have been originally displayed, and why the artist made it. These require imagination more than memory of art history classes long forgotten. While the questions who and when may require memory, it might be easier to start with rote learning and move on to the imaginative challenges of what, where, how, and why.

As we become more familiar with favorite works at a local art collection, we can expect higher scores as our memory of each work improves. We should get to know a nearby museum's holdings as if we lived with them at home. Within a few visits, you will surprise yourself with how much you retain through this simple exercise. Once you have mastered five works of different epochs, we can move on to conquer another five each visit.

Once you have mastered this simple game, try it out at another museum with some overlap in the kinds of works on view. You should be very satisfied by scoring anything at all as you base your guesses on the techniques you've learned so far.

The goal of these exercises is simple: to learn or relearn how to look at and "see" a work of art. To refine a quality instinct, we first need to master the tactics in this chapter.

This is a bit like knowing how wine is made. It won't guarantee that your palate can tell which year is best from a particular vineyard, but the knowledge will surely enhance your pleasure at the whole experience of drinking wine.

MAKING THE FAMILIAR FRESH

Occasionally I have a sensation—I assume you do, too—of looking at a vista or setting and having a sudden shift in perception. After returning home from a trip, for example, a familiar landscape or cityscape beckons, and I take it in. All of a sudden

TABLE LAMP. PHOTO BY GORDANA SERMEK / SHUTTERSTOCK.COM.

it clicks into place as if a precisely detailed picture postcard is substituted for what had been, until the instant before, a collage of individual features. In an instant, the whole panorama is transformed into a memorized tableau. I'm not seeing the cityscape any longer, I'm seeing my memory of it. Psychologists refer to synesthesia, which is a neurological condition that results in involuntary sensory shifts. I suspect these phenomena are related.

I find that a sensory shift can occur when approaching a work of art in a familiar setting. Its features can resettle suddenly from a recognizable composition into a memorized one. In some ways, this isn't helpful. Our cognitive faculties are constantly processing information in search of rational order, and this quest can end up making us visually lazy. Once we recognize something as familiar and safe, our critical faculties shut down. In this age of media saturation, the shutdowns are becoming more frequent, and the moments of un-memorized reflection are reduced.

We have to reject this sensation of familiarity, and do battle with it. Here's an exercise in just looking—not in sorting quality.

Identify a familiar object in your home. It should be well made, whatever it is.

Take a few moments to stare at it. If it's a lamp, begin by separating its constituent elements. The cord leading to the outlet is a banal feature. But it's also potentially sensuous. It's smooth, dark, and unwittingly undulates towards its goal. At one time its housing was liquid, and you can imagine it being formed into its current state. The base of the lamp might be pleasingly plump, rising like a dome toward the long neck of the lamp. A horizontal support penetrated by a vertical member, it can take on a sexual connotation. The swelling neck may be shaped with a gratuitous flare, or bow in or out. At some point a designer made the choice to give it a particular profile. What did she accomplish visually by exercising a decorative impulse? Was she trying to evoke a past tradition, or make a new one? Is the lampshade fabric conveying the same impulse, and does it match up in color, texture, or tone with the base and neck?

I'm locked in a perpetual cycle of observation, deduction, and the pursuit of visual satisfaction. I'm impatient with unimaginative design, settling for less than the best, and with expedient choices that could just as easily have aspired to a distinctive end. So a lamp to me is more than a source of illumination, more than an accent on a table or a statement by the buyer. Humble and mass-manufactured though it probably is, it stems from the imagination of a designer who had a responsibility to a creative past that may have been honored or ignored.

As onlookers, we too have a responsibility. Life is precious and worthy of our best efforts to observe it fully—to see it and evaluate it. Someone in the humblest of circumstances can have a more refined sensibility around quality than a well-to-do purchaser who defaults to the taste of others. If you can afford only one lamp, you probably put more thought into the selection than would a person concerned about how the choice will reflect on his ostensible taste.

There is no greater satisfaction for an aesthete on the prowl than nabbing his quarry and laying bare its attributes to others. A trip to the Bargello Museum in the heart of Florence is invariably satisfying. The Gallerie degli Uffizi up the street is crammed with visitors, while this smaller palace offers case after case of gleaming treasures, dozens of pedestals crowned by sculptures of Michelangelo and Donatello.

But the real satisfaction comes from sharing my pleasure in the achievements of artists with others. I've given museum tours and talked about art with royals, noblemen, presidents, celebrities of all kinds, as well as patrons, friends, families,

students, and kids. I'm indiscriminate in the joy of opening someone else's eyes, whoever they may be. The awakening of appreciation for the artistry of even the greatest sculptors of the High Renaissance is becoming more of a challenge in a world content with snap judgments. But prolonged looking, and thoughtful conversation about how a work of art measures up against the five quality features is time well spent.

Let's go through the five features, one at a time. We're going beyond looking, into the more rewarding realm of seeing.

CHAPTER IV : On Originality

Great art is sparked by an original idea. A breakthrough in art can be a function of a technical advance, such as oil paint replacing egg tempera or the decision to base paintings on photographs. It can also be a choice about what is represented, such as deciding to move out of the studio into nature, as the Impressionists did. Or it can be, more generally, a function of taking inspiration from something long neglected.

I once got to witness such inspiration. On a hot day in June, 1984, I headed up Riverside Drive to 158th Street, an improbable location for some of the Metropolitan Museum's treasures. I was eagerly anticipating a meeting with the artist George Segal, who had asked for access to the works stored in northern Manhattan.

Exiled to the Department of Transportation's former garage facilities were some 2,000 of the museum's works, many acquired in the first two decades of the Met's existence. They were stacked on wooden shelves extending 20 or more feet in the air—and what air it was. Fetid, filled with pigeon guano, feathers, soot from extinguished fires of past years. Hundreds and hundreds of objects were amassed across nearly a city block of space below the thundering reverberations of cars speeding overhead on the West Side Highway.

Okay, these were plaster casts, not original works of art. But they were the basis of the Met's founding collection. In 1870, when the founders of the museum agreed

GEORGE SEGAL (1924-2000), *WALK, DON'T WALK*, 1976. PLASTER, CEMENT, METAL, PAINTED WOOD AND ELECTRIC LIGHT, OVERALL 277.2 X 182.9 X 188.3 CM. WHITNEY MUSEUM OF AMERICAN ART; PURCHASED WITH FUNDS FROM THE LOUIS AND BESSIE ADLER FOUNDATION, INC., THE GILMAN FOUNDATION, INC., THE HOWARD AND JEAN LIPMAN FOUNDATION, INC., AND THE NATIONAL ENDOWMENT FOR THE ARTS. 79.4A-F. PHOTO BY SHELDAN C. COLLINS.

to create an institution to further the education of the working class, they could ill afford to purchase masterworks from Europe. Instead they began with plaster casts. (Happily, the casts are today responsibly stored elsewhere in far better conditions.)

Segal (1924-2000) was an acknowledged master of contemporary sculpture, and he favored plaster as his medium. For him, this visit was a stimulating event—surrounded by hundreds of unseen forms, many cast directly from the surface of some of the world's most treasured statues and monuments. He did not expect to find them in such sorry condition. Even so, he was thrilled to be among these ghostly evocations of Western art from antiquity to the nineteenth century.

We made our way through the darkened, sooty interior, scanning its contents with two powerful flashlights. An artist accustomed to less than pristine surroundings, Segal revealed no discomfort with these sub-par conditions, unlike others I had brought to the facility.

"How much do you want for this?" Segal joked, pointing to a replica of *The Dying Gaul*, the original of which is today in Rome's Capitoline Museums.

"How about an even trade with one of yours?" I replied with a laugh.

I knew he was hoping that it might end up in his studio, but that was not to be. Ordinarily my goal was to pitch other museums and academic institutions to take a large selection of casts off our hands, so that they might be restored and used in a public context. I was eventually able to send about 90 life-size statues and architectural elements to the University of Munich, where students in art and archaeology to this day can study replicas of objects that are the touchstones of art history.

Segal had a different approach to thinking about casts. In 1979, five years before our visit, he produced for the Met a pamphlet on plaster cast technique. Describing himself as obsessed with art history, he was on a never-ending quest to learn about antecedent forms in art. These were long-lost cousins of his technical ingenuity. For Segal, the perfect replication of a form was not the goal, as it had been for the Neapolitan master cast-makers in the late nineteenth and early twentieth centuries.

Segal pursued a formal education in fine art at several institutions, including Cooper Union, Pratt and Rutgers. After his work was shown in a 1957 exhibition on second generation Abstract Expressionists, he turned the next year to using plaster, burlap, and wire mesh as the basis of sculpture. He went on to use medical bandages in his sculpture, and in *Man at a Table*, made what was in effect a self-portrait. His

travel to Europe in 1963 resulted in a fresh appreciation of works of the past as inspiration for his art. His career took off in the mid-'60s, with his first one-man show at Chicago's Museum of Contemporary Art.

Segal's works alternate between the haunting ethos of the frozen forms of victims buried at Pompeii and the timeless repetition of the rituals of everyday life. His work began with a breakthrough—the decision to make casts of figures from life. The nineteenth century was awash with death masks. Rodin's mottled surfaces led to unfounded accusations that he cast from life. But Segal was the first artist we know of to work in this way, freed by the openness of the art world at the time. He attributed the breakthrough to a chance encounter with a student:

> I was teaching an adult art class, and one of my students, this woman's husband worked for Johnson & Johnson, and he brought home some brand new material, this plaster-impregnated material, and I was given a gift of three boxes of the stuff, and asked to write a booklet on how to use this stuff to make children's arts and crafts. And I was offered $75 for this, and I had the gift of these boxes. They were dry plaster, and you dipped it into water, and you had to rub it, and the plaster became alive, and it set very fast—so it was an amazing new material. I got the idea I could cover a living body with this material, let it set for a few minutes, pop it off, and I'd have a perfect record of a human being. I covered myself in the material when I got home, and it was July, it was very hot, and I had no idea that plaster sticks to hair like crazy, and I'm covered with—I'm very hairy, all over—and pulling it off was like ripping off a gigantic Band-Aid. But I was entranced, entranced with the look of the chunks I pulled off, because it revealed my structure. And I was amazed at the ability of this new material.
>
> — *from Amber Edwards's "George Segal: American Still Life," (PBS, 2001)*

So it was a simple accident of fate that led Segal to a technical breakthrough and allowed him to pursue his own original approach to art. He would go on to transform our thinking about the direct appropriation of forms from life, so integral to the character of what we today call Pop Art.

AUGUSTE RENOIR (1841-1919). *BLOND BATHER*. KUNSTHISTORISCHES MUSEUM, VIENNA, AUSTRIA. PHOTO BY NIMATALLAH / ART RESOURCE NY.

BEING ORIGINAL IN THE AGE OF TWITTER

Interest in Pop Art is assured and mainstream. Popular culture is now in charge, and the guardians of "fine art" are in retreat. Part of this has to do with the technical breakthroughs, the advent of the microchip and the Web. Crowd sourcing is only the latest in a series of innovations changing how creative acts are adjudicated not by experts, but by mass response. Or, more accurately, the combined and near-simultaneous response of countless individuals.

While expertise was once assumed to be indispensable to informed judgment, today's restless fingers on screens and keyboards no longer await some authoritative opinion. Twitterfalls are an example of today's rush to judgment, which prevails over the old-fashioned model of the movie, book, or exhibition review written by acknowledged critics. The bases of judgment devolve from who is saying what: a celebrity endorsement will normally carry more weight than that of a lesser known commenter. But said celebrity carries no obligation to present her or his credentials in defense of an opinion's legitimacy. This leaves us with a quandary. If with clattering hooves we are led stampeding in one direction, what chance can a single contrarian view have, even if touted by someone indisputably knowledgeable about the matter at hand?

The currency of celebrity connotes more social value to more people than mere depth of knowledge. But for someone on a quest to learn what is approved not by a majority but by the *conoscitore*, or connoisseur, the distraction of mass appeal need only be that.

WHEAT FROM CHAFF

Such is also the case when noting distinctions among things visual. Lines invariably form at museum exhibitions of Auguste Renoir, but the jury is still out on this painter, 90 years after his death. For me, Renoir is the poster child of the overrated artist. His technique was, by 1872, incontrovertibly connected with that of his loose-brushwork associates. But his sugary palette, plump subjects, and unchallenging fare combine to make much of his oeuvre forgettable at best and abysmal at worst. Many of his society portraits have no more wall power than today's greeting cards. But his early notoriety and his close association with Monet, Pissarro, and other titans of the time have carried him along like a stowaway. He has yet to meet the harsh judgment

of art history, but I would stake my reputation on his eventual eclipse as time marches on. There are exceptions—he made some remarkable landscapes, and some rewarding larger-scale pictures, as with *The Boating Party* in the Phillips Collection in Washington, D.C. But for me these are outliers. And the exceptions in the career of a great artist should really be the poor works, not the great ones.

As an art historian and museum director, I have veered back and forth between absorption in the oldest art and in the newest art. Often the best lessons about the present are found in the distant past—even the preliterate past.

In 1984, I arrived in Jerusalem after a long, exhausting flight and was greeted by the miraculous warm yellow limestone of this beautiful ancient city. A team of Met staff was in Israel to coordinate the exhibition "Treasures of the Holy Land." It was during the first two weeks of December, and the magic of being in Jerusalem so close to Christmas was lost on none of us. This was an exhibition in the making for several years, sidelined, it seemed, by the politics of the Middle East until the moment we made our flight reservations.

Our jetlagged group checked into the King David Hotel, where diplomats, dealmakers, and jetsetters roosted. Its luxury was in stark contrast to the markets in the streets of the Armenian, Arab, Jewish, and Christian sections of the city. Our first day was euphoric, and the coordinator of the show, John McDonald and I, along with our other colleagues, headed for the bar.

We were in Jerusalem to look over the first proposal of the Israelis for the Met's show. Our task was to define the challenges ahead in the cataloguing, installation, and shipment of works, and, for John McDonald and me, to ensure that the works selected achieved a balance between the archaeological thoroughness sought by our Israeli colleagues, and the art historical resonance expected by the Met's audiences.

Easier said than done. The Israel Museum curators had been affronted by the delays in getting this project off the ground. It was to be expected that they wanted more editorial control of the exhibition contents than might otherwise be warranted. But John and I knew that if we returned to New York with images of works that recounted the sweep of the Holy Land's past but failed to ignite the audience's imagination, we'd be sunk with the Met's director as well as with the public.

So the negotiations were really about achieving a representative balance of

work from the museum's collections while doggedly chasing down artistic quality. John was an Egyptologist, and I was a classicist—he was expert in the early part of their collection and I was the go-to guy for the later work. But we agreed to be good cop/bad cop around context and quality—that he would ensure we didn't sacrifice the historical narrative, and I would ensure that we didn't get seduced into including too many Aramaic inscriptions in limestone that did nothing for the eye.

Our Israeli colleagues were wise to our *modus operandi* right away, and it quickly became evident that there was a tradeoff. For every historically important work—like the only known inscription bearing Pontius Pilate's name—we were to include a "work of art," like the Tel Shalem bronze statue of the emperor Hadrian.

The second night back at the hotel after a long day of looking and negotiating, most of us took to the King David's sauna, where former Secretary of State Henry Kissinger used to unwind after a day of much tougher negotiations. We were a motley assortment of curators, administrators, and technical staff.

"So what's the plan?" the Met's Deputy Director Jim Pilgrim asked John and me gruffly.

John was his usual diplomatic self. I was tiring of the slow pace of discussions.

"How about we flip a shekel for each loan?" I proposed. Jim was unamused.

I grew concerned as the days went on that we were falling far short of an exciting, illustrated history, and instead lurching toward a show more appropriate for the Museum of Natural History than for the Met. So I kept insisting on scoping out the storerooms until we saw every possible candidate for the exhibition. Curators often place objects on view that mean more to them than to the public—I had certainly strayed into that vanity—and I couldn't return to New York without knowing in my gut that I had mined every potential work for the exhibition.

In the course of these deliberations, I saw for the first time the works that were perhaps the most exciting in the exhibition, and possibly in the museum's collection: The Judaean Desert Treasure.

For a first-time viewer, many of these red and brown metal rods, finials, mace heads and maces, scepters and crowns with decorative patterns resembled nothing so much as canes from a stand in a foyer. But in fact these are the earliest known objects to be smelted in a fire, and date from the second half of the fourth millennium B.C., the so-called Chalcolithic Period, from the Greek words "chalkos" and

HOLLOW SCEPTERS, COPPER, FROM THE CAVE OF THE TREASURE (NIHAL MISHMAR). JUDEAN DESERT. COLLECTION OF IDAM. THE ISRAEL MUSEUM. JERUSALEM. PHOTO BY ERICH LESSING / ART RESOURCE NY.

"lithos," or "copper-stone." This was a transitional era between the Stone Age and the Bronze Age, when implements made of each coexisted. We know of no other objects of comparable sophistication for a thousand years after these, such as the late third millennium objects found in the royal tombs at Alaca Höyük in Turkey.

I had to touch these objects, as talismans of a remote human past. It was thrilling to see them, and to have them open the exhibition.

Found in 1961 in a cave in the steep cliffs of the Nahal Mishmar canyon, a few dozen miles south of Jerusalem, the 429 elements of the treasure together represent one of archaeology's most spectacular finds. The treasure's contents represent a creative breakthrough like none other in human history. Found bundled in a reed mat, these copper objects are as mysterious in form as in function.

Whether there were still earlier smelted objects of this sophistication—and a half-century later, none have been found—was less important than that they stood for the revolution in the human imagination that led to harnessing nature through technology. And it didn't hurt that they were inexplicably beautiful and sophisticated. Conspiracy theorists could have no better evidence of space aliens than these ceremonial scepters—that's how striking they are.

Any other artistic innovation in the aftermath of the Chalcolithic treasure is in their shadow. They are so original that they are, quite literally, an origin. It is

impossible to imagine how these objects might have affected the late Stone Age men and women who saw them for the first time. But little in human history save space travel can have produced so much awe. To move from a world composed of found materials to one harnessing nature through technology was perhaps the most radical step for mankind until the moonwalk.

While most visitors probably whipped past these stunning objects at the entrance to the exhibition in New York, for me, the experience of bringing them to the New World was as epochal as any scene in Stanley Kubrick's *2001: A Space Odyssey*.

TAKING ART WAY OUT OF ITS COMFORT ZONE

Mention of space conjures up for me another adventure——that of the "space tablet," as it became known. It's a story all about artistic context. In mid-1989 Emory University's president called upon the deans and directors to help him out. Astronaut Sonny Carter, an alumnus of Emory, was set to go on a mission aboard the space shuttle Discovery. Carter had made known his willingness to bring something from Emory along for the ride as part of NASA's "Object in Space" program.

I got to the meeting in the President's Board Room in the Administration Building and spied a pile of pennants, key chains, and other logo-bearing keepsakes hastily snagged at the College gift shop. They all seemed to be pretty innocuous fare. When the floor was opened for ideas, I held back until all had put forward their suggestions. I then passed around a photocopy of an enlarged photograph of a Mesopotamian cuneiform tablet from the museum's sizable collection of tablets. This one seemed especially *apropos*, given that there would be six astronauts aboard the mission: It was a 4,000-year-old account of rations for six persons working as messengers for the city governor. Made in the Mesopotamian town of Umma, it dated to 2040 B.C. It resembled a

CUNEIFORM TABLET WITH AN ACCOUNT OF RATIONS. MESOPOTAMIA, UMMA, THIRD DYNASTY OF UR, CA. 2200-2000 B.C. CLAY. COLLECTED BY WILLIAM A. SHELTON, FUNDED BY JOHN A. MANGET. X.3.23. © MICHAEL C. CARLOS MUSEUM, EMORY UNIVERSITY. PHOTO BY BRUCE M. WHITE.

miniature shredded wheat biscuit.

My point was simple: how cool would it be to send the oldest object ever on a journey to orbit the earth? And more than being cool, it would allow Emory to be in the media spotlight because of the poetry of the gesture. I did feel a pang about sending the tablet to such an uncontrolled environment. Our registrar Lori Iliff went so far as to inquire whether the museum's insurance policy would cover the tablet in the event of a loss. A startled insurance representative at the other end of the phone volunteered that we were going into uncharted territory, and not to count on it.

The cuneiform inscription noted rations for six messengers. These were pretty far from Tang and shrink-wrapped astronaut food:

> For Bama: 5 quarts beer; 5 quarts bread; 5 ounces onions; 3 ounces oil; 2 ounces alkali
>
> For Baza: the menial: same amount
>
> For Lugal-sazu: same amount
>
> For Su-Esdar: 10 quarts beer; 10 quarts bread; 5 ounces onions; 3 ounces oil; 2 ounces alkali
>
> For Mas: 5 quarts beer; 5 quarts bread; 5 ounces (onions); 3 ounces oil; 2 ounces alkali
>
> For Ubarum: 3 quarts beer; 2 quarts bread; 56 ounces (onions); 3 ounces oil; 2 ounces alkali
>
> Day; 24 Year: Huhnuri was raided (=Amar-Suen 7, 2040 B.C.)

When we retrieved the tablet after its flight in space, I asked our conservator what a thermoluminescence reading of the work would reveal if we tested it. She laughed and noted that it would have been irradiated while in space, thereby wildly throwing off the test. It would likely give results showing it to have been made in the future, because the radiation would have heated it up sub-atomically to a point far beyond the infinitesimal temperature remaining from its original firing in an oven 4,000 years ago.

Which got me thinking about the proper context of such an object. What age and significance did this object now have? Scientifically speaking, it had gone through a transformative experience that materially changed its physical

composition, as could be proven through a test. Its intended meaning had been hijacked by a museum director and an astronaut. Now the six messengers it had originally referred to were inextricably linked with Sonny Carter and his five fellow space travelers.

Upon its return to Atlanta, the tablet quickly became one of the museum's most popular exhibits. Schoolchildren were thrilled to be in its presence because it had an aura, created from a temporary context. The thrill was no different materially from the thrill one has at being in the presence of the *Mona Lisa*. You can barely make out the painting behind the stanchion, the dim lighting, and the bulletproof glazing. But it is your proximity to a famous work that creates the frisson.

Emory had dozens of other cuneiform tablets, each with earnest inscriptions that recounted the elements of ancient life no less banal than the rations tablet. But none had any allure for the general public. This particular example, however, had jumped so radically out of its original context that it took on a magical, talismanic quality. Similarly, it has been argued, had the *Mona Lisa* not been stolen in 1911, it would likely never have risen above all other Renaissance portraits to become the most famous of the lot. It got that way because it was ripped way out of its comfort zone.

NOTORIETY AND QUALITY

There are a few works of art that reach this status in every museum through external circumstances, unrelated to the quality of the work itself. Such is the case with many famous actors and actresses who are catapulted into the limelight after a stint as a model or a professionally famous person, but whose thespian skills are questionable, at best. While notoriety may not be synonymous with quality, it *can* open our eyes to a form of art that might otherwise have passed us by.

More often than not when considering art from the past, notoriety is in step with artistic quality, as was the case with an exhibition of Impressionist pictures from London's Courtauld Collection that I organized for the Art Gallery of Ontario, its only stop, in 1998. The highlight of the exhibition was the loan of a work considered by many to be the greatest masterpiece by Edouard Manet: *The Bar at the Folies-Bergère*.

I had succumbed to the quest for relevance and audience by organizing the display—it was in some respects a lazy idea for an exhibition. The work at our end

EDOUARD MANET (1832-1883). *BAR AT THE FOLIES-BERGERE* (1882). OIL ON CANVAS. COURTAULD INSTITUTE GALLERIES, LONDON. PHOTO BY LUTZ BRAUN / ART RESOURCE NY.

was technical, not intellectual. All we had to do was make a hospitable setting for a collection of great pictures that had already been vetted by the stewards of the Courtauld Collection. And it was a ravishing installation, given that we had at our disposal the kind of lighting and the generous proportions of gallery space that allowed works of art to operate with minimal distraction.

The chance to share with North American audiences the number of works by Monet, Pissarro, and Manet was very exciting. But nothing prepared me for the joy and privilege of having Manet's masterpiece all to myself, whenever I chose to view it, during museum hours, or before or after. I treated myself to an encounter with the barmaid in the painting, whose superficially bland expression is part of her charm. Like other working women accustomed to the unwanted solicitations of men, this young woman pauses in her ministrations of alcohol to take us in, the viewers, one person at a time.

Manet mastered the creative breakthrough of dispensing with the fourth wall, permitting the subject of the picture to stare directly into the eyes of the observer. The idea was not new. In Renaissance painting, the *festaiuolo* directs us to see the center of the action, such as a Madonna, or a saint. These sprightly figures are like extras in a Hollywood film—they supplement the main thrust of the scene and add context. But even more effectively, they direct our attention to the topic of abiding importance to the artist—by pointing at it.

Manet's barmaid does both things at once—stares out at us *and* is the primary subject. Our voyeurism, and that of a nineteenth-century *boulevardier* who saw the picture for the first time, is titillating. We are given permission to look back at a beautiful woman we don't know. Manet used this device on other occasions, most notably in *Le Déjeuner sur l'Herbe*, his revolutionary mixture of contemporary fashion with a mythologized past.

The celebrity of an object or an artist can overwhelm our faculties. Because it is human nature to build up and tear down, certain objects meet an unfortunate fate through later research revealing them to be less than meets the eye. This was the case with The Metropolitan Museum of Art's Cellini Cup, which, after recent scientific examination, turned out to be a nineteenth-century imitation of a Renaissance masterpiece. What happened to the aura? It's the same work that countless visitors thrilled to when it was displayed as an original work. The sensation is like seeing a popular actor in a mug shot—all of our prior associations with that person are thrown into doubt. But while an actor can enter rehab and emerge with career intact, the Cellini Cup sits on a shelf unmasked, and tainted forever. That its maker sought to deceive experts and the public puts a life sentence on the work, with no possibility of parole.

THE FLIPSIDE: QUALITY AMONG THE UNSUNG

One of the urgent questions of our time is how to assess the quality of works of art that do not fit into standard hierarchies—the work of self-taught artists such as quilt-makers, craftspeople, and digital designers. Almost 400 years after the first stirrings of the French Academy, art is being returned to its longer-standing place in life, not apart from it.

It's one thing to reflect on artistic achievement when grappling with artworks

CUP, ITALIAN, PROBABLY 1840-50, OR SOMEWHAT EARLIER, GOLD, PARTLY ENAMELED; PEARLS, 19.7 X 21.6 X 22.9 CM, THE METROPOLITAN MUSEUM OF ART, BEQUEST OF BENJAMIN ALTMAN, 1913 (14.40.667) IMAGE © THE METROPOLITAN MUSEUM OF ART.

by established artists validated by the marketplace. Choosing among portraits by eighteenth-century British painter George Romney can be a parlor game. Which pictures have originality? Those that best capture the fresh personality of young noble women, while remaining technically adept? It's time well spent.

It's another matter to stray from the confines of artists within an established canon, especially when considering works by artists who don't belong to a royal court, the British Academy, or Yale's School of Art. This is a risky business, and one beset by doubters from every quadrant: critics, curators, collectors, and dealers. Yet it holds the potential for real satisfaction if an early, unsubstantiated hunch proves to be on the mark.

Such was the case with the remarkable phenomenon of the quilts of Gee's Bend, Alabama. The saga has roots as far back as the 1960s, when the small collective of

quilt makers was the subject of a faddish line of replicas at Bloomingdale's department store in New York. A story in *New York Magazine* "discovered" the singing quilters of the faraway reaches of Alabama, and with the alacrity of a New York minute, vanished from popular consciousness as quickly as they emerged.

Until 2001, that is, when Houston Museum of Fine Arts Director Peter Marzio began organizing the first survey exhibition of the decades of quilt-making in the hands of a few families living in the WPA-rescued town of Gee's Bend. The passionate Atlanta collector William Arnett had sought to persuade me to organize the exhibition when I became director of the Whitney Museum of American Art in 1998. But he was sympathetic when I explained that I was enough of a newcomer to the clubby contemporary New York art world, and that while I would happily present the show in New York, it would be folly for us to organize it. There were enough people already piqued that the Whitney's new artistic compass did not chart the trends anointed by the SoHo and later Chelsea galleries. This provocative endorsement of "self-taught" artists would doubtless raise the hackles of every artist whose absence from our galleries to make room for mere quilters would be construed as a personal affront. So Peter and I quickly came to terms about a New York venue to follow his in Houston.

The results of the show at the Whitney surprised both the most diehard enthusiasts of African-American art, as well as the show's bitterest antagonists within Chelsea's priesthood. *The New York Times* chief art critic Michael Kimmelman pronounced them "some of the most important works of modern art ever made." The exhibition and its sequel went on to ten American museums, which may stand as a record.

But to the key point: what led Kimmelman to vouch for the gamble that Arnett, Marzio, and I had taken?

A clue can be found in the enthusiasm of artists who viewed the exhibition at the Whitney. Ellsworth Kelly spent a satisfyingly prolonged time in the display. He noted the fact that these untutored women had, over two generations, found their way to an improvisational technique, using the humblest of materials, and devised bold, memorable patterns that were every bit the visual equivalent of the most accomplished jazz musicians of their time. Richard Serra also lingered in the exhibition, after skeptically telling me that he was short on time.

IRENE WILLIAMS, AMERICAN (B. 1920) *GEE'S BEND QUILT, "HOUSETOP" VARIATION WITH "POSTAGE STAMP" CENTER ROW,* ABOUT 1965, COTTON, COTTON/POLYESTER BLEND, POLYESTER DOUBLE KNIT, WOOL, CORDUROY, 75 X 78-1/2 IN., 2007.6, INDIANAPOLIS MUSEUM OF ART, PURCHASED WITH FUNDS PROVIDED BY DANA AND MARC KRATZ.

These two titans of contemporary art, respectively undisputed champions of abstract gestures in painting and sculpture, saw the genius in these dozens of fabric assemblages. It is hard not to get caught up in the improbable tale of how this remote community became an artists' colony of sorts, minus the burden of invidious comparisons to Old Masters, past and present. But the exhibition's goal was to earn parity for these quilters with the leading protagonists of twentieth-century art. The critical public acclaim was welcome, but no less than the nod from a jury of peers: Kelly, Serra, and others of their stature.

The collective judgment hung not on the human-interest angle of unlettered artists, seductive though that was. It was based on the ease with which these women (and all were women) had confidently blended improbably aligned patches of fabric, blue jeans, flour bags, and countless other remnants to create bold but subtle fields of color and texture. They fit well into the five features of artistic quality that I return to time and time again, and did so with the humblest of materials and methods, in the humblest of settings.

Naturally a tidal wave of unsolicited missives came my way in the aftermath of the exhibition. They were filled with quilt samples, slides of quilts, and handwritten testimonials to the talent of other quilters we had yet to discover. I didn't have the heart to say then what I can say now: quilting is not an easy path to artistic distinction. The risk of being derivative, saccharine, or banal is very high, and the art world's bias against fiber art is strong to begin with. It's not that I look for refuge in biases, but it is very hard to deny that the closer artifacts are to the ethos of what we commonly call folk art, the harder the road.

Which is why the other example of unlettered artistry represented a harder climb. Thornton Dial, born in Bessemer, Alabama, began to make things from found objects early in his life, but was only encouraged to think of himself as an artist after the same William Arnett happened upon his work. Over many years, Dial and Arnett forged a close relationship, leading to a form of patronage that elicited unwarranted suspicion on the part of would-be collectors and dealers.

What Arnett saw in Dial's work was a remarkably self-assured artist, whose origins in the field of Southern "yard art" should by all rights have entitled Dial to the same notoriety as his fellow Southerners Jasper Johns and Robert Rauschenberg. Like those two pioneers of what would become known as Pop Art, Dial exhumed the detritus of his surroundings and created unexpected assemblages.

Thornton Dial's work is as freighted with symbolism, dependent on mixed media, and filled with unexpected juxtapositions as the oeuvres of his more famous contemporaries. But unlike Johns and Rauschenberg, Thornton Dial never left the hardscrabble South, never attracted the notice of the image- and career-makers of the New York art world, and never saw his work enter the so-called art historical discourse. In multiple ways, his creative path can be likened to others of his generation. But the absence of critical inquiry ensured his marginalization, at least until now.

I was very pleased to offer Dial a full career retrospective at the Indianapolis Museum of Art in 2011, and to watch multiple museums sign onto a tour, from New Orleans to Atlanta. The press juggernaut accompanying the opening of "Hard Truths: The Art of Thornton Dial" echoed the critical reception of the Gees Bend quilts. Favorable reviews in *The New York Times*, *The Wall Street Journal*, along with five pages in *TIME Magazine*, were the kind of endorsement that had eluded Dial for a generation.

Critical pans or plaudits are fleeting pronouncements in the first flush of exposure, unmediated by the passage of time or its accompanying benefits of perspective. Instead of cringing from dismissive appraisals or reveling in applause, those of us concerned with the artistic value of a work or an artist have to rely on our instincts and our perspectives. Without these frames of reference, we would be like pets awaiting the next pat on the head or dreading the next swat on the rear. The validation of art's contribution must begin and end with informed and thoughtful commentary, not with the fever of an auction price, the clamoring of collectors, or the knowing nods and murmurs of the art crowd.

Thornton Dial's work sticks in our consciousness not only because it is formally the equal of other artists adept at mixed media. It is also because of his unvarnished, homespun insights into the human condition.

FASHION FORWARD

The value of originality in judging quality is not limited to fine art, of course. In October 1985, I made my way to the Cooper-Hewitt Museum on Fifth Avenue at 90th Street. My mission was a bit off the beaten path. Accompanying me was Fiamma Ferragamo, the daughter of the master shoe designer, Salvatore. Fiamma approached me to see if I might help her obtain a New York venue for the Florence exhibition of her father's shoe designs. This was few years before a wave of like exhibitions made their way into the Met, Guggenheim, and numerous other major institutions. So it was a bit of a stretch to make a case for an exhibition of the ancestral legacy of a going commercial enterprise. There would be the charge that this was simply a way of fluffing a reputation to promote sales.

As a master craftsman, Salvatore had more than a passing acquaintance with the unsavory leadership of the Fascist Party, gaining him access to markets that

THORNTON DIAL, AMERICAN (B. 1928), *DON'T MATTER HOW RAGGLY THE FLAG, IT STILL GOT TO TIE US TOGETHER*, 2003. MATTRESS COILS, CHICKEN WIRE, CLOTHING, CAN LIDS, FOUND METAL, PLASTIC TWINE, WIRE, SPLASH ZONE COMPOUND, ENAMEL, SPRAY PAINT ON CANVAS AND WOOD, 71 X 114 X 8 IN., 2008.182. INDIANAPOLIS MUSEUM OF ART.

might otherwise have eluded him. But his accomplishments as a designer were prescient and beautiful, and I believed in the reasonableness of the project. Titled "A Centennial Exhibition: Salvatore Ferragamo: The Art of the Shoe," it had real promise as an eye-opening experience for a broad public.

Born in 1898 in the tiny town of Bonito, east of Naples, Salvatore was one of 14 children. He made his first pair of shoes at the age of nine for his sister on the occasion of her Confirmation. By 13, he was in charge of a small shop in Naples. He joined four of his brothers in the States, and persuaded them all to move to California with him, where Hollywood was the destination. Mary Pickford, Rudolf Valentino, and John Barrymore were among his early clients. Returning to Florence in 1939, he acquired the Palazzo Spini Feroni, where the Ferragamo fashion empire began and is still headquartered. By the 1950s, with over 700 artisans making as many as 350 pairs a day by hand, he was the uncontested prime mover in this

INVISIBILE SANDAL BY SALVATORE FERRAGAMO, 1947. © MUSEO SALVATORE FERRAGAMO, FLORENCE, ITALY.

deceptively pedestrian art form. On his death in 1960 at the age of 62, his legacy passed into the hands of his widow Wanda and their children, to whom various business responsibilities devolved.

From his signature leather pumps to Persian mules, colored sandals, and wedge-heels, the exhibition promised to tell a story of innovation in the face of privation, and an exotic sensibility that transcended its time. So many early Ferragamo shoes—from the 1930s onward—are startling in their contemporary feel today, and reveal an intelligent design sensibility. The last of the great ladies of Hollywood—Ingrid Bergman, Bette Davis, Marlene Dietrich, Ava Gardner, Audrey Hepburn, and Katherine Hepburn—were to be part of the exhibit.

I made an appointment for us and Edward F. Maeder to see Lisa Suter Taylor, the director of the Cooper-Hewitt. Maeder had been tapped to curate the show, and his ideas were subtle and carefully calibrated to deal with the snob reflex of art museums fearful of going first. The meeting was brief, the rejoinder polite. The retrospective was apparently ahead of its time.

I was particularly smitten by one of Ferragamo's greatest creations, the *Invisibile*. Designed in 1947, it was so named because, in the aftermath of the Second World War, he had to minimize his use of leather, and turned to the new material known as nylon. A single "invisible" line of nylon was wound around the sole, revealing a woman's foot in all its potential glory, and giving rise to the name of the shoe. What struck me was the unforgettable profile of the shoe, its technical sophistication, and its obvious ties to the formal language of Expressionism. All this from a man who studied the anatomy of the foot at UCLA to perfect his trade.

SHARED LANGUAGE ACROSS MEDIA

Another European work, dating from the early 1920s, had presaged the look and character of the *Invisibile*: Erich Mendelsohn's remarkable Einstein Tower. This astrophysical observatory in Potsdam was the first work of an architect whose Expressionist forms were never better realized than in this compact, dramatically proportioned building. Planned and built in the years 1919-24, the main tower was complete by 1921. A very young Richard Neutra was part of Mendelsohn's architectural studio. Neutra would make his way to the U.S. and become a key protagonist of architectural modernism.

The tower and shoe were separated by a quarter of a century, but they share a gestural, futuristic language, and were each a revolutionary design. To me, they epitomize the value of originality in assessing creative gestures. Each breaks free from conventions, and each draws from a well of invention in an act of genius that quickens our pulses. Thornton Dial did the same, as did the ladies of Gee's Bend. In each case, we have much fresh and exciting territory to explore, without regard to the valuation of the marketplace.

EINSTEIN TOWER, POTSDAM, GERMANY.

CHAPTER V : Crafted with Skill

A rt of high quality is crafted with technical skill. And artistic technique is mostly about materials and media: what something is made from, and how it is made. Artistic technique is as mutable as changes in conversational tone. If you are trying to make a point, there are many avenues into the listener's consciousness. For simplicity's sake, we can boil these down to three basic approaches:

1. You can *reason deliberately*, although studies continuously show that people respond less to reason than to their gut.

2. You can look for an *emotional point of entry*, like an anecdote, so that the listener can empathize with your point.

3. Or you can *yell* if you feel you aren't being heard, although that rarely ends well.

Artists face a similar series of choices when it comes to technique. Based on the point they are trying to get across, subject they are tackling, or audience they are seeking, they can set about making an artwork by starting out with one of three basic approaches to materials and media.

1. They can go for austerity, simplicity, and subtlety, with muted colors, minimal modeling, elegant restraint, or calm abstraction.

ADAM DIRKSZ, DUTCH, LATE 15TH TO EARLY 16TH CENTURY, PRAYER BEAD: *LAST JUDGMENT AND THE CORONATION OF THE VIRGIN*, C. 1500-1530, BOXWOOD. OVERALL: 5.7 X 3.2 CM. OUTSIDE: 6.1 CM. ART GALLERY OF ONTARIO, THE THOMSON COLLECTION. © ART GALLERY OF ONTARIO.

2. Or they can use materials and methods that overtly appeal to the senses, such as extreme realism, soft textures, pliable materials, or thick brushstrokes.

3. They can make something that is bombastic, massive, baroque, extravagant, shiny, or ornate.

While many works of art blend aspects of these three technical points of departure, the question we should begin with is how the artist uses materials and media to make a point or seek a connection with the viewer, whether that viewer is an Egyptian god, a Pope, a factory worker, or a fellow artist. The judgment we hand down about the success of the artist's effort is best made once we have a sense of her or his technical predilection.

If a sculpture by Donald Judd, such as a plywood desk, is plain to the point of being composed of simple geometries, it serves no point to observe that it lacks color or nuance. Plain was what he wanted.

If the maker of a Byzantine icon presents Christ *Pantokrator* as a frontal, expressionless, authoritative figure, we shouldn't criticize the artist for failing to make it "realistic" or for making it too decorative. He was focused on Christ's majesty, not his humanity, and his choices of media and materials stayed right there.

And if a contorted seventeenth-century statue of a mythological figure is so detailed that we can see the veins in its arms, we can't say it isn't technically subtle and condemn it for being "over the top." The artist sought complexity and drama.

The terms of the artist and artwork are their own, and we can only be effective and fair jurors if we make an effort to understand the technical starting point of the artwork.

INSTRUCTIONS TO THE JURY

Let's take these three technical points of departure one at a time—the equivalent of instructions to the jury—before we rush to judgment on the technical achievements or lack thereof in a particular work of art. We can consider pairs of artworks with shared technical attributes that strive to get a message across, and see why one is better than the other.

Starting with *subtle* artworks, let's compare two portraits that are technically simple.

Limner portraits were painted in the American colonies in the eighteenth century to capture the essence of the sitter. They are technically simple, with limited modeling of color, normally expressionless, with repetitive backgrounds if any, and reliant on a few formulaic poses.

By contrast, the technically simple self-portraits drawn by Matisse around 1940 are achieved with an astonishing economy, almost as if he put pen to paper and lifted it only once or twice. While the technique could not be simpler, the result is a far more penetrating, recognizable likeness of the sitter.

BEARDSLEY LIMNER (C. 1785- C. 1800). *DR. HEZEKIAH BEARDSLEY*, BETWEEN 1788-1790. OIL ON CANVAS. 115.6 X 110.0 CM. GIFT OF GWENDOLYN JONES GIDDINGS. 1952.46.1. YALE UNIVERSITY ART GALLERY. NEW HAVEN. CONN. PHOTO: YALE UNIVERSITY / ART RESOURCES NY.

HENRI MATISSE (1869-1954), *SELF PORTRAIT WITH PANAMA HAT*, 1945, INK ON PAPER, 40.1 CM X 26 CM, MUSÉE NATIONAL D'ART MODERNE, CENTRE GEORGES POMPIDOU, PARIS, FRANCE. © SUCCESSION H. MATISSE, PARIS / ARS, NY.

Moving onto the territory of technique that mines *sensuality*, we can compare two images of nudes that are technically comparable, but yield different levels of success.

The human nude is a conventional subject in art schools, since students are taught to unlearn formulaic approaches to art-making by confronting the ever-startling subject of breathing, vulnerable flesh. An art student's charcoal or painted version of a nude model may be highly proficient—it might capture the shape, proportion, and appearance of the subject.

But rare is the example that goes beyond veracity—the realistic portrayal of the subject before us—and arrives at something more timeless, such as the palpable sexual tension between artist and subject, or the psychological mindset of the sitter, who, like Manet's *Olympia*, stares back at the artist and the viewer with equal disdain for our voyeurism.

Artists that mine technical territory to communicate something directly and without subtlety do so at their peril, since the end result can fall flat, like an emotionless, dry rendering of a nude.

Finally, turning to works of art that go for the Hail Mary pass of over-the-top technique, we can compare two images of Christ from different epochs in art history.

The statue of Christ the Redeemer in Rio de Janeiro towers over the city, rising 130 feet in the air at the peak of Corcovado Mountain. Made between 1922 and 1931,

it is obviously impressive in scale, but fails several technical tests. The materials are reinforced concrete and soapstone, and by virtue of scale and medium admit of few details. Like so many sculptures in the era of Fascism, the image sacrifices emotional impact in its quest for balanced proportion and imposing scale.

Another statue of Christ, this one in Santiago di Compostela, might be argued to have an unfair advantage because it has stood the test of time—it is seventeenth-century, not twentieth. But it has a far more important technical advantage over its Brazilian counterpart: it is gruesome, with traces of red paint to simulate blood. The technical choice made by the artist was to "go for baroque," and the outcome is more powerful, reso-

AERIAL VIEW OF CHRIST THE REDEEMER MONUMENT IN RIO DE JANEIRO. PHOTO BY MARK SCHWETTMANN.

nant, and memorable as a work of art, largely because of technique.

There are many ways in which artists leave their tracks in the technique of a work of art. In sculpture, it can be literal. The artist's thumbprints are often visible in wax, terracotta or plaster versions of renowned sculptures, as is the case with examples of the *Dancers* by Edgar Degas, countless works by Auguste Rodin, and other artists throughout history. But these are only ciphers of authorship, and although it will send a chill to the connoisseur to take notice of that very human, direct connection from maker to onlooker, what we are looking for in this chapter is for evidence that may first be overlooked, and that reveals the artist's technical ingenuity, improvisation—or, by contrast, his mechanical, slavish imitation.

ADAM DIRKSZ, DUTCH, LATE 15TH TO EARLY 16TH CENTURY, PRAYER
BEAD: *LAST JUDGMENT AND THE CORONATION OF THE VIRGIN*. C.
1500-1530. BOXWOOD. OVERALL: 5.7 X 3.2 CM. OUTSIDE: 6.1 CM. ART
GALLERY OF ONTARIO, THE THOMSON COLLECTION. © ART GALLERY
OF ONTARIO.

THE COMPETITIVE SPIRIT IN ART

Boxwood is an extremely dense substance—so much so that it permits exquisitely detailed carving. Much favored in the Netherlands during the late Renaissance and baroque periods, it was used for astonishingly intricate scenes of multiple miniature figures, with many features not much thicker than a pin. Evidently executed with magnification, the medium was popular for rosary beads and other private devotional objects. The Thomson Collection in Toronto, which I mined for a large display when directing the Art Gallery of Ontario, includes a number of works in boxwood and ivory, and afforded me the luxury of prolonged and close scrutiny. Equipped with a pair of cotton gloves and a magnifying glass, I spent the better part of an hour poring over the inexplicably fine carving of one example, a single, large prayer bead by the southern Dutch artist Adam Dirksz depicting the Last Judgment, and The Coronation of the Virgin (c. 1500 - 1530). The artistry is supernatural. No other art form in history approximates the microscopic proportions of the scenery. The Lilliputian technical accomplishment is approximated in other media, including medieval manuscript illuminations. Persian miniature paintings of the same time period also mine this terrain, although one could argue that the snap of impossibly thin elements of the enthroned Virgin's crown would be more final than a slipped horsehair bearing pigment in genre scenes. The prayer bead was a private devotional object, which opened to reveal these two often-paired episodes. Like other such devotional objects, such as gold, silver, and bronze statuettes for private shrines, this bead was both an object for religious worship and an exemplary work of art.

The workshops that produced these marvels were few in number and highly competitive, rather like the ancient Greek workshops of vase painters in the

Kerameikos district of Athens. In the latter example, there is evidence of spirited competition among vase painters. In one famous inscription on a late sixth-century B.C. amphora today in Munich's Antikensammlungen, the painter Euthymides wrote of his rival: "Euthymides painted this as Euphronios could not."

As my wife would say, we never really get out of high school.

ORIGINALITY CAN TRIP UP THE EXPERTS

Evidence can be hard to come by when there is no artist to pin a work to, as was the case with a remarkable discovery I was once fortunate enough to stumble on.

On a winter afternoon in the early 1980s, I was in one of my preferred haunts— the Metropolitan Museum of Art's "Tunnel"—a four-block-long storage facility that runs beneath Fifth Avenue. Many of the works stored there a generation ago had been subject to curatorial neglect, or were runners-up to comparable works on display in the galleries upstairs. I found myself there not infrequently in search of under-appreciated marvels, and over the years made an effort to document works that were unpublished but deserving of scholarly or even public recognition. The bar was set pretty high to make it from scholarly to public awareness—scholars of art history can get excited about revelations that would put the average museum-goer to sleep, such as a reattribution from one minor painter to another, or the discovery of a long-lost document revealing its provenance (history of ownership).

But that afternoon I came upon a situation that would change the way I thought about the relationship between fact and opinion in connoisseurship—and it hinged on a previously unknown technical tradition.

Over the course of the summer I methodically made my way through dozens of gunmetal gray racks of sculpture in a gated section of the Tunnel. Hundreds of works sat expectantly on the shelves like so many puppies in a pet store. Dozens of years of neglect seemed warranted for many of them. Sure, they were 2,000 years old, but their more attractive and successful cousins were disporting themselves on pedestals upstairs. These works might have held center stage in a smaller institu-tion, but at the Met, the standards must be unassailable.

On the floor in a nondescript crate was a dark shape largely obscured by a raw packing material that resembled hay, but was in fact "Excelsior," a manufactured product of shaved pine that had the advantage of being biodegradable but the

disadvantage of being highly flammable. Sold in large bales, it began to go out of use 60 years ago or so as synthetic materials were developed. Today, foam and bubble pack have made it obsolete, save in developing countries.

The fact that this box was overflowing with Excelsior was my first clue that the object in it had been left untouched for quite a while, perhaps decades. I approached it with caution. The light bulb overhead didn't provide enough illumination to get a good sense of what was in the partially open crate, and my flashlight didn't afford much help. But I could make out a life-size female form with rippling drapery.

I ran the light along the crate's edges in search of an accession number; that would allow me to go back upstairs and look up its records in the card catalogue. There on the side was a number in red ink: 16.141. To a curator those digits carry a fair bit of information, and I mulled them over as I made my way back up from the basement to the rooftop offices.

The first two integers meant that the work entered the Met in 1916. The second set meant that it was the 141st object to be acquired that year. Nineteen-sixteen was a pretty lively time at the Met; the curatorial staff was actively buying overseas with the help of an agent named John Marshall. The lead curator in the Greek and Roman Department was a very formal lady named Gisela Marie Augusta Richter. (There is quite a Teutonic tradition in the department—her long-standing successor was my then boss, whose full and daunting title and name was Freiherr Dietrich Felix von Bothmer von und zu Egloffstein.)

Miss Richter, as she was unfailingly known at 1000 Fifth Avenue, was born in London in 1882 and died in 1972 in Rome. Her parents were art historians, and saw to it that ample time was spent in Rome and Florence. Miss Richter attended a prestigious girl's school, Maida Vale School, and returned to study at the University of Rome, where lectures in classical archaeology by Emmanuel Loewy convinced her to pursue this as her field of study. She went on to Girton College in Cambridge, where, as a member of the fairer sex, she could not be degreed. But she pursued her studies at the British School at Athens in 1904-05, and was taken under the wing of Harriet Boyd Hawes (1871-1945), who moved to Boston in 1905 and persuaded Miss Richter to get her career underway there. She met Edward Robinson, director of the Museum of Fine Arts, Boston; when he moved to the Metropolitan Museum to become its assistant director, Miss Richter followed with a contract assignment to

help catalogue the Met's already renowned collection of Greek vases.

In 1906 her appointment was made permanent. Robinson and his purchasing agent John Marshall had added significantly to the collection of Greek and Roman art, using the newly established Rogers Fund. The fund was named after a gentleman who remembered having been politely directed to the museum's water closet, and decided to leave the Met millions in his will. To this day it remains the Met's largest purchase fund.

Miss Richter was made assistant curator in 1910, and began publishing major monographs, which would ultimately make her an international authority in classical art. In 1915, the year before she purchased the work in the basement, her tome on Greek, Etruscan and Roman bronzes quickly became a primary source for the field. Her distinguished career was all the more remarkable given the roadblocks placed in front of women at the time.

Dusty and short of breath after my basement expedition, I reached the card catalogue, and flipped through the well-thumbed 3 x 5 blue index cards. Miss Richter's accomplishments flew by—statues, vases, gold and silver jewelry, all of which she had brought in through purchase, gift and bequest. And many of which came by way of Robinson's contact, John Marshall.

Marshall spent his time overseas, culling collections and antiquarians in search of treasures for America's museums, especially Boston's and New York's. For archrivals to share one runner must have been complicated at times. Of course this was old school to the Met—their first director, General Luigi Palma di Cesnola, had been simultaneously the American *and* Russian Consul to Cyprus. This privileged position paved the way to his excavating and sending two shiploads of antiquities to the Met in 1874, kick-starting its comprehensive collection of Greek and Roman art in a way unthinkable today.

Finally I reached the set of cards for the mysterious statue in the basement. The work was described as an Etruscan *kore*, or girl, made in terracotta, or baked clay, dating from the Hellenistic period. Our Etruscan collection was distinguished, but we had no other life-sized statues—which are exceedingly rare, since Etruscans lacked marble quarries. Terracotta statues made cheap infill for later rebuilt walls, and works in wood disintegrated over time. The well-worn card bore a penciled word at the top right: "Falschung," German for fake.

STATUE OF A YOUNG WOMAN. ITALIC. LATE 4TH-EARLY 3RD CENTURY B.C. H. 74.8 CM. THE METROPOLITAN MUSEUM OF ART, ROGERS FUND 1931 (16.641).IMAGE © THE METROPOLITAN MUSEUM OF ART.

Typed below was a note that Ernst Langlotz had ruled it to be a forgery in 1926, a decade after it entered the Met. I felt a sting of disappointment. That year the esteemed archaeologist had spent a period of time as a guest of the Greek and Roman Department, and methodically noted his observations about works of interest. This statue was unequivocally determined by him to be a fake.

And with good reason, it would later turn out. Between 1915 and 1921, Miss Richter acquired three other Etruscan statues. Langlotz apparently did not question these works. But in 1960 it was discovered, through the use of a non-ancient ingredient in their glaze, that they were modern forgeries, a scientific fact corroborated by one of the forgers, Alfredo Fioravanti, who had kept a thumb from one of the works.

So by the time I pored over the records of this Etruscan maiden, there was a lot of water under the bridge. The phrase "Etruscan statue" did not sit well at the Met, which had been very embarrassed by the 1960 revelation.

Still, something nagged at me, and later that day I had our departmental technicians, headed by Richard Gauser, remove the statue from the tunnel and bring it to a newer storeroom so that I could better examine it.

I was very excited to see this girl revealed and lit when I entered the storeroom the next day. Even under unforgiving fluorescent light, she popped—she gave off an aura of authenticity invisible in decades-old black-and-white prints upstairs. It was true that I had never seen anything quite like her—let alone a life-size work. Her beautiful face looked more like a quattrocento Madonna than an ancient idealized goddess, but its technical features were flawless and rendered with self-assurance. Her chin was chipped, and this was cause for concern for me, as it must have been for Langlotz. Forgers routinely inflict minor damage on their works to throw off the scent.

The gray terracotta was striking—more common of course was reddish baked clay. There were other anomalies. Her hair hung straight and flat just below her ears—I knew of no comparable hairstyle from antiquity. Women in antiquity wore their hair long and piled up on the head in a bun. This girl's coiffure looked altogether modern, like a flapper fresh out of the shower. To a man of Langlotz's day, she must have seemed like an improbably dressed girl from a Speakeasy. All of these features, both technical and stylistic, seemed problematic.

But the casts of Etruscan amulets hanging on her multiple necklaces looked

spot on, as did her arm bracelet, wet drapery, and the stylized proportions of her upper body. I was hooked. My frame of mind was akin to what I understood defense attorneys to feel when deeply invested in the fate of a suspect they believed to be innocent. Part of me was excited about the sheer drama of such a discovery, and part of me wanted to reverse a long-standing and apparently unwarranted conviction.

After asking Gauser to put the work in a corner, I headed to the department library. My quest was simple: I had to find evidence commuting the sentence Ernst Langlotz had conferred, or give up before I made a fool of myself for contradicting that great connoisseur.

Long before DNA testing became a commonplace technique in law enforcement, science offered little in the way of proving the authenticity of artworks. But in the 1970s, A.G. Wintle and D.J. Huntley made a remarkable discovery. They were able to determine the age of an object, plus or minus two hundred and fifty years, by taking a sample and then inducing it to give off luminescence by re-heating it. The energy released is the measure of self and ambient radiation, which affected minerals in the ceramics since the last firing. The test is considered foolproof in detecting the most recent time the object was heated in excess of 500 degrees Celsius—in other words, when it was last in an oven or a fire.

In the case of a baked clay statue like our maiden, the test would be conclusive, since there was no blackening or any trace of her having been in a fire after her manufacture. The test at this time was only a few years old, which made my boss Dr. Dietrich von Bothmer more suspicious of it than not. But the files intimated that the maiden *had* been thermoluminescence-tested in the 1970s—and that the results suggested that the statue was ancient. Apparently that had not offered enough evidence to satisfy lingering doubts in the Greek and Roman Department. Besides, the argument went, the sample taken could simply have been from a section of an authentic terracotta work blended with the balance of a newly made statue.

Instead of relying on that scientific evidence, I started along the conventional route of a connoisseur, poring over collection and exhibition catalogues in search of comparable works. I found some statuettes—one-twentieth her size—that seemed vaguely similar. But a favorite trick of forgers is to take a work on a small scale and make a life-size or over-life-size version. So unless I found a comparable statue of the same scale, I knew this would be a fruitless quest.

After several days of a fairly comprehensive search of the world's collections of Etruscan and Italic antiquities, I was losing faith in my instincts. While I sensed that she was a masterpiece, I couldn't afford to risk my new reputation on what could easily be interpreted as grandstanding.

I'd be very surprised if there exists anything more tedious than published excavation reports. Page after page of dim black-and-white photos of trenches with fragmentary pottery and a meter stick, accompanied by floor plans, site photographs, and mind-numbing detail about the circumstances and context of discoveries. But I plunged into the excavation reports of sites throughout central Italy, hoping to come up with anything that might point me in a direction. After a few days I came across the recent reports of Lavinium, a site not far from Ostia, the ancient port of Rome. It was of note because it was the home of Aeneas, the hero of divine birth who left Troy after its fall and was the founder of Roman culture. In the course of the late 1970s, a trove of finds was poorly illustrated, but ultimately published in a catalogue that appeared in Italy in late 1981.

I flipped through the book and caught my breath as I saw image after image of fragmentary statues and heads that were almost duplicates of my maiden. I composed myself and made my way to Dr. von Bothmer's office.

"Yes?" came his familiar bark.

"Dietrich, I think I may have found some recently excavated *comparanda* for that terracotta maiden."

"Show me," he commanded brusquely.

I made my way around the pot fragments and dry-mounted photographs to his desk, handing him the illustrations and the photograph of our piece.

"Look at the jewelry. The bullae and rosette buttons are dead-on."

"And what do you want me to do?" he countered, after his silent perusal of the evidence.

I wasn't sure what he meant. Sculpture was not his area of interest. He was all about pots and decorative arts. I imagined that he always saw my passion for sculpture and painting as the mark of a lesser being.

"I'd like to publish her and put her on display."

He looked up at me, pushing back his magnifying-glass headgear. I drew in a breath.

"Very well," he replied, immediately returning to his scrutiny of a box of vase fragments, and seemingly unmoved by this turn of events.

Suddenly, what had been considered a fake, consigned to oblivion for 60 years, was to be resurrected as one of the museum's most treasured masterpieces. Proof of that assessment came when she was subsequently chosen to be a postcard—at the time the ultimate testament to an object's *virtu*, or quality, in the eyes of not only curators, but of the Met's merchandising wizards, as well. I imagined that her cool beauty was visibly improved by being in a big vitrine off Fifth Avenue.

Once the story of her rehabilitation broke in February 1987 in *U.S. News and World Report*, titled "The Lady in the Met: Six Decades in Exile," she became an iconic figure of sorts. Nothing pleases the press more than to reveal the travails and foibles of experts. In this case, the expert Dr. Langlotz was long gone. I wrote her up that year in a volume titled *Greece and Rome* that the Met published in partnership with a Japanese publisher. My satisfaction was in erasing an adverse judgment on a blameless work through an irrefutable combination of connoisseurship and science. So often objects make their way into a weird limbo, like the Getty Kouros, wherein their date is left in doubt, and along with it, our sense that the work may be a fraud.

So what was it about this girl that kept me in the stacks of libraries for days on end in what could well have been a fruitless quest? A combination of features that seemed to argue forcefully for her authenticity, and the work's high quality. The five hallmarks of quality that we examined in the introduction were all in evidence. Remember these?

1. *Original* in its approach
2. *Crafted* with technical skill
3. *Confident* in its theme
4. *Coherent* in its composition
5. *Memorable* for the viewer

AN ORIGINAL IDEA

The original idea that sparked the maker's imagination was unknown. It could be connected, albeit in some inscrutable way, with Lavinium's place in classical mythology. This maiden's identity might be explained in various ways. She could be an

idealized beauty meant to represent a priestess in a cult; a likeness of someone who was being celebrated or commemorated; or an image of a goddess. Her proper right arm was made separately and attached, and appears to have held out an offering of some kind in an act of piety.

But whomever she represents, the maker's desire to impart specificity on her face and hair is instantly clear. Unlike the legions of Etruscan and Italic terracotta faces that blankly stare back at us from the 4th and 3rd centuries B.C., this is an "it girl" with exquisite facial proportions.

The parallels I found from Lavinium didn't measure up in this sense. Made by other hands working in the same style, they were more generic in their physiognomy, or facial characteristics. In certain periods of classical art, like the Severe Style around 480 B.C., generic was in. It is hard to distinguish the face of a god from that of a goddess during that transitional moment before the flowering of High Classical Greek art. But in other periods of ancient art, this one included, a certain degree of improvisation and individuation was welcome.

CRAFTED WITH SKILL

Next, the statue reveals technical sophistication. While other examples of life-size statues from Lavinium are highly competent, they lack the subtle surface texture of our maiden, and are often grainier. Their facial features are less delicate, and tend more towards blandly idealized figuration. Their hair tends to be matted and more wig-like, whereas our maiden's sharply delineated strands of hair seem plausible.

Prolonged looking at similar sculptures was the only formula at my disposal. The key reason I doubted the label "*Falschung*" had to do with the technical sophistication of this work, down to the expert modeling of her sympathetic, beautifully proportioned face.

CONFIDENCE IN THE SUBJECT

A third test of quality is passed: her subject is rendered with confidence. The economy of form is peerless. Her planar face radiates simple beauty, and the full mantle is Spartan. While her elaborate jewelry reflects the fashions of the day, the artist manages to balance the ornate with the pure, and we are not over-stimulated

by detail. Unlike other examples of the same type, this maiden is preternaturally lifelike and spiritual at the same time.

COHERENT COMPOSITION

The fourth test is also passed with flying colors. The sculpture has achieved compositional harmony. We are persuaded that she is lifelike, notwithstanding the oddly attenuated proportions of her midsection. The looping necklaces draw our eyes across her body at the height of the collarbone and then accentuate her bosom. The graceful fall of folds doesn't disrupt our focus on her face, jewelry, and physique. A lesser artist might have devoted attention to one part of her at the expense of another, or made her features so generic as to be unappealing, or oversimplified the drapery or made it fall in non-naturalistic ways. But our artist avoided each of these traps.

MEMORABLE WITH A SUSTAINED CONNECTION

Also, unlike the other examples I came across, she makes a memorable connection with the viewer. We are drawn into her psychology. Mysterious though she is, her youth and beauty are in no small measure responsible for the connection. As today's vacuous celebrity culture emphasizes, it is human nature to be drawn to representations of beautiful young people—in classical statuary as in tabloid magazines. There is no confusing why the *Mona Lisa*, *Venus de Milo*, and the *Nike of Samothrace* are the three most sought-after works in the Louvre. They represent a trinity of respectively sultry, shapely, and wet-draped women who draw us nigh, while other works by Leonardo and the Louvre's hundreds of life-size classical sculptures nearby go barely noticed.

Our maiden's near-transparent *chiton*, or undergarment, calls attention to her modest but pert breasts by drawing the folds across her chest, accentuating her nipples, and falling below her bosom to a slightly rumpled state before being covered up by the thick mantle pulled over the top of her head and wrapped around her shoulders, then wrapped around her waist and hips. Greek and Roman artists were adept at mixing up piety with sexuality—as do Indian sculptors of the thirteenth century onwards, African makers of effigies, Mughal court painters—indeed, most artists around the world.

Even art forged in furtherance of the Christian faith is filled with examples of diaphanous drapery, come-hither glances, and even, in a little-known tradition, images of the Christ Child with an erection. The Catholic Church's longstanding suppression of sexuality spawned ingenious artistic license, and has been notably ineffectual in repressing human nature. When Attorney General John Ashcroft felt obliged to cover up the nude embodiments of Justice when addressing television cameras, it was hard not to see the absurdity of a gesture that would have met with the approval of religious extremists everywhere.

So the erotic and the pious coexist throughout most of the world, and within the Western world to some extent up until the Reformation. And this maiden, virginal in pose but sexual in attire, connects with us instantly despite the centuries that have passed since her manufacture.

The journey from the basement to the galleries for this girl was triggered by a chance discovery, and made possible by homework. But her ascendancy into a pantheon of ancient masterpieces was the result only of her maker's virtuosity, evident by careful comparison with similar versions of a prevailing type.

PUTTING A NAME TO A FACE

Other discoveries of a like kind can move an object from merely noticed to celebrated. On a slow afternoon in March 1983, I was seated in my office at the Met. I got a call from Jim Draper, whose normally languorous voice had a different note. The number two curator in the Department of European Sculpture and Decorative Arts wanted to know what I was doing at the moment. Actually, I was doing precious little, I confessed. He asked if we might go for a walk, and I readily agreed, mystified though I was.

I had known Jim fleetingly for years, but had only spent a lot of time with him during preparations for the exhibition of the Vatican's treasures over the previous several months. We worked side-by-side with the Italian curators and conservators, and shared a passion for marble sculpture of all periods. He had an expansive, over-the-top sense of humor, was slight in build, widely respected in the field, and like so many talented curators at the Met, a bit trapped by those with more seniority above him.

We met up at the Information Desk in the Great Hall, and he greeted me warmly.

"Sorry to spring this on you, Max. Do you know that statue in the lobby of the French Consulate?"

My mind leapt to take in what he meant. There was a fragmentary sculpture in the entrance vestibule of the Cultural Services of the French Embassy, a couple of blocks south on Fifth Avenue. I had never really focused on it before. From outside the building it seemed like a run-of-the-mill garden statue.

"I think so. Is that where we're going?"

"Yes. I have something I'd like to try out on you."

This quickly took on the air of a detective story—which I loved. And it was flattering that such an accomplished scholar was moved to include me in his deliberations. We gossiped about the museum until we arrived at the embassy. Entering the building, he waved to the receptionist who seemed to know him, and walked up to the white marble figure on a pedestal.

"Max, is there any chance this is ancient?" he asked.

I slowly scanned the figure from top to bottom. A figure of a young man, it was missing most of both arms and both legs below the knees. The head was turned slightly to the left and looking upwards. Richly carved with full, curly hair, and subtle modeling of the body, it seemed too slender to be an ancient cupid, or *putto*, the Roman precursor of an angel. The carving technique also made it seem Renaissance or later. The eyes were left blank, with the upper and lower lids about the same size, and the face less oval and more flat than would have been the case with an ancient figure of a boy. Its iconography, or subject matter and type, was not instantly clear, as would likely have been the case with an ancient statue of a youth. He wore a strap running diagonally from his left shoulder across the right side of his chest. Furthermore, his pose involved slight torsion—what became known in the Renaissance as *contrapposto*—with the top turning one way and the waist another. His left leg was advanced, with his right engaged, or weight-bearing, but it wasn't immediately clear if he was walking. The sculptor intended to make him a figure of Cupid, or *Amor*, in Latin, but went about it in his own way, not slavishly copying a classical forebear.

Putting all this together, it seemed highly unlikely that it was late Greek or Roman. Accomplished ancient artists were amazingly talented at capturing the motion of a human or animal form, but were also pretty formulaic. In other words, there were specific ways of representing motion and poses that cropped up over and

ATTRIBUTED TO MICHELANGELO BUONARROTI, (FLORENCE, 1475-1564), *YOUNG ARCHER*, CARRARA MARBLE, H. 94.2 CM., W. 33.7 CM.,
D. 35.6 CM., ON AN ANCIENT ROMAN TRIANGULAR BASE. LENT BY THE FRENCH STATE, MINISTRY OF FOREIGN AND EUROPEAN AFFAIRS.
IMAGE © THE METROPOLITAN MUSEUM OF ART.

over again. When Renaissance and later artists sought to recapture the naturalism of ancient art, often as not they improvised, and did not rely on the successful, oft-repeated formulas of ancient typologies. While a Roman statue of Apollo could be classified in one of a few types, Renaissance and later statues of the god often departed from the originally established types. In antiquity the use of formulas made it much easier for a devout Roman to recognize his gods, just as Christian iconography developed in the early Middle Ages to favor canonical types, like the Madonna with the Christ Child on her lap.

But Renaissance and baroque artists couldn't resist experimenting with the depiction of ancient gods and heroes, since they had less investment in making them instantly recognized than in showing off their own sculptural skills.

So before us was a depiction of a young man who wasn't instantly advertising his identity. The strap clearly indicated that he was an archer. But in antiquity, *erotes* (Greek) or *putti* (Roman) who shot arrows to spark love had heads proportionate to their bodies; this little lad had a head that was notably larger than his body size would have suggested.

What other options were there? Often Renaissance and baroque sculptors took damaged or unfinished statues from antiquity and used them as a point of departure, reworking features and finishes. But here, there was no reasonable chance that the unusual pose could have been derived from a Roman version of Cupid or Amor.

"Jim, I'm pretty sure this isn't ancient," I finally said, going through my reasoning with him in rapid detail.

He looked at me with a knowing glance.

"I think it may be by Michelangelo."

I was stunned. Masterpieces by one of the greatest sculptors of the Renaissance don't turn up every day on Fifth Avenue. Jim proceeded to share his reasoning, which seemed highly convincing, although I had no way to go through his comparisons in front of the sculpture, and would have needed to see illustrations of the works he cited. As we walked back to the museum, I asked what he planned to do next. He said he was mulling that over.

The story of how the statue arrived at Fifth Avenue wasn't that complicated. It had been in the gardens of Rome's Villa Borghese in the eighteenth century, and in 1902 made its way onto the art market in London by way of a dealer named Stefano

Bardini. It returned to Italy, unsold, but was ultimately bought by an American, ending up in the French Government's possession four years later, in 1906.

Days went by after our visit, then weeks. I saw Jim again in the staff cafeteria one day. When pressed, he said he wasn't prepared to go public with his attribution to the master. I was surprised, since he seemed so committed to it when we stood before it. But reputations could be won and lost with daring attributions. Other scholars, either jealous of having missed something so major, or skeptical about the speculation, can be merciless in private, at public fora, and in print. They can besmirch an accomplished curator's standing overnight. Jim decided not to take that chance.

But in October 1996, Kathleen Weil-Garris Brandt did. A professor at the Institute of Fine Arts, one door away from the French Consulate, she cut a dashing figure in the art world. Attractive, worldly, self-possessed, and well-spoken, she was a leading scholar of Renaissance and baroque sculpture. It was Brandt who hazarded a public attribution of the figure to the hand of Michelangelo. Her findings led to the statue going to the Met's conservation lab for study, and to a major exhibition at the Louvre in 2000.

I thought about calling Jim to see whether he had any hand in this announcement. But I never seemed to get around to it. Almost 30 years later I walked into the French Embassy's outpost with Jacqueline, our son Chase, and daughter Devon. The *putto* before me was a plaster cast, since the original was being shown at the Met— as an autograph work by Michelangelo. It took a long time, but Jim's hunch was corroborated in the most rewarding of ways.

Just as in science, where claims of an advance had better be backed up by evidence, art historical "discoveries" can be very problematic. Usually there are dissenting views instantly expressed by established authorities. And what qualifies as evidence when dealing with partially documented or altogether undocumented artworks? Often as not, attributions, dating, and stylistic comparisons are a matter of informed opinion that must stand the test of time—and run the risk of being overturned years later.

Brandt's claim was instantly challenged by the late James Beck, Columbia's flinty expert in the art of the Renaissance, and others joined in on each side. To this day the attribution remains in question, just as Jim might have known it would, had he stuck his neck out.

Homework was needed here, and still is. The simple passage of time after a claim of a new attribution is often enough to lay bare the facts. Just like walking into a dim room after being in the bright sunlight, the eye of the scholar adjusts to the image of the work in a putative new light, and either accepts it or doesn't.

I learned a lesson from Jim about quality in the wake of this experience. To him, it was important to ask the questions, but not so important to make the claim public unless he was certain. One could chalk that up to modesty, responsibility, or fear. Whatever prevented him from shouting from the rooftops, the statue stands to this day, visible from the steps of the building, silently posing the same questions Jim asked over two decades before. Who made it? Is it a work by a very young Michelangelo? Or a middling statue by an imitator?

NOTE:

G.M.A. Richter, "The Department of Greek and Roman Art: Triumphs and Tribulations." *Metropolitan Museum Journal* 3 (1970): 73-95

CHAPTER VI : Confident in Subject or Theme

G reat art radiates confidence. Among the easiest ways of separating sheep from goats in artistic quality is by comparing versions of the same subject. Icons of the Madonna and Child, portraits of famous subjects, still lives, images of the nude—all are on a spectrum from derivative to fantastic, based on how much they tend towards being tentative or being authoritative.

The materials and methods of art making are as varied as the elements of nature—and, since the invention of plastics—as anything the mind can conjure up and physics can support. And that same variety complicates our task. Shared subjects offer the easiest means by which to compare artistic quality. Time-honored artistic traditions yielded so much bounty, including a couple of thousand years of Egyptian depictions of animals.

While a curator at the Met, I had a running gag with my two closest friends in the Department of Egyptian Art, Peter Dorman and John McDonald. I would disparage Egyptian artists by alleging that they made the same cat for 1,000 years. They in turn noted the decadence and relatively brief existence of Roman civilization. The sparring was all in good fun, but it highlights a facet of qualitative assertions about originality. The challenge to an Egyptian artisan was to remain within the narrowly prescribed limits of compositional improvisation while keeping the seated cat archetype fresh, century after century. Egyptians revered continuity, while classical

PIRIFORM TRIPOD VESSEL WITH MODELED JAGUAR FEATURES. COSTA RICA OR NICARAGUA. PATAKY POLYCHROME, PATAKY VARIETY. PERIOD V. 1000-1350 A.D. CERAMIC. EX COLLECTION WILLIAM C. AND CAROL W. THIBADEAU. 1991.4.337. © MICHAEL C. CARLOS MUSEUM. PHOTO BY BRUCE M. WHITE, 2008.

artists embraced innovation. Close observers of the depiction of the seated cat between the Middle Kingdom (2055-1650 B.C.) and the end of the New Kingdom (1069 B.C.) can find much variation among thousands of surviving examples.

By contrast, it is harder to pick out better from lesser Greek and Roman portrayals of felines precisely because there were multiple typological varieties. It's harder to compare apples and oranges, or classical reliefs, including tigers and panthers, than to line up 1,800 statues of Sekhmet and pick the slightly more majestic from the slightly more make-work.

A colleague of mine, Robert Cohon, wrote his doctoral dissertation on Roman table legs. Not as obscure a topic as it sounds, since many table legs, dressed up with the Greek name *trapezophoroi*, were zoomorphic, and most took the form of a leg surmounted by a feline head. Robert was a familiar sight around Rome—you could always spot the soles of his shoes as he genuflected under Roman tables among dozens of galleries in multiple museums. But his work separated the strays from the purebreds, as it were, and established a taxonomy for the evaluation of workshops and, by extension, artistic achievement.

STUDYING EARS IN THE HUNT FOR QUALITY

One scholar, Giovanni Morelli (1816-1891), made an extraordinary advance by pioneering this simple comparative method. His insight was revolutionary and became known as the "Morellian" method. Having been trained as a doctor, he was a keen observer of features and details, and sought to classify the approaches taken to representing innocuous details on Italian pictures. His reasoning was that artists working against the clock with drying paint are likely to use shorthand for a variety of features, most notably the human ear, since these elements of a painting are far from the central subject and draw less scrutiny. Thus an artist could resort to familiar, shorthand approaches to representing the curvature and contours of the ear, so that he could devote more time to the singular aspects of his work.

Other scholars would later adapt the Morellian method in the study not only of Old Master pictures, but of classical sculpture, while notable connoisseurs such as Bernard Berenson applied it to other periods in art history. Sir John Davidson Beazley of Oxford took this technique to its logical extension in the study of Greek vases in the course of the 1920s to 1950s. He in turn trained my supervisor, Dietrich

von Bothmer, who devoted his life to the study of Greek vases and to the detective work of piecing together fragments of such vases found in collections around the world. His archives were a stunning catalogue of such *disiecta membra* (scattered pieces), and I knew him to be able to join a single vase from fragments in six different museums.

Morelli's influence extended beyond the art world. Sigmund Freud is known to have admired his method, as did Sir Arthur Conan Doyle, whose protagonist Sherlock Holmes relied on the same method in pursuing clues from the obvious and easily overlooked. Carlo Ginzburg was the first to note the explanation for this triangulation: "Freud was a doctor; Morelli had a degree in medicine; Conan Doyle had been a doctor before settling down to write. In all three cases we can invoke the model of medical semiotics or symptomatology—the discipline which permits diagnosis, though the

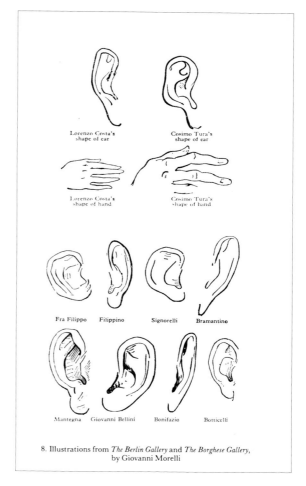

8. Illustrations from *The Berlin Gallery* and *The Borghese Gallery*, by Giovanni Morelli

MORELLI EARS.

disease cannot be directly observed, on the basis of superficial symptoms or signs, often irrelevant to the eye of the layman, or even of Dr. Watson." (Carlo Ginzburg, "Morelli, Freud and Sherlock Holmes: clues and scientific method," *History Workshop Journal*, 1980.)

One of my Harvard professors, the late Konrad Oberhuber, was a devoted Hegelian. He was the only person I've ever known who believed—and made a brilliant show of proving—that where an artist came from dictated how he drew or painted. Oberhuber sorted out the artists of Florence from those of Venice by a

variant of the Morellian method, and what at first seemed like a parlor trick became a useful way of looking at the art of the Renaissance and Baroque. It boiled down to this: if the artist relied heavily on lines and outlines, he was Florentine. If he relied on color, he was Venetian. I had studied the difference between a focus on *disegno* and *colore*, but Oberhuber spoke as if he could see through the eyes of the artists themselves. It was uncanny at times.

If you have a favorite artist, it's a good idea to explore Morellian clues as way of educating your eye. Home in on the features that at first seem the least significant in his or her work, and seek these out in each example you come across. This method will speed you on your way to recognizing not only the hand of the master, but also to making comparisons among innocuous elements in various representations of the same subject.

LOOKING AT ART FARTHER AFIELD

I maintain that the Morellian method works in the arts of many cultures, and not just those of Europe. In 1991, a jaguar vessel (page 130) was added to the collections of the Michael C. Carlos Museum at Emory University in Atlanta, along with hundreds of other Pre-Columbian objects donated from the collection of Bill and Carol Thibadeau, and remains among the most memorable pre-Columbian works I have ever seen. The work is from Central America, likely either from Costa Rica or Nicaragua. It is attributed to the Greater Nicoya, Pataky Polychrome style, and is dated to Period IV, AD 1000-1350. The Gran Nicoya culture was centered in the northwestern part of modern-day Costa Rica, bordering on Nicaragua to the east.

A stylized portrayal of a crouching jaguar, the vessel is a combination of a stolid functional shape with ornate sculpted and painted decoration. For those of us trained in the field of classical Greek vases, the zoomorphic shape and decorative field are bracing. An open field of ochre slip is surrounded by polychrome fields on the legs of the animal-vase, rich with linear patterns as well as stylized animal heads.

There are multiple versions of this pottery type in collections throughout the world. What distinguishes the example in Atlanta for me is the careful balance of colors, with beautiful red and black markings. The jaguar is in a standing human pose, as if the image is a hybrid human-animal being, simultaneously taut and at rest.

As an object, it meets the tests we look to for its originality, the extent to which

we are drawn to it, its technical sophistication, and self-assured translation of its invented subject onto a satisfyingly tactile, inviting shape. A comparable work in the Managua collection of the National Museum of Nicaragua is only slightly less successful—because the arm/legs of the hybrid creature below the neck of the vessel lack the jaunty, taut quality of the Atlanta version and seem to lie flaccidly on the standing legs. The pattern work on the neck is rich and detailed—but the mouth of the vessel is irregularly thrown, and lacks the terminal lip capping the Atlanta version. The Managua version accordingly looks less carefully made. The red slip on the paws of the legs at the front of the vessel is also less neatly applied, and bleeds into the claws, whereas the version in the Carlos meticulously segregates the red from an ochre field and the claws below.

While each of these distinctions is subtle, they accumulate and result in a final verdict for me: one vessel is better than the other. To an anthropologist, the technical and stylistic distinctions would be immaterial: these two vases are parts of a ritual tradition of jaguar worship that is revealed in equal measure. But to art historians, we covet one over the other on the grounds that the potter and painter were more talented and more methodical, yielding a more expressive and satisfying object.

The comparison of like subjects in a quest to pit one work against another in a search for quality is, in my view, a worthy exercise in any field of art history. Pre-Columbian art was the fruit of urbanized civilizations no less majestic than those in Asia and Europe. There are superficial resemblances that commonly accrue to cultures known for architectural monumentality, technological sophistication, a predilection for military conquest, and prevailing religions.

Thus Mayan step-pyramids are fundamentally analogous to Indian stupas, Egyptian pyramids, Near Eastern fortresses, and the outcropping of the Leshan Giant Buddha in Sichuan, China. Affinities among visual languages are wholly expected when there is so much else in common. And while art historians have avidly sought direct or indirect influences from one culture to another, it cannot be excluded that a Jungian interpretation is as merited: visual archetypes are shared among people of extremely divergent backgrounds, since human psychology can point to unconscious ways of seeing the world across very divergent cultures.

AFRICAN ART AND MULTICULTURALISM

Unlike the art of civilizations, including urbanized, fortified settlements, the art of Sub-Saharan Africa has long been said to operate under its own rules. As a field of study today, the art of Africa is under constant reevaluation. Antiquated, discredited perspectives reliant on the construct of "primitivism" were discarded as part of a general rethinking of Western supremacy in the 1960s, as were other prejudices about non-Western art in general. Claude Levi-Strauss and other influential writers before him, including Franz Boas, postulated that Western bias was impermeable, rendering judgment highly problematic. A new generation of scholars advocating the emergence of a "multicultural" perspective came into positions of authority in universities and museums, and exchanged one approach for another, embracing structuralism and later post-structuralism and deconstruction. These philosophical vantage points have been widespread in the academy for nearly half a century.

The basis of multiculturalism was at least in part an effort to overturn centuries of bias privileging European art, literature, and creative acts in general over all other cultures lumped together as "non-Western." While no thinking person would today defend the racist underpinnings of the past, the extreme relativism of multiculturalism, as some have espoused it, leads to the position that Westerners are incapable of fairly judging the caliber or significance of non-Western art because of inherent cultural bias.

The peculiar result of taking multicultural sensitivities too far is that all judgments must either be suspended, or all judgments are equal. Both positions are absurd. This is why a new generation of scholars is chafing under the relativist multicultural worldview of their professors, and is seeking a fresh platform from which to consider the arts of Africa. This new generation would have us become better informed about the sources and perspectives of artists and artisans working in Africa before and after European contact, and apply the same energy to seeking objectivity that scholars do with regard to all cultures, European and non-European.

The renowned cultural historian Sir Isaiah Berlin (1909-97) was a thoughtful critic of the notion that one culture might rise above another, and at the same time sought to codify ways of making assertions about the achievements of cultures other than our own. His belief in what he called "objective pluralism" or "values pluralism" left open the possibility that judgment need not be suspended when straying

from familiar terrain. It is that position that I embrace in thinking about artwork made without regard to Western traditions or norms—as in the case of the art of Africa or of Pre-Columbian Central and South America. I won't argue that my framework from which to judge the value of works of art is unbiased. On the contrary, this book is little else than one person's compendium of biases. But despite the assumptions of extreme relativists, I wouldn't claim that my views are better than those of others; they are simply my own.

But for me and for everyone else who has seen them, a group of twelfth-century copper-alloy sculptures of the Ife people detonate any stereotype of African art. These works are as inexplicable as the fourth-millennium B.C. Chalcolithic hoard from Nahal Mishmar described in Chapter Four. The Ife sculptures disrupt the convenient and comfortable narrative of Western art as a pioneer in embracing extreme naturalism during the Italian Renaissance. The chance discovery of these copper-alloy sculptures in Ife, Nigeria, beginning in 1938 has radically altered previous narratives of African art history.

Dating from as early as the twelfth century A.D., these lifelike and life-size, cast metal portrait heads are in every sense the equal of the finest naturalistic portraits in the history of the West. Until their discovery in 1938, and only since their long delayed display on a world tour that included the Indianapolis Museum of Art, few had any idea that a visual tradition on the African continent could match or exceed that of Europe at the time. As representational art, the copper heads of Ife are not only an astonishing achievement, but also a timeless and geographically boundless one that should make us all question our most basic assumptions about art.

PATTERN AS SUBJECT

Sometimes the "subject" of artwork has nothing to do with representation, but only with pattern work. Another discovery in the Metropolitan's basement was one I almost tripped over. This one was all about seeing past a commonly shared visual language to the particulars of individual examples.

Among the confines of the Met's "tunnel" was another cage, adjoining the largest reserved for the Greek and Roman Department. This one lacked shelving, and had a smaller concentration of marble sculptures in it. One day in 1983 I was rummaging around it and took in something I had walked passed on multiple occasions:

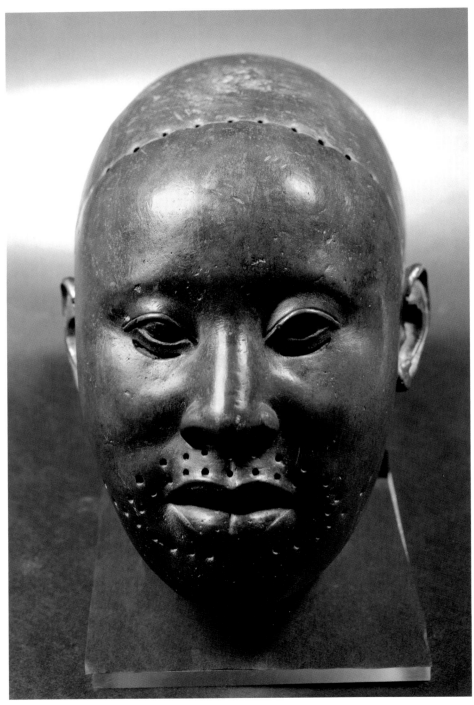

MASK OF THE ONI OBALUFON, FROM IFE. NIGERIAN CULTURE. 12TH TO 15TH CENTURY A.D. COPPER. NATIONAL MUSEUM OF IFE, NIGERIA. PHOTO: SCALA / ART RESOURCE NY

a massive six-foot-long stone section of an architectural element.

The shower curtain unceremoniously draped over the section of what looked to be an entablature had presumably helped shield it from dust, but it had also shielded it from careful examination. Once I located the red painted accession number, I headed back up to the department to learn what I could about the sculpture. Because it started with the integer "17," I knew that it was almost certainly a gift from J. Pierpont Morgan, one of the museum's original founders, and among its greatest benefactors of art, as well as money.

The index card revealed next to nothing, apart from the fact that Morgan had indeed given the sculpture along with hundreds of other objects in 1917. It had been procured, like so many other Morgan gifts, by purchasing agent John Marshall, who was active in Rome at the time.

It struck me as odd that Morgan would have deigned to acquire such a large architectural element without some specific motivation. Few American museums have any such remnants, since they were very difficult to transport, and often without much merit as artworks. Their weight makes them a challenge to display, and without individuated features, they offer little to the non-specialist.

I returned to the tunnel in search of more clues, and happened upon three other sections of architectural elements, all bearing a series of accession numbers connecting them with the first section. One was a very distinctive block with highly ornate egg-and-dart motifs, and was clearly from the architrave of a building. Their marble looked very similar, even if one had suffered more from exposure to the elements, and I surmised that they could be from the same structure.

Where to turn next was simple enough. Professor Peter H. von Blanckenhagen, the erudite German scholar who spent much of his career at New York University's prestigious Institute of Fine Arts, across the street from the Met. He had literally written the book on late first-century Roman architecture—the period that most consider the apogee of architectural achievements in the Roman world. I headed to the Watson Library to consult the monograph, which he published after it had served as his doctoral dissertation. I found much concurrence with examples of ornament from the Flavian (81-96 A.D.) and Trajanic (98-117 A.D.) periods. The egg and dart carvings were sharp, taut, and executed with great skill. So many other temple carvings from the Roman world were executed with less care, revealing

variations in size, proportion and finish among the features of even a single register of ornament. The Met's were so precise as to appear laser-cut. They were clearly the product of a master mason.

Blanckenhagen's monograph gave me a head start, but I needed more to see if there was any way to find an exact match with buildings from first-century Rome. It was one thing to look in published materials, but in the pre-digital age, it was truly looking for a needle in a haystack to compare sections of architectural relief by means of photography alone.

I undertook as complete a study as was reasonable to compare and contrast examples of the acanthus ornamentation, bead-and-reel and egg-and-dart motifs. I was soon dreaming about the infinity of these familiar architectural formulae. If you look up in any neoclassical building standing today, from an office building to a bank, you will find endless supplies of these decorative elements. They served a purpose that Roman architects first perceived: colossal architectural forms often benefit from minute articulation, to lead the eye across long sections of buildings. Today plastic sections of crown molding are glued or nailed to the ceiling to simulate the effect of past glories. But their soapy, undifferentiated texture makes them like a Thomas Kinkade landscape: reassuring and forgettable.

My quest seemed to require plowing through an insurmountable pile of evidence. I began with the review of publications of Roman buildings, but quickly found that the details I needed—precise measurements, high-quality photography, visible tool marks—were sparsely available, if available at all. So I decided that on my next pilgrimage to Rome, I would spend some time with binoculars on scaffolding and ladders to see if the pool of comparable architectural pattern work could be narrowed.

Dumb luck played its hand once again. After a solid week of examining ornament—including a visit to the French Embassy's Palazzo Farnese, a series of displays at museums, and mining of free-standing ruins around the city—I paid a call to the Palatine Hill, where some stray examples of architectural relief remained outdoors. And there I made a discovery that still warms my heart. On top of a brick wall, supported by travertine blocks, stood a section of the entablature of nothing less than the *Aula Regia* (Throne Room) of the Flavian Palace of the Emperors. It seemed from below an exact match of the Met's section of cornice.

The palace was an enormous complex built under the Emperor Domitian (91-96

ARCHITECTURAL FRAGMENT FROM DOMITIAN'S PALACE, ROMAN, EARLY IMPERIAL, DOMITIANIC, CA. 90-92 A.D., MARBLE, THE METROPOLITAN MUSEUM OF ART, GIFT OF J. PIERPONT MORGAN, 1906 (06.970B, 06.970D). PHOTO BY SCHECHTER LEE. © THE METROPOLITAN MUSEUM OF ART.

A.D.) to supersede the Golden House (*Domus Aurea*) of the Emperor Nero. The Palatine Hill was the location, according to legend, chosen by Romulus, the founder of Rome, for his first hut. The first emperor, Augustus, chose the location for his first imperial residence. The marble-clad concrete structure (our word "palace" derives from its location on the Palatine) was the work of the architect Rabirius, and was a sumptuous combination of ornament, statuary, colored marbles, frescoes, mosaics, and other furnishings.

The Throne Room of the Imperial Palace was massive: 138 feet long, and 105 feet wide, or wider than the central nave of St. Peter's in the Vatican. Domitian, who was not known for his restraint, sought to make his throne room and this complex the most opulent official residence imaginable.

I swiftly obtained permission to take a pair of calipers up the brick wall and take detailed measurements, leaf by leaf, dentil by dentil, egg by egg. I sat on the ground after I had finished and compared these dimensions with those of the Met's massive cornice section. Sure enough, they matched, with remarkable precision. The tool marks were the same, with fine hatched lines scraped in parallel, and the marble, while subject to some three-quarters of a century more weathering than the

section in New York, had granules of the same size.

The quiet astonishment I felt at this attribution had as much to do with solving the mystery of the sculptures' origins as the fact that the emperors of Rome, from Domitian until the end of the Western Empire, sat enthroned below them. The emperors' eyes almost certainly passed over the very section of marble still resting under shower curtains below Fifth Avenue.

I made an appointment and walked over to the Institute to present my findings to Professor von Blanckenhagen during his office hours. His diminutive stature contrasted with a distinctively deep voice. As I prepared to pull the documentation from my briefcase, he growled a startling adage about scholarly hypotheses.

"Mr. Anderson, let me warn you of something. In my experience, young people propose things that are new but not right, or right but not new."

Then he looked on as I went through a set of laboriously prepared photographs, tracings, profile drawings, measurements, and reconstructions. To judge from his grudging nod, it seemed that experience could not always be relied upon. Afterwards I vowed to resist dressing down younger scholars were I ever to scale the academic or professional ladder. The mock-seriousness of much German humor is an acquired taste, but I did love his aphorism, nonetheless. N.B.: It is best recited with a Prussian accent.

This kind of detective work yields other benefits for the close observer. I have never looked at cornices the same way since. For the casual viewer, it can help to linger over repetitive details and pattern work that at first glance seem unworthy of admiration. The eyes of mortals prior to the Industrial Revolution must have made room to admire repeating elements in ways foreign to a modern onlooker. Today we are, after all, accustomed to mass production, and we unconsciously gloss over features and attributes of art and architecture derived not from the hand and chisel or brush, but from millwork, molds and casting on a grand scale.

In the pre-industrial world, all things visible were fabricated by hand, and someone had to lavish the same kind of attention to repeated elements as to one-off images, forms, or features. The respect accorded the entirety of rooms, buildings, complexes, and ensembles must have differed notably. Concrete was a reasonably novel technology in the first century A.D., allowing for previously unimaginable spans of interior space. Combining grand scale with detailed carving of marble

architectural ornament must have made for a heart-stopping experience when supplicants, foreign emissaries, and mere citizens entered the *Aula Regia*.

Little measures up to the finesse of these sculptural elements, now on prominent display at the Metropolitan. They will spoil you if you make time for them.

SHARED PATTERNS, DIFFERENT RESULTS

Not long after this, I had the unusual opportunity to tour the White House. Denny Brisley, an acquaintance from college who served as assistant White House press secretary for President Reagan, invited me for a behind-the-scenes look. In those relatively innocent days of the 1980s, security at the White House was already very tight, but it was possible to see the Oval Office once you obtained a certain level of clearance, and, of course, if the president was not in residence.

I was conscious of the privilege, and fascinated by the opportunity. But I couldn't hide my disappointment when I entered this storied room and detected fluorescent above the plaster cornice intended to illuminate the elliptical ceiling. Fluorescent lighting? Could a technology that pedestrian be integral to the design of our nation's greatest interior working space?

This was not the only capitulation to expediency in the modern realization of this hallowed interior, which included multiple floor types since Roosevelt—the nadir being wood-grain linoleum tile under President Johnson.

It was natural to compare the interior "throne rooms" of world leaders, and to reflect on how ornament was used with propagandistic intent in each. There is little doubt about who comes out on top, two thousand years later.

The last reminiscence on this front takes me to the final days of President Obama's campaign for president in 2008. My wife Jacqueline and I received a call from his advance team, with a cryptic request for a site visit to the Indianapolis Museum of Art's official residence that we called home. Obama was addressing a rally in town, and it developed that he was planning to buy time for a televised address to the nation. Based on illustrated magazine spreads about the museum's residence, his local campaign office proposed using my study as the location for a fireside speech in what would later be cited as a pivotal campaign event. The idea was simple enough: they were seeking a context behind a desk that would remind viewers of the authority of the Oval Office.

After a couple of nail-biting days, his campaign chose another location. But I frequently looked up from the nineteenth-century writing desk in the study and pondered how the cornice carved in dark-stained knotty pine would have measured up in his televised address. It's more than enough for my tastes, and there's nary a fluorescent fixture to be found.

COMPARING MASTERPIECES

The settings of world leaders and of artworks certainly contribute to our experience of them. In the late 1990s I was courting the collection of Kenneth Thomson, a.k.a. Lord Thomson of Fleet and Northbridge, hoping to land it for the Art Gallery of Ontario. It was clear that we had to make the case to Thomson, literally, for the collection, so I had a pair of galleries filled with cases created to house what would eventually turn from a long-term loan to a gift.

The centerpiece of one of the galleries was the Malmesbury Chasse, or reliquary, among the best-preserved and most important examples of medieval art in North America. Made between 1180 and 1190, it fairly gleams with the authority of the Catholic Church, and rewards sustained and repeated looking.

In 1996, Lord Thomson had purchased the Thomas Becket casket at auction, and subsequently withdrew the bid to allow it to remain in Britain. The National Heritage Memorial Fund, to which Thomson contributed, was the eventual purchaser. The Malmesbury Chasse is believed to have originated in Malmesbury Abbey—and to have contained a relic of Maidulf, the seventh-century missionary Scot. Far more exciting than a Hollywood version of historical intrigue like *The Da Vinci Code*, the casket is a marvel of inventiveness, layered meaning, and rich ornamentation. For anyone who still imagines the Middle Ages to have been the Dark Ages, one glance at this treasure chest will change your mind.

It is in the form of a house, as was typical of chasses from twelfth-century workshops in Limoges, France. This was natural enough, since caskets of this genre functioned as reliquaries for the mortal remains of saints. Remains of the Scottish monk Maidulf, the erstwhile occupant of the interior, would likely have been in the form of a bone fragment. This eminent teacher's name would ultimately be invoked for the place he lived, first Maidulfsburg, and later Malmesbury. Effectively a hermit earlier in life, he later opened a school in a huge forest bordering Wessex and

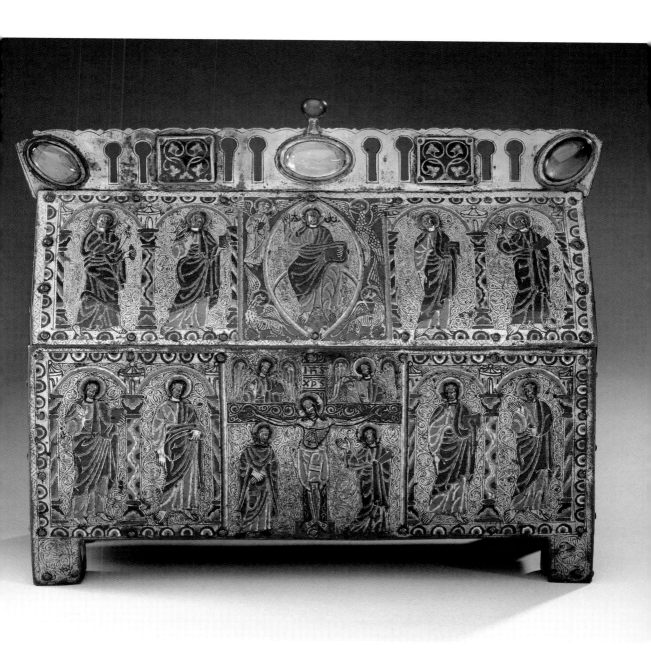

THE MALMESBURY CHASSE: THE CRUCIFIXION AND CHRIST IN MAJESTY. C. 1190-1200. FRENCH (LIMOGES). GILDED COPPER, CHAMPLEVÉ
ENAMEL, ROCK CRYSTAL, WOOD, PAINT; ENAMEL, GILDED COPPER ALLOY, ROCK CRYSTAL, OAK. OVERALL: 26 X 32 X 10.5 CM. ART GALLERY
OF ONTARIO, THE THOMSON COLLECTION. © ART GALLERY OF ONTARIO.

Mercia. The school in turn became a monastery.

The chest is about one foot long—huge by the standards of this genre—and is made of gilded copper, with inlays of champlevé-enamel and crystal. On one of the short ends is a key-entry door with a rounded top—whereby Maidulf's remains were inserted. The principal long side has two horizontal registers—the top featuring Christ in majesty, and the bottom featuring the crucifixion. In each case, the central square panel with these scenes is flanked by images of standing saints within a colonnade.

The house form and horizontal division of figures recall sarcophagi of the Roman and Early Christian periods—which were receptacles for human remains as well, although for life-size inhumations of bodies. What is most striking about this example is not only its imposing size, but the sensitive, naturalistic depictions of the figures, the extent of gilding, and the intricate patterns throughout.

Its companion, presumably from the same workshop, is today in the collections of London's Victoria & Albert Museum. It enjoys international reputation because it is thought to have contained the remains of St. Thomas Becket, and thus its historical value trumps the lesser protagonist in the history of Christianity, the humble Scotsman Maidulf.

The London version presents the momentous event that changed a world religion. On the night of December 29, 1170, Archbishop Thomas Becket was assassinated by four knights in Canterbury Cathedral, under orders of King Henry II. His martyrdom galvanized the faithful, who made pilgrimages to Canterbury to pray at the site of his death. Henry VIII would eventually destroy his shrine. This, then, is a kind of newsreel of the twelfth century, capturing current events, and in that respect is a thrilling and rare example of the documentation of contemporary history in the Middle Ages, redolent of the Bayeux Tapestry from the preceding century, which recounts the Norman Conquest in a 224-foot-long embroidered cloth.

The two chasses are twins by virtue of the distinctive shared roofline, punctuated by a slender sheet of copper perforated with keyhole shapes, interrupted by identical oval rock crystal inlays. In the Malmesbury Chasse, there are rectangular enamel plaques as well, while in the Becket Chasse, they are oval. Both are crowned in the center by a distinctive finial.

These are the signature elements of twin commissions from the 1180s. But as our

eye drifts down to the fields of decoration on the front, the Becket chasse is a far less ambitious affair. The Malmesbury Chasse, to invoke our five features of quality, is more original in scale and solemnity. It is crafted with more detail. It conquers its subject with authority. Its composition is very resolved and harmonious. And the ensemble sticks with you long after a first glimpse.

While the figures of the Malmesbury Chasse are articulated with multiple enamel inlays to differentiate the folds of their cloaks, those on the Becket Chasse are simply gilded with relief lines. The background of the Malmesbury Chasse is intricately cold-worked gilt copper inlay, while the Becket Chasse is simply turquoise inlay. The two scenes on the Becket Chasse are compositionally simple, with rosettes scattered throughout the field, while the elegant inlaid colonnade of the Malmesbury Chasse is far more formal, detailed, and meditative.

Part of the difference is the narrative tone: the Toronto version is more composed, and the London version is more active. This, of course, is not a qualitative difference, but one of attitude. Yet while the ensemble is engaging, Becket's chasse lacks the austerity and nobility of the Toronto version, and in that more closely resembles so many other chasses from twelfth-century Limoges—which can be busy in their narrative but with a relatively plain technique.

There was no doubt in my mind that we made off with the better of the two in quality—though there is no gainsaying that the version in the V&A resonates more with devout Church of England visitors by virtue both of its subject and its original contents.

WHAT'S IN A NAME?

Returning to Toronto, another quarry that I set my eyes on was a life-size seventeenth-century marble bust of Pope Gregory XV, which was in pristine condition, notwithstanding the fact that it had been through the ringer. Art Gallery of Ontario trustee Joseph M. Tanenbaum and his wife Toby had purchased it in 1983, believing it to be an autograph work by one of the most important sculptors in history, Gian Lorenzo Bernini. Their conviction was not universally shared at the time, and the attribution became a tug-of-war.

In 1985, with millions of dollars in the balance, renowned NYU and Princeton Institute of Advanced Studies Bernini scholar Irving Lavin noted a November 18, 1622

GIAN LORENZO BERNINI, ITALIAN (1598-1680), *POPE GREGORY XV*, 1621, MARBLE, 83.2 X 62.3 X 32.4 CM. ART GALLERY OF ONTARIO. GIFT OF JOEY AND TOBY TANENBAUM, 1997. © ART GALLERY OF ONTARIO.

diary entry by the artist's cousin, Francesco Bernini, citing two busts of the pope, one in marble, and one in bronze. More tellingly still, Lavin uncovered a Ludovisi family inventory from 1633 that mentions the unusual "motley stone" base supporting the marble bust—which might describe the base of the Tanenbaums' work.

Lavin pronounced the bust to be a masterpiece by Bernini, lost for over a century, adding that it is "one of the most important and perfect of Bernini's early works." (Roberta Smith, *New York Times*, December 29, 1989.)

In January 1990, the bust was put up for auction at Christie's in New York. Bidding reached $6 million, but failed to meet the seller's $7 million reserve, and so the artwork made its way back to Toronto.

A year after arriving in Toronto, I and Chief Curator Matthew Teitelbaum cajoled Joey Tanenbaum to part with this masterwork, and cement his credentials as a connoisseur ahead of his time. Joey and Toby decided to donate it to the museum the next year. Today it stands as one of the greatest works by this master in North America.

The man whom we confront in his marble likeness lacks the emotion of other

sitters, and he is depicted in a reserved manner, with none of the baroque flourishes for which Bernini is best known. The elderly pontiff wears an ornate copse and presents a world-weary, knowing countenance.

Dating to 1621 when Bernini was 23, the bust captures the gravitas of a man who served in the Holy See for only three years, but enjoyed the reputation of a scholar and a thoughtful figure in papal history. He was obviously pleased by the likeness carved by the young genius: Bernini was knighted by the Pope the year he completed the bust.

The details are remarkable in their combination of taut restraint and refinement.

In light of the attribution, a legitimate question lingers: would the bust still be of the same quality if not by Bernini? It would clearly not be of the same commercial value. My conviction is that it would, without doubt, be of the same quality regardless of its authorship or its fair market value. The sliding scales of quality and of commercial value are related but not inexorably so. Secondary works by great artists are often highly valued in the marketplace simply because of rarity—either the artist was not prolific or there is a dearth of works believed to be available. So we can't rely on value to key us into quality.

And in a related vein, there are artists who lack household names whose works are clearly the equal of other, better known protagonists. For most of the first 6,000 years of art history, artists didn't sign their artworks, and we are largely in the dark about authorship. Once documentation became more readily available, that began to change—for example, during the Renaissance in the West. In Chinese painting, it was conventional for artists to be identified along with their works as early as Northern Dynasties during the fourth century A.D. Accordingly, I would be leery of assuming that every Bernini deserves the same accolade. He had his Monday mornings in the studio as often as any other artist.

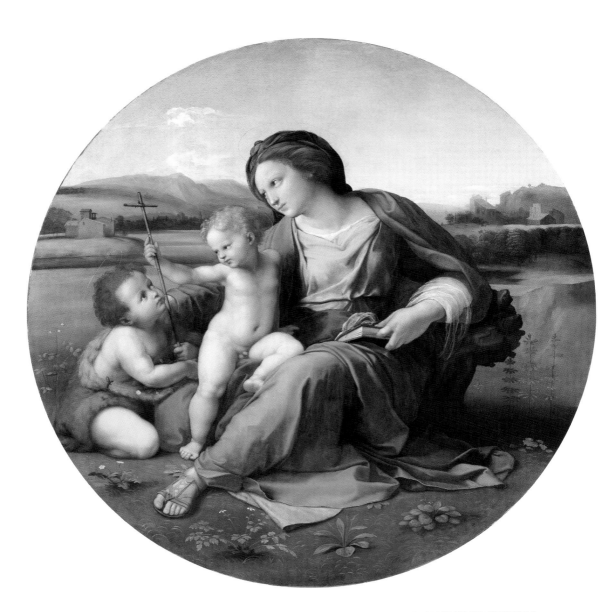

RAPHAEL, *THE ALBA MADONNA*, C. 1510, OIL ON PANEL TRANSFERRED TO CANVAS. OVERALL DIAMETER: 94.5 CM. FRAMED: 139.7 X 135.9 X 14 CM. ANDREW W. MELLON COLLECTION. IMAGE COURTESY OF THE NATIONAL GALLERY OF ART, WASHINGTON.

CHAPTER VII : Compositional Coherence

G reat art is great in part because its formal character is resolved and coherent. Patterns and forms can yield better or lesser results. If an artist relies too heavily on patterns to carry the day, he or she will overlook the opportunity to imprint a personal gesture on a work of art, and the result can be muddy or boring. Let's turn to how artists can take that leap, moving from technical choices, and choices in how subjects are portrayed and themes explored, to how artists manipulate our reaction through the compositional and formal features of artworks.

Such features can result in artworks of high quality that nevertheless may range from harmonious to dissonant—from the balanced composition of a pyramidal Renaissance *Madonna with the Christ Child and St. John the Baptist* by Raphael, to the tangle of limbs in a Mannerist painting by Parmigianino, or the jumbled, precarious fields of monsters and men by Hieronymus Bosch. Dissonance can be a wonderful artistic strategy—as with a great jazz composition marked by riffs that spin around and sheer off but keep our attention. Coherence is derived from the Latin word meaning "to hang together." A great work of art doesn't require simplicity or balance to do so.

THE ROMAN INVENTION OF COMPOSITION

Ancient Roman painting was awash with subjects, ranging from mythology to daily life. The settings created by Roman painters were for the most part intended to simulate exteriors not visible through barely fenestrated walls, or to propel the viewer into an imaginary landscape or mythological scene. Symmetry was all-important to ancient painters, and the first-century A.D. architect and writer Vitruvius set the stage for our understanding of Roman painting through his how-to book, *De Architectura* (still in print, 2,000 years later).

Most Roman painting was of the so-called fresco technique. The word means fresh, and it's how Roman artists would tackle a mural, by applying paint on the wet plaster walls of a room. Each section of wall was called a "giornata"—meaning the amount of space that could be reasonably completed in a day. The next day an adjoining section of wall would be plastered and painted. So-called "secco" painting would follow on the dried surface of the *buonfresco*, and highlights, unusual colors, and other features were applied after the primary background, narrative, and decoration were complete. Some 1,500 years later, Michelangelo relearned the techniques of Roman painting from Vitruvius. But in the heyday of Roman painting, the technique was much more sophisticated than any later employed in the Renaissance. As many as seven layers were methodically applied to a wall, including thin sheets of lead to prevent moisture from creeping out of the brick beneath the plaster surface. Marble powder was mixed into the paint of the top layer, so as to leave a protective sheen. If Leonardo's *Last Supper* had relied on centuries-old techniques instead of new ones, it might have survived in far better condition.

Since ancient artists rarely signed their surviving works—with the notable exceptions of certain potters and painters of ancient Greek vases and a few Roman sculptors—we are rarely sure about how many hands were involved in creating large-scale commissions, such as frescoed walls. There's no doubt that these were the product of workshops, with one or more master artists and multiple craftsmen collaborating. The race to complete a wall's decoration before the plaster hardened demanded a team.

The Met has the largest collection of Pompeian painting outside of Italy, acquired from the excavations of two villas near Pompeii in 1903 and 1921, respectively. I was the first curator at the museum in a generation to focus on that

collection, an exciting and daunting task.

The original ancient homes were discovered beneath private property, and in the days before Mussolini's reign it was possible to acquire ancient finds from beneath a homeowner's land. The villa of Boscoreale had been dug up at the end of the nineteenth century, and the Met purchased numerous sections of frescoed walls from several rooms. Rectangular slices of wall weighing hundreds of pounds were framed in wood and shipped to New York in 1903. They caused a sensation on this side of the Atlantic, and influenced generations of American painters, including Willem DeKooning.

In 1921 a similar acquisition was made of the painted remains of a villa at Boscotrecase. In this instance, the Naples Museum held back some examples of the painted villa walls, where they remain to this day. But the Met acquired sections of two *cubicula*, or bedrooms, known on the excavation plans as rooms numbers 15 and 21. These went unpublished for some time, but were methodically examined and illustrated in a monograph by Peter von Blanckenhagen—he of the Flavian reliefs. The Black Room is basically a combination of still life and a series of imaginary balconies looking out into inky blackness.

I set about studying the frescoes from Boscotrecase in 1986. Those from Boscoreale had been on prominent view for years, most notably the bedroom, then displayed at the southeast end of the Met's Great Hall. But the Boscotrecase frescoes had been in storage for decades, and I was eager to get them freshly researched, published, and on view.

Roman wall painting had been studied extensively in the nineteenth century, and by the last quarter of the century, a persuasive, if slightly fluid, chronology had been devised. There were four styles of painting, starting near the beginning of the first century B.C., and ending with the eruption of Mt. Vesuvius in A.D. 79. The First Style (200-60 B.C.) involved no figuration, but simulation of marble as an inexpensive way of decorating wall surfaces. It was a direct outgrowth of late Greek, Hellenistic painterly traditions. The Second Style (first century B.C.), into which the Boscoreale frescoes fit, hearkened back to the Hellenistic period as well, replicating lost masterpieces of Greek mythology, and experimenting with perspective for the first time in Western art.

The Boscotrecase frescoes dated from the Third Style (20 B.C. – A.D. 20),

developed during the height of refined classicism under the Emperor Augustus and his successors. I was intrigued by what appeared to be a rejection of the perspectival tricks of the Second Style, and an embrace of the painted surface as field for decoration without implied recession or projection.

To my mind, this was the first time in the history of Western art that a group of artists had consciously ceased pushing the envelope of innovation for its own sake. They abruptly stopped pursuing realism and reveled in the patterns and decorative possibilities achievable by mixing up fresco and secco techniques. Instead of creating simulated windows open to distant landscapes, they painted the wall as a flat surface with decal-like patterns and plants and flora. It reminded me of Abstract Expressionism, with the subtleties of Ad Reinhardt and Mark Rothko.

I had a few obstacles in my way. To start with, there were no funds to restore, publish, or display the frescoes. They were in sealed crates in the storerooms, and opening these for inspection was a major undertaking. So I set about studying them as best I could through photographs. Finally I had two crates opened up with two of the key sections of wall from the so-called Black Room. I thrilled to the high sheen of the rich black painted surface, discreetly adorned with thin reed-like stalks of green plants rising two meters, decorated with acanthus patterns and diminutive mythological creatures.

Unlike the bombast of the Second Style, these walls spoke of a self-confident austerity on the part of the artists and their patrons. Remarkably enough, the villa at Boscotrecase was securely identified through inscriptions found there as the property of the innermost circle of royal power—the consul Agrippa (63 B.C. – 12 B.C.). He was not only a great military leader and statesman, but also the closest friend of Rome's first emperor Augustus, who reigned from 27 B.C. to A.D. 14. Agrippa was also the leading patron of public works, personally overseeing the renovation and expansion of Rome's elaborate water system of aqueducts and sewers, along with public baths and public gardens. From inscribed brick stamps in the excavated remains, there was no question that these very rooms were frequented by the Roman oligarchy of the time, in particular the emperor's daughter Julia. Thus the iconography of the fresco cycles had much to tell us about the private taste of the imperial family.

The plant stalks, borders, finials, and ornament were all in keeping with the decorative arts and sculptural commissions of the day, as one would expect. But the

WALL PAINTING ON BLACK GROUND, AEDICULA WITH SMALL LANDSCAPE; TWO PANELS WITH EGYPTIANIZING SCENES AND PAIRS OF SWANS. FROM THE IMPERIAL VILLA AT BOSCOTRECASE. FRESCO, ROMAN, POMPEIAN, EARLY IMPERIAL, AUGUSTAN, LAST DECADE OF THE FIRST CENTURY B.C., 20.192.1-3. DIMENSIONS: 233.1 X 114.3 CM.; 233.1 X 51.1 CM; 233.1 X 49.8 CM. THE METROPOLITAN MUSEUM OF ART, ROGERS FUND 1920. IMAGE © THE METROPOLITAN MUSEUM OF ART.

frescoes' restraint and simplicity seemed at odds with the exuberance of contemporary public monuments such as the Ara Pacis in Rome. The vegetal ornament of the Ara Pacis, however, is also harmonious and stylized to an unnatural degree.

I quickly fell for the paintings and their apparent sophistication in the face of so much Roman art that was overtly imitative of classical and Hellenistic precedents. I was determined to make them better known.

Through friends I got word to Gianni Agnelli, the scion of Fiat, that there was a major campaign underway to restore some of the greatest examples of ancient

Italian art in the world. The *avvocato* (lawyer), as he was nicknamed, called on the museum after a few weeks to see the works in question. I was curious to meet him. Not only was he Italy's wealthiest man, but he was also dubbed by *Esquire* one of the best-dressed men in history. His fashion sense was famously defined by *sprezzatura*— the studied effort to appear uninterested in appearance. True to form, he wore an unbuttoned button-down shirt and untied Timberland boots. He wasn't much of a talker, but nodded a lot. He brought a small entourage that walked two steps behind. I spoke in Italian, to the mild consternation of the Met's fundraising staff with us, who had their sights on more general support from him and didn't want me to limit his interests to the frescoes. After a short tour, he seemed impressed, as well as I could read him, and left asking me to send more information.

Once I had cleared the proper channels within the Met's administration, I sent him what I could assemble by way of plans to restore, display, and publish the frescoes, and then set off for a couple of weeks in Naples to research the villa and its elements in the Naples Museum. Four days after arriving in Naples, I returned to the Santa Lucia, one of the hotels on the Bay of Naples, to find an envelope at the front desk. It was a telex from the Met's then head of development, Emily Rafferty, alerting me that Agnelli had agreed to contribute $300,000—a major victory that assured I could continue the project.

I returned to the Naples Museum's storerooms the next morning with a spring in my step. I knew the staff well, having spent a month there on a cultural exchange program in 1982. Today I was heading up to the storerooms, which were on the top floor of the museum. Shelves of treasures were arranged with the casual ingenuity of earthquake-averse professionals, including padded bumpers and buttressing frames around the fragile finds. I climbed up to the uppermost shelf and continued measuring the exact dimensions of the decorative elements of each Boscotrecase panel. These were framed identically to those in New York, and as the long-neglected cousins left behind in the "Old Country," they had much to say about their origins.

I was almost finished with the largest of the panels when something caught my eye. Towards the center of the very deep, 20-foot long shelf, was a startling sight. It appeared to be a previously un-catalogued section of the very walls in New York. I called a technician over to help move it within reach. Sure enough, it was the base of a painted candelabrum, a dead ringer for the two panels in New York. I asked to

return to the offices to see its records. It was identified only as a Third Style fresco—with no mention of Boscotrecase. If there was one such section, maybe there were more! I returned to the storerooms, and found three more previously unpublished panels. It was a truly gratifying day.

What made the sustained connection for me was the harmonious pattern work in common across the Atlantic. By studying the features of the New York frescoes so methodically, I had become fluent in the decorative language of the original workshop. It made the Naples frescoes instantly recognizable across a crowded shelf. And while there were other black-background frescoes on the same shelf, none betrayed the distinctive features that jumped out at me.

Rather like learning a spoken language, it is possible to become fluent in an artistic style. The subliminal cues that prompt me to see Third Style paintings in comparable examples are indispensable to that fluency. The texture, sheen, and subject are all so familiar from extensive study that what might be nuances become broad accents.

The shapes and patterns of much of the history of art are in effect the syntax of visual languages. Learning to read them with fluency is a function of practice and hard work, rather than some mysterious skill set inaccessible to the general public.

The challenge on my return to New York was to place these heretofore undocumented sections of wall in a new reconstruction of the *cubiculum*. I was reminded of my mother spending hours at the sewing machine, taking patterns and cutting fabric into exact sections to make dresses. This was the opposite challenge. I had the sections but lacked a pattern. So I started where one should with Pompeian frescoes: I followed the shadows.

Remarkably, the rooms in these ancient southern villas usually lacked windows. These houses favored the interior, to conserve heat in the winter and cool and the summer. Peristyles and courtyards provided the experience of nature. The closed-in architecture is what moved painters to simulate windows with landscapes, precisely because bedrooms were for the most part unfenestrated.

The painters' task, then, was to achieve naturalism with only one primary light source: the doorway. While smoky braziers and candelabra could provide some illumination at dusk and nighttime, they were useless for the full appreciation of a painted cycle on a wall. So these daytime settings reflected the realities of their

context, and the proper left wall of a room from the entrance always had simulated shadows moving left to right; for the proper right wall it was the reverse.

By studying the direction of the shadows on these new panels, I could identify the proper wall for each. Paintings on the narrow wall facing the door naturally had either no shadows or bi-directional ones. Once I had established the relative placement, I was able to get to work on the exact placement. In the case of the New York frescoes, some existing elements were exactly contiguous with others, like a part of a room-sized jigsaw puzzle.

The patterns and shapes were isolated features of a decorative program, but they were indispensable to understanding the ensemble. And the small distinctions among the sections of wall, the so-called *giornate*, can be seen to this day at the Metropolitan Museum.

To train your eye, plan on spending a protracted time in Cubiculum 15, if you have the chance. Let your eye linger over each tendril, each shoot, to see if you can discern subtle distinctions among the plant forms, as well as the architectural elements. You will be surprised by how much variety can be seen in what at first glance appears to be a highly symmetrical, uniform decorative program. You just have to learn to see it.

THE IMPORTANCE OF FILLING IN WHAT IS LOST

That's the secret to finding quality in artworks that are intentionally harmonious. As Morelli posited, the miniscule features are where to look for variation in the sureness and finesse of a brushstroke. When everything purports to be the same, but is executed by multiple hands—as with large-scale buildings that predate the Industrial Era—you can start to see variations in quality.

Portrait heads are excellent for studying shared attributes. The likeness of a person is something we can read almost subliminally, which is why we can recognize faces more easily than recall names. This goes back to a hardwired survival reflex to separate friend from foe. A happy twist of fate meant that I was able to cohabitate with a Roman portrait, very much a friend, for some years.

Opening the mail one day just over a decade ago, I came across a letter from a law firm in Connecticut. I didn't recognize the firm, which was not a promising sign. As a museum director I had received letters before from those seeking some

kind of retribution, and was able to hand them off to the museum's attorneys. But this one came to my home. As I opened the letter, I sought to conjure up which patron I might have crossed in some now-forgotten episode that is part of the terrain in the museum world. But no. The letter bore news of a very different kind. Inside was an official record informing me that an elderly acquaintance of mine who had passed away some weeks earlier had left something for me in her will. Her name was Mrs. Edward S. ("Bambi") Litchfield, and I had met her while lecturing on a cruise for the Met. Bambi Litchfield was an original. A feisty, incorruptible, strong-willed woman who took kindly to a young curator, and who helped me buy a rare example of Roman armor for the Met. And now, due to her generosity, I would be lucky enough to live with a masterpiece.

The life-size marble portrait head of a Roman woman resided in my study. Day after day I looked at her with pleasure. At times Jacqueline joked about being jealous. I had misgivings about the portrait's provenance, or history of ownership, which is unknown before the 1980s. If she were any less beautiful or haunting, I might not have held on to her for so long. But she is both.

The head was made to be set into a draped statue or bust. She was carved in the 220s A.D., when the Roman Empire was heading into a maelstrom of conflict, with assaults on every border, when art might have been the last thing on anyone's mind. But it was, in portraiture, an amazingly creative time. Human suffering and uncertainty were everywhere, and in the portraits of men, the creased brow and wrinkles are ciphers for that societal upheaval.

Roman women never betray any such torment. Their faces are oases of calm and beauty, and works like this head must have served as an analgesic for the constant state of vigilance in those violent times. How nice to have a Madonna by your side when you're at the Roman equivalent of *DefCon 4*.

As soon as I saw the head I recognized her as the Syrian-born empress Julia Mammaea. Years of studying Roman portraits had paid off. She was the niece of Julia Domna, who was married to the emperor Septimius Severus. Julia Mammaea was also the mother of a future Roman emperor, Severus Alexander. He was to be the last monarch of the Severan Dynasty in Rome, marking the poignant end of Rome's golden age of art and letters, and the beginning of incessant hostilities through the end of the Empire.

MARBLE PORTRAIT HEAD OF JULIA MAMMAEA, ROMAN IMPERIAL, C. 222-235 A.D. SOTHEBY'S SALE NO8137, LOT 61 (7 DECEMBER 2005).
PHOTO COURTESY OF SOTHEBY'S, INC. © 2005.

Severus would rule for 13 years, always under the watchful eye of the woman whose portrait sat benevolently on a stand in my home. The author Eusebius describes her as a woman of exceptional piety. She was, in effect, regent, or co-ruler, of the greatest civilization on earth.

In 235 Julia Mammaea, along with the emperor, was assassinated in Mainz, Germany by Maximinus Thrax. She suffered a *damnatio memoriae*, meaning that any memory of her was to be expunged from history. This explains two things: why this head is broken along the proper right side from a single blow, and why so few portraits of her survive.

The head is carved in a fine-grained white marble from the Carrara quarries, signaling the portrait's origins in the city of Rome. She is turning to the right in an active pose that was conventional for the time. Her eyes are heavily lidded, which was also typical, and her small mouth has a slight pout. The hair is wavy, parted in the center, pulled back behind the ears, and wound up in back in a braided bun. She radiates royalty. She apparently wanted her portrait to mimic those of the elegant women of the preceding Antonine Dynasty, whose monarchs included the philosopher-king Marcus Aurelius. Not bad for a Syrian girl who grew up to rule the world.

As with any portrait, the eyes are the key. They are exquisitely wrought—even though only the left eye survives intact. There is a delicately incised line for the iris, and what German scholars call a *bohnenformig*, or bean-formed pupil, depicted by means of two adjacent drill holes and a sharp ridge between them. From a distance these lines, forms and holes combine to look very much like an eye.

Roman portraits survive at all levels of quality: from provincial ones made in Asia Minor and North Africa to those from the top workshops in Rome. The delicate features of the cheeks, lightly incised eyebrows, and soft contours of the neck leave little doubt in my mind that this hunk of stone was converted into an official state portrait by the hands of a master sculptor working for the imperial court.

The key point to be made about the head is this: she is missing almost a third of her face, broken off at some point in the distant past. But this loss was not intentional, and cannot be used to judge the quality of the artwork. The art market would see the loss as a failing—it depresses the financial worth. But as a judge of quality, you must make allowances for the unintentional fact of the missing portion of the portrait. Her countenance must be read not as it is seen today, but as it was seen in

a court in second-century Rome. Intact, painted, and resplendent. Our search for quality in art cannot be led astray by virtue of an accidental damage or loss that compromises the appearance of a work today. That has no bearing on the quality of the work.

After leaving the Whitney, and needing to care for my family, I sold the portrait of Julia Mammaea at Sotheby's. Today she is on prominent display at The Metropolitan Museum of Art, on loan from a private collection. Visiting her at the Met always gives us a twinge, since she was much at home with us. But she is today among others of her time and place, and available to everyone.

Although I don't own it any longer, this portrait head is one object that gives me undiluted pleasure. There are countless works in museums around the world that have the same effect. Owning such an artwork is a great privilege and a great responsibility. But all of us own the works of art in public institutions.

COMPOSITIONAL HARMONY: THE RENAISSANCE HANDOFF

The quest for artistic harmony is part and parcel of why artists of the Italian Renaissance turned back to Greece and Rome for inspiration. When I am in Washington, D.C., I almost invariably make a pilgrimage to the National Gallery and stand in front of one work of art: Raphael's *Alba Madonna* (page 150). Since I was a graduate student of Sydney Freedberg at Harvard—then perhaps the world's pre-eminent scholar of Renaissance Italian art—I have treasured this masterwork.

It is believed by most to be Raphael's finest painting in the United States. Painted around 1510, it is a flawless example of High Renaissance harmony and beauty. Typical of a *tondo*, or round painting, its composition includes three crouching and seated figures that also form a circle. Swathed in a classical red *chiton* and blue mantle, the Virgin Mary looks left with the infant Christ in her lap; he holds a small red cross. A cherubic St. John the Baptist kneels to the left and looks up in rapture; all three of them appear to fixate on the cross, as if to contemplate fatalistically the future of this infant. The top third of the round painting shows the blue sky of Latium, Rome's province, the middle third shows its hills and a lake, and the bottom third is the manicured ground on which this threesome sits peacefully.

What makes this version of the Madonna and Child so remarkable? There are thousands of paintings of this subject, from the late Middle Ages to the nineteenth

century. They range from formulaic to riveting, as in this case. The answer lies in the harmony of the composition, the sure and invisible handling of the brush, the palpable humanity of the figures, the subtlety and harmony of the colors, and the delicate but inviting pastoral landscape. Most versions of the Madonna and Child might excel in one or more of these features—but this one excels in all of them. To be in its presence is to sample the devotional joys of the faithful—and I am not a religious person. It is to imagine life during the apogee of the Renaissance, a time when the mixing of humanistic values and a yearning for a benevolent higher authority sparked countless innovations in the arts, humanities, and natural sciences.

My pilgrimage to the National Gallery one warm day in November 2003 was disappointing—the *Alba Madonna* was not in her customary place in the galleries. The great thing about traveling exhibitions is the chance to see works that are otherwise in the permanent collections of far-flung places. The downside of traveling exhibitions is being deprived of your favorite works when you visit those permanent collections.

I was in Washington for a Board meeting of the Foundation of the American Institute for Conservation, and the next day we finished a productive discussion, followed by a tour of the Paintings Conservation Laboratory. Imagine the chills I felt when I spied, at the end of a long succession of easels, tables, and hi-tech equipment, the very painting missing from upstairs. Unframed, propped up on a freestanding easel, without artificial lighting, it was in the soft raking light of a nearby window. It was somehow vulnerable in this clinical setting, far from the baronial gallery it normally commanded, now below eye-level and at the right height for a seated conservator. His name is David Bull, the retired head of conservation at the Gallery, who came back every week or two, for one day, to treat the preeminent masterpieces of the museum.

Only a few weeks earlier, I learned, an x-ray had revealed a pair of towers once in the background that Raphael chose to over-paint with clouds above a mountain. For the first time I could see that the *tondo*—or round painting—was actually a panel painting made from three pieces of wood, of irregular shape. Just to the proper left of St. John the Baptist was the vertical seam of one of the panels, and it made the in-painting more complicated for Bull, who was struggling with the ticklish challenges Raphael had left for him.

The conservator on our tour turned the easel around, and we saw the back of the picture that explained the rectangular green canvas onto which the panels had been mounted. That canvas was normally covered by an elaborate picture frame. On the back of the picture, in Russian, with the date 1837, someone wrote of the transfer of panel to canvas. The painting was originally property of the Hermitage Museum in St. Petersburg. After the Russian Revolution, the Bolsheviks began selling masterworks to help pay for their new social experiment, and Paul Mellon acquired this work for the National Gallery a century after the transfer, in 1937.

How does all of this help us evaluate the picture? First of all, by seeing the work of art in a neutral setting, I was astonished by how the blues and reds jumped out even without special lighting. The three-dimensional composition was somehow subtler than it was when lit by floods in the galleries. And the choices Raphael made—from assembling three disparate sections of wood, to painting out the architectural features at the top left, helped me appreciate how much improvisation there was behind this seemingly perfect work. The transfer, three centuries after it was painted, onto canvas, had done nothing perceptible to flatten the surface. And all of this new information only gave me more respect and appreciation for what Raphael had accomplished in the first place. His quest for harmony was undeterred by the technical challenges of his medium.

I will never look at the picture without noting the over-painted section or the faint seams between the panels. But I will also drink in this archetypal High Renaissance composition with increased insight into and empathy for Raphael's choices.

FINDING QUALITY IN COMPOSITIONAL DISSONANCE

It's a much harder assignment to sort out the quality of art that eschews harmony for energy—whether filled with tension or dissonance. Returning to the theme of Dutch doors and my Dutch grade school, my most satisfying professional collaboration was with Pritkzer Prize-winning Dutch architect Rem Koolhaas.

When the Whitney's board of trustees decided, in 1999, that it was time to revisit options to expand, the most exciting decision was where to turn for a new architectural scheme. Michael Graves had tried to rethink the Whitney's familiar 1966 home by Marcel Breuer using the language of architectural history. In time, the

schemes he proposed were put aside, in part because of divisions on the board about whether the plan was too ambitious, and out of reluctance to press ahead in the face of criticism from neighbors as well as members of the architectural establishment.

So it was with much caution that the board consented to a new process to identify an architect. I was leery of any decision that might default to a safe choice. The Whitney, I believed then and now, was the one major museum in Manhattan that existed not to ratify the prevailing tastes of the city's conservative cultural leadership, but instead was forged out of a posture of advocacy. Gertrude Vanderbilt Whitney, the museum's founder, was the rebellious daughter of the world's richest man, Cornelius Vanderbilt. She saw the museum as a home for artists who had yet to be accepted by the art establishment. Among these were artists who came to be called, disparagingly, the Ashcan School. Among these were William Glackens (1870-1938), Robert Henri, (1865-1929), George Luks (1867-1933), Everett Shinn (1876-1953), and John French Sloan (1871-1951). They were, in the context of their time, not uniformly accepted as members of the art establishment, but enjoyed a mildly bohemian reputation.

I proposed that rather than jump into naming architects, we should agree on attributes of architects. My reasoning was that the misgivings of past efforts to expand had hinged largely on personal likes and dislikes, and that the tighter we could hold onto something as objective as features, the less likely we would either default to a name game or popularity contest. You've gathered by now that I think arriving at attributes or features before rushing to judgment is typically a better point of departure.

The board appointed a selection committee, chaired by the notable art patron Melva Bucksbaum, and my suggestion was honored. I began by proposing that we choose from among a small field of proven talents, rather than having an open competition. I suggested that the field be limited to architects fitting the following three criteria: 1) that they had never before built a major art museum in the U.S., 2) that their prior work suggested an ability to plan in sympathy with Breuer's pre-existing conditions, and 3) that their work would bring distinction to New York's then-tepid commitment to visionary architecture.

Renzo Piano's name predictably came up early on, but the committee held to my first criterion—I didn't want our effort to compete with the Menil Collection

in Houston, his only U.S. museum project to date, and I was insistent that Breuer's pioneering architecture demanded a pioneering response. The Museum of Modern Art's choice of modernist Yoshio Taniguchi was on everyone's mind, and I was not keen on selecting Piano, a highly accomplished architect but one operating in the same canon.

With the committee approving the three criteria, I could compile a list of architects spanning a spectrum from the adventurous to the proven: Maya Lin, Rem Koolhaas, Peter Eisenman, Steven Holl, Jean Nouvel, Machado & Silvetti, Richard Gluckman, and Lord Norman Foster.

The Committee voted to exclude Maya Lin and Machado & Silvetti, and we invited the rest to compete. Foster declined to compete, saying he would consider doing the addition but would not enter a field of competitors. I called on him during a visit to London and he didn't waver.

After more weeks of flying to Europe and around the U.S. to visit the architects and their buildings, Koolhaas was the Committee's unanimous choice. On October 11, 2001, a month after the Twin Towers fell, Koolhaas presented his ideas to the full board. The third floor of the Whitney had been emptied out between shows, and was turned over to a dramatic installation of his design concepts. The board voted unanimously and enthusiastically to appoint him as our architect.

In short order Koolhaas and I met with Mayor Bloomberg and his chairs of Landmarks, the Board of Standards and Appeals, and City Planning. All indicated informally that they would support his brilliant if unconventional solution.

During the course of 2002, the board's ardor for his plan cooled. The aftermath of 9/11 had hit our finances and those of our donors, and the challenge of fundraising began to seem insurmountable. My commitment to the design led to a familiar *denouement* for many directors who attach themselves to expansions, whether built or unbuilt: the clock on my tenure was ticking down. I announced my intention to resign in May 2003, and stepped down at the end of September, once the Board had chosen Adam Weinberg as the next director.

What was it about Koolhaas's design, which he nicknamed NEWhitney, that elicited so much excitement when first proposed and approved, and does so to this day? It was, in my view, his remarkably talented harnessing of dissonance. Nicolai Ourossoff, architectural critic of *The New York Times*, wrote in 2006 that "Mr.

NEWHITNEY BY REM KOOLHAAS, 2001. MODEL FOR THE EXPANSION OF THE WHITNEY MUSEUM OF AMERICAN ART. © OMA.

Koolhaas's addition would have been one of the boldest pieces of architecture to emerge in years, while offering a powerful lesson in how to deal responsibly with historical context."

The boldness of the design was rooted in Koolhaas's intoxicating mix of the practical and visionary. By stacking cantilevered floors above the Breuer building without eclipsing it, he sought to remain in compliance with zoning regulations

about setbacks, while offering a three-part program that would retain the historical character of adjoining brownstones, let the Breuer building remain a freestanding Brutalist monument for art of the 1960s and 1970s, and add a third part of contemporary engineering for the art of our time.

His design haunts me to this day. It crouches behind the Breuer building and offers a new irregular promontory in a city defined by cubes, rectangles, and blocks. It would have redefined the cityscape of New York forever, and remains, in my admittedly biased view, a missed opportunity. The adjudication of Koolhaas's vision has repeatedly hinged on his independent, unexpected choices, all of which are indexed to the specific features of a site and its program—which is why there isn't a "Koolhaas look" to his buildings. The common language of the Beijing CCTV headquarters (2004-9) and Seattle Public Library (2004) has to do with their skin and their muscular geometry. When the same *Times* critic said of the CCTV building that it "may be the greatest work of architecture built in this century," I couldn't help but wonder how, in the arc of time, his NEWhitney would have been seen today.

An artist's or architect's predilection for the untidy, or the jaunty, or the raucous in no way blocks the work from being evaluated qualitatively. We simply have to adapt how we evaluate such work. If the history of art includes works on an energy spectrum from harmonious to dissonant—from results that feel at rest to results that are kinetic—we have to make room for these stylistic and compositional choices, and judge accordingly. Imposing our own preferences prematurely is what leads to compromised judgments. Once we have acquainted ourselves with the visual language used by an artist, architect, or other creative person, we can be more receptive to what they have to offer.

Sometimes it is simply a matter of learning to see.

DINING ROOM FROM LANSDOWNE HOUSE, 1766-1769, ENGLISH. DESIGNER: ROBERT ADAM (1728-1792). PLASTER CEILING BY JOSEPH ROSE (1746-1799). WOODWORK CARVED BY JOHN GILBERT. MARBLE CHIMNEY BY JOHN DEVALL & CO., LONDON. WOOD, PLASTER, STONE. OVERALL ROOM: 1437 X 746.8 X 546.1 CM. OVERALL MANTELPIECE: 190.5 X 221.9 CM. THE METROPOLITAN MUSEUM OF ART, ROGERS FUND, 1931 (32.12). IMAGE © THE METROPOLITAN MUSEUM OF ART.

CHAPTER VIII : Memorable for the Viewer

E ach day's headlines trumpet another human tragedy, the cold martial exercise of power, and no shortage of contentious debates about how to solve the world's enduring problems. The pursuit of art experiences seems at first frivolous in the face of all of these traumatic accounts of natural and man-made disasters.

Then again, part of what makes us human is that we feel emotions. Art can prompt a *visceral* reaction—an artwork gets us in the gut. (*Viscera* is Latin for guts.) And if it does that, you will remember it.

There is scientific evidence that some artworks produce a physiological response. A study published in 2011 elucidates the findings. Outfitted with electronic gloves, hundreds of visitors had both measurable cardiac and "skin conductance" responses in sync with particular works of art based on what they described as "Aesthetic Quality," "Surprise/Humor," "Dominance," and "Curatorial Quality."

Artworks that get you in the gut or tickle your skin, and more important, make a sustained connection, are often the result of the artist's passion, compulsion, or conviction. And while the degree of the artist's obsession is not a uniform test of artistic quality, it may inform whether an artwork will stand the test of time. The history of the art world is a history of flashes in the pan, of *ingénues* who subsequently vanished from the awareness of both the art establishment and the world at large. Artistic quality should be something that survives beyond the life of an artist, and well beyond it if we are exploring the very summit of creative contributions.

ARTISTIC LONGEVITY

More attention today is focused on sports than almost any other feature of the human spectacle. And yet the number of basketballs that make it through a hoop over the course of a century will not prove significant in the annals of history. The paradox of peoples' lifetime obsession with sport despite the evanescent fame of all but a few athletes is palpable. Sport has been used by rulers from the remote past to distract the populace from their daily woes. That's why the first-century A.D. Roman writer Juvenal used the expression *panem et circenses* (bread and circuses) in his satirical poems to characterize politicians' cynical use of free food and physical entertainment to create complacency and earn the loyalty of the citizenry.

The emperor Titus built the 50,000-seat *Amphiteatrum Flavium*, which we today call the Colosseum, because he sought to distract the masses from material privations. The nickname stemmed, ironically enough, from a neighboring work of art. Towering next to the amphitheater was an enormous—indeed, colossal—statue of the Emperor Nero, moved there half a century after his death. It had undergone head transplants after that disgraced ruler's image was banished by the Roman Senate upon his death. Among these was the head of Helios, or Apollo, the Sun God, which bore a solar crown.

The statue eventually became known as the Colossus. The English monk Saint Bede the Venerable (c. 672–735) wrote an epigram that highlighted the value of the artwork's longevity: *Quandiu stabit coliseus, stabit et Roma; quando cadit coliseus, cadet et Roma; quando cadet Roma, cadet et mundus.* ("So long as Colossus stands, Rome will stand as well; when the Colossus falls, Rome will fall; when Rome falls, so falls the world"). At some point during the first millennium, the Colossus did fall, either from an earthquake or by those seeking to put its bronze to other uses. And of course, Rome would again fall to invaders, as Bede had prophesied.

The longevity of an artwork is only one test of its quality. After all, mediocre works survive just as long as great ones. There are thousands of second-rate Roman marble copies, medieval bronzes, baroque landscapes, nineteenth-century genre scenes, twentieth-century knockoffs of modern masters, and derivative contemporary artworks that will be with us for millennia to come. But they usually go unheralded with the passage of time. Far fewer are those we take pains to locate, plan to visit, linger before, and remember. And these are the works we seek to identify

with the help of visual literacy and a quality instinct.

The quest for artistic longevity is universal. When NASA conceded it would be reasonable to alert aliens to our presence on earth, the agency avoided turning to experts in visual language. Instead they used a 6" x 9" gold anodized plaque, titled "A Message from Earth." It was bolted to the Pioneer 10 and 11 spacecrafts in preparation for their 1972 and 1973 launches. NASA was persuaded to affix this plaque by astronomy professor Frank Drake and by Carl Sagan, whose wife Linda Salzman Sagan drew the images that were inscribed on the plaque. The outline forms of a nude man and a nude woman were rendered with the help of a computer. One can imagine the inhabitants of planets far away tut-tutting that the Earthlings' science may be equal to intergalactic travel, but they sure could learn a thing or two about art.

TOP: CARL SAGAN (1934-1996)
BOTTOM: THE "MESSAGE FROM EARTH" PLAQUE AFFIXED TO NASA'S PIONEER 10 SPACECRAFT.

Drake, Sagan, and Bernard Oliver also saw to it that a gold-plated phonograph record including, among other samples, the world's best music, humpback whale songs, an elephant's trumpet, and greetings in 54 languages was subsequently sent along with the Voyager spacecraft in 1977. Pioneer 10 and the Voyager spacecraft are now orbiting billions of miles from earth, ready to be intercepted by curious aliens. Perhaps they will have better luck playing a phonograph record than we Earthlings today.

Because while specific technologies change every day, and while languages die out every year, the one thing that has the potential to last is the physical evidence of our creativity.

If there is something enduring in the human condition, it is not personal

suffering, which eventually fades with the loving memories of descendants. It is not mirth and joy, which can be stilled by the wash of time. It is not wealth, which is ultimately recycled into another's good fortune or squandered by its possessor. Power goes to the grave with the powerful.

It is science and art that most notably separate human endeavors from other life forms. After all, beavers are industrious, squirrels accumulate abundance, dogs enjoy sports. But only humans go to the moon or make enduring monuments.

People often speak of museums today as the cathedrals of our time. But what religion are the hundreds of millions of visitors to art museums each year seeking? It must be a search for that which elevates us above the daily challenges we face—or, for that matter, which elevates us above the accumulation of wealth and the quest for comfort. But in art we don't find the certainties that attend religion. Perhaps in part it is today's impatience with the dogma of televangelists, the prevarications of politicians, the corruption or vanities of sports and celebrity culture that drive millions of people into America's art galleries.

SHARPENING YOUR SENSE MEMORY

There is one place I know well that is the opposite of fleeting. Rome's charms have been evident to millions for over two millennia. So it will come as no surprise that I am yet another of countless supplicants. But it is a useful exercise to recount my infatuation with Rome. I have no doubt that the city's hold on me has been fundamental in my efforts to hone an instinct for quality.

Which sense to begin with? They are all affected in equal degrees of sensuality, illogic, and reward.

The sense of taste when it comes to Italian cooking is easy enough to invoke, you might say. But in fact, Roman cuisine is sneered at in Italy, from north to south, from the Veneto to Sicily. It is, Italian gastronomes will attest, a peasant cuisine, evolved without credence paid to the standards of the fabled culinary academies of Tuscany and Umbria.

Which is why the experience of a good meal in Rome must be about far more than the subtlety of a chef's ministrations; typically there are few. Instead, the experience is memorable through a combination of attitude, ambience, and yes, flavors.

As a wet-behind-the ears graduate student in 1981, I was spirited out to dinner by an avuncular friend, the Marchese Benedetto di San Giuliano, who chose a *trattoria* in Trastevere. When I looked around for a menu, he waved it away and said that we were having "*assaggi*," or tastings. I cocked my head uncomprehendingly, but it was not long before small plate after plate of every pasta dish on the menu was at intervals whisked out from the kitchen, almost like the orgy of *dim sum* at a Sunday brunch in Chinatown. I couldn't believe my good fortune. Instead of having to commit to one dish, we were sampling the "*resti*" left behind in the saucepans after serving other patrons.

Soon we were comparing the virtues of one fettuccine Alfredo against another serving five minutes later. Benedetto explained how the cook was gaming the system, keeping the sauce at the ready and losing thereby the preferred *croccante* (crackly) state of the bits of ham just five minutes later. The revelation was that as with art, it is difficult to contrast the results of any human endeavor in the absence of a close comparison with another such endeavor.

That night I also learned, with some embarrassment, that the American declaration "I'm full" (or even more graphically, "I'm stuffed") ranks in offensiveness just above "your mother is a harlot." For Italians, it is simply too much information. Saying no thank you will suffice. The lesson is that our native predilection to share everything that crosses our consciousness, like the protagonists in a reality show, is not only vulgar, but robs the human carnival of grace and mystery. The Romans manage to balance a bawdy sense of humor with myriad types of decorum. Unlike their northern brethren, they lack for pretension. And unlike their southern compatriots, they are resolutely attuned to what is stylish, sexy, and understated.

Every sense in Rome is rewarded, including the sense of smell—the smell of coffee, myrtle, pine trees, and fountains. The smells in other modern cities are for some reason less rewarding, whether because we are always rushing and don't "stop and smell the roses," or because a city as dusty as Rome is constantly sweeping its streets with old-fashioned stick brooms and water, instead of by means of massive, churning machines with brushes and belching fumes.

The sense of touch? Try a slab of cool travertine on for size, smooth but pitted. Or the worn wooden pews and *bigio morato* columns in churches. The wicker seats at a *caffe*, or the rough crust of a *rosetta* in the morning. While every nation has its

treasures, Italy is superabundant with what UNESCO estimates is half the Western art in the world—some of which you should feel free to touch.

The sounds of Rome are cyclical. Morning steam for cappuccino in bars, with the repetitive clinking of saucers on the counter as one client after another downs the heart-starting elixir. Motorbikes peeling off on cobbled streets, protestations at cars blocking entrances, church bells beckoning the tiny minority of churchgoers, and the loud jubilation of schoolchildren outside their *scuola secondaria*.

Things slow down at lunchtime, and the afternoon is respectfully quiet for the workday interval. Then the early evening is raucous, with clumps of young people converging on *piazze*, more church bells, the rolling down of storefront shutters, farewell shouts, and street musicians.

Last and best of all is the sense of sight. Rome pulls off something impossible: it balances weather-beaten ruination of exterior settings with effortless interior elegance. The homes of our Roman friends are an encyclopedia of exquisite décor—offered up with no trace of a desire to impress, just to live well. Little is more excruciating than American homes in which the clearly stated goal is to make a point about wealth, prestige, or presumed rank. True quality is most easily appreciated when the setting of an expression of creative talent is authentic and appreciated "*inse*"—for itself, not as a trophy.

My awakening of a quality instinct was born somewhere, but I lay at the entrance to Rome its nurture and development. But any city can, with sufficient drive, be mined for ways of rewarding all five senses. As an exercise, you should of course start with your hometown, and make a note of your favorite, most stimulating sensuous gifts around you. It will help you develop a more discerning palate and radar, and can become a habitual reflex when discovering a new town or place. Empathize and project yourself into the mindset of the residents of any new place, and tune in to how they go about ordering life. Looking for that spark of a connection between the maker of an experience and you is part of the search for a richer life.

Americans are the least habituated to this kind of analysis. We may say "when in Rome," but often as not it gives way to "Why don't they serve more ice?" Breaking free of the inherited quest for comfort above all else is the best way to open our senses to new discoveries.

MAKING YOUR OWN TIME MACHINE

In September 1983 I was in Rome for a routine visit to some of the storerooms of that city's many museums. After arriving, I rang up Gianluigi Colalucci, head of the paintings conservation department at the Vatican Museums. Over the next two years, I would climb onto the mechanized scaffolding set up in the Sistine Chapel a total of four times to arrive within a few inches of the ceiling that Michelangelo called home for three years, from 1509-1512. Colalucci began the restoration of the chapel in 1979, and it took some 20 years until it was declared complete in 1999.

A visit on the scaffolding was a privilege extended to scholars, including those who were skeptical about this radical transformation of the world's most famous ceiling. In my case, I was already persuaded about the value of the work underway, having seen Colalucci at work on the Vatican's treasures in the exhibition he had shaped for the Metropolitan. But to come face to face with Michelangelo's magnificent achievement was an unforgettable thrill. After all, for most of us, the magic of the frescoed images is taken in from dozens of feet below, but this viewing promised a sensation comparable to scaling Mt. Rushmore or clambering in the caves at Lascaux.

Using your imagination to recapture something of that original setting is a crucial part of connoisseurship. It's useful to practice rewinding your mind's eye to the time and place of a work's creation. Michelangelo's complicated relationship to his patron, Pope Julius II, is the stuff of legend. Their scrapping over billings and payments is well documented, as was the artist's frustration with the Pontiff's supervision of the project. It began with the discovery of a crack along the ceiling in May 1504, engendered by the earlier construction of the adjoining Borgia Tower and the new St. Peter's. Julius asked the architect Donato Bramante to do what repairs he could to stabilize the ceiling, but the damage to the existing painting persuaded the Pope to undertake a fresh commission. On May 5, 1508, Michelangelo signed a contract to undertake the depiction of the twelve apostles in the pendentives, along with some ornamental motifs. Michelangelo soon complained that this was too restrictive a commission, and he succeeded in assuming direction of the painterly program. His work came to an end before October 31, 1512, as the Pope celebrated Mass in the Sistine Chapel on November 1, officially reopening it.

Michelangelo was in a sustained conflict with his patron because the pace of his work was almost as deliberate as that of the restorer Colalucci, who came in

MICHELANGELO BUONARROTI (1475-1564), INTERIOR OF THE SISTINE CHAPEL, GENERAL VIEW, PRE-RESTORATION. VATICAN CITY. PHOTO: SCALA / ART RESOURCE NY.

his wake a half-millennium later. What drove Michelangelo to innovate by taking chances with perspective? In part it was his devotion to the Church. But it was no less so the thrill of doing what no artist had done before in such a massive decorative program in the heart of Catholicism. The quest for something seemingly impossible—filling a ceiling of the size of the Capella Sistina—must have both frustrated and energized Michelangelo.

CONVICTION AND COMPULSION CAN MAKE FOR MEMORABLE ART

Artists who are primarily cerebral—who lack evident passion—can nonetheless be rich in conviction or compulsion. Sol LeWitt (1928-2007) was an artist whose compulsion was notorious. His wall drawings, which could rival the Sistine ceiling in scale, are methodically mapped shapes of varying colors, which the artist plotted with paper as a topographer might map a district. The geometries were painstakingly formed, along with the adjacencies of color and pattern, in a way that is uniquely his. LeWitt had a finely honed talent to move colors and shapes around in a pre-digital technique that defies the imagination.

Conviction is another driving force for many artists. Politically motivated artists often make works that are, on the face of it, bold but bald, such as Swiss artist Thomas Hirshhorn's riots of assemblage in large-scale installations. His opposition to tyranny, war, and exploitation is mercilessly laid out in dizzyingly dense room-sized displays made from humble materials. His art is born of the progressive politics of the 1960s, in the hands of a younger activist. But other artists who stray into his territory rarely achieve the same intensity and vivid impact as Hirshhorn.

The highest quality works are often those that are forged in the feverish heat of creativity, rather than the cool remove of the observer. Exceptions there are, and we make room for these when they exhibit technical mastery or originality. Albrecht Dürer (1471-1528) shows little in the way of what we today would call passion. But his attachment to refined illustration and sympathetic portrayal of the human form are in the spirit of his time. His work is filled with conviction and compulsion.

YOUR HEAD IN THE QUEST FOR CONTEXT

The accidents of history often complicate our ability to "rewind" and imagine the original context of works of art. In the winter of 1983 I was browsing through the card catalogue of the Met's collections of classical sculpture when something jumped out at me. A Roman portrait head of a woman from the Flavian period was noted as on view in the galleries of the Department of European Sculpture and Decorative Arts (ESDA). It was known as the Lansdowne Tyche, so named because the renowned English country manor of the Lansdowne family had been her home in the eighteenth century when the head was mounted on a headless marble statue of the goddess of fortune, or Tyche. She stood in a niche in the dining room, along with eight other faithful copies of statues of Greek and Roman divinities.

I found an instant connection with this carved block of stone, marooned as it was on top of a statue to which it had absolutely no connection. I was drawn to it out of an impulse to free it from an artificial, loveless marriage with a statue lacking in antiquity or authority. But it was also among the Met's few portraits from that time, and it had a story to tell that had been effectively suppressed.

I made my way to the period rooms of ESDA, and I found her standing as one might imagine in the reconstructed room of a remarkable, rococo English home completed between 1765 and 1768. Designed by Robert Adam, the interior was a treasure trove of works obtained on the Grand Tour, typical of English nobility at the time. With a 17-feet ceiling, the room allowed for dramatic vistas and life-size statuary looking down on the fortunate guests at the table. The Met acquired the dining room lock, stock, and barrel in 1931. It was set up as it is seen today, with all of its rich furnishings and decorations displayed behind a Plexiglas divider.

The Lansdowne Tyche had stood for decades in its sumptuous museum setting. It struck me that the average visitor—even the accomplished connoisseur of European decorative arts—couldn't see all the way across the barrier to notice whether the head on the statue was of marble or a plaster cast.

So I began the elaborate process of removing the statue from the period room in May, 1984. This was followed by having the marble head removed from the statue, a cast made of the head, the cast head attached to the statue, the statue reinstalled in the dining room, and a base made for the original Roman head, now freed of its rococo context and ready to be installed among her fellow Romans.

DINING ROOM FROM LANSDOWNE HOUSE, 1766-1769, ENGLISH. DESIGNER: ROBERT ADAM (1728-1792). PLASTER CEILING BY JOSEPH ROSE (1746-1799). WOODWORK CARVED BY JOHN GILBERT. MARBLE CHIMNEY BY JOHN DEVALL & CO., LONDON. WOOD, PLASTER, STONE. OVERALL ROOM: 1437 X 746.8 X 546.1 CM. OVERALL MANTELPIECE: 190.5 X 221.9 CM. THE METROPOLITAN MUSEUM OF ART, ROGERS FUND, 1931 (32.12). IMAGE © THE METROPOLITAN MUSEUM OF ART.

Today I think back to that chapter of cutting and pasting and sometimes wonder if I did the right thing. I was so eager to reclaim an antiquity from the clutches of another department that in the process I deprived the Lansdowne Dining Room of an increment of authenticity, and changed the aura of a corner of the Met forever.

Admittedly this is a nuanced matter, a matter of degree. After all, there was no way to tell from a distance that the head was other than of plaster, I remind myself. But of course one can make the case that all of art history is only a matter of degrees. The authenticity of a setting can be chipped away by an eager young curator or blasted away by the Taliban, as happened in March, 2001 to the rock-cut statues of Buddha in the central Bamiyan province of Afghanistan.

On the other hand, a reconstructed dining room is hardly the same as the real thing. Period rooms are only a partial context, since curators are usually obliged to improvise. The light in the room bears no relation to that of the original setting. And the connection to the original sculpture's intention had been severed, literally.

Reclaiming the original feeling of that dining room in London requires an act of the imagination. We would begin by imagining ourselves helped out of a horse drawn carriage by a footman at Landsowne House's entrance in Berkeley Square, on the north side of Picadilly. The south side of the square is a large garden, surrounded by the sights, sounds, and smells of a pre-industrial European city. The house was built by the late Earl of Bute, and sold to the Earl of Shelburne, who later became Marquis of Lansdowne. A colossal statue of King George III stood in the center of the square.

Greeted by a succession of staff at Lansdowne's palatial home, one would have passed through serial rooms to take sherry in anticipation of dinner. Lively conversation there must have been aplenty; after all, Joseph Priestly made his discovery of oxygen while serving in this house as the librarian to Lord Shelburne. Surrounded by works of art from around Europe, including masterworks by Sir Joshua Reynolds, a contemporary artist of great repute, the call to dinner must have promised yet more memorable experiences.

Entering the majestic dining room, a guest was immediately aware of the taste and discernment of the proprietor, the Marquis of Lansdowne. Elegant grey walls, with delicate white plaster detail throughout, a sprightly Georgian wooden table and chairs, a gleaming silver service, crystal chandeliers, a warm red and blue carpet, and the imposing life-sized classical figures looking down benignly on the dinner guests, made for an unforgettable evening. Tyche's head was more than ten feet above the floor.

But she wasn't Tyche. She was an affluent Roman woman from the 80s A.D. who had been commemorated in this head, which later ended up on the statue of a goddess in the course of the eighteenth century. To me, it was a jarring mismatch, like the head of Mamie Eisenhower on a statue of the Virgin Mary. To a scholar of Lansdowne House, it was a decision made in the course of rediscovering antiquity, and warranted commemoration. To a member of the public, it might only be noticed fleetingly as one of nine white statues in an elaborately decorated dining room from the time of the American Revolution.

Each interpretation of the room's context and contents is fair. On balance, my "separation anxiety" is probably misplaced. But it's useful to flinch once in a while when serving as a custodian of the past. Being too certain about the context and its contents can lead to mistakes.

IMMERSING YOURSELF IN AN AUTHENTIC SETTING

The Met has another room not far from the Lansdowne Dining Room, but from three centuries earlier. The Gubbio Studiolo is one of the most miraculous settings in the history of the Renaissance. Walking into it is now a privilege that anyone can claim. Its origins date back to about 1476, when the Duke of Urbino, Federico da Montefeltro, commissioned a study (*studiolo*) for his home in the city of Gubbio, not far from Perugia. The Duke was obviously keen on making an impression for those who called on him, but would also have been inspired by the results himself: they would have easily withstood daily encounters without getting familiar.

Talk about a sustained connection with the viewer! For a student of Roman wall painting, the Gubbio is the nearest equivalent from the Renaissance that I have ever seen. It's a superb example of *trompe l'oeil*, or eye-tricking detail. Thousands upon thousands of pieces of wood were inlaid to simulate cupboard-lined walls, filled with the attributes of a learned man. Books, musical and scientific instruments, and other features of a civilized life are everywhere apparent.

I often lose track of time in the Gubbio Room, because the combination of technical sophistication and sustained connection is unbeatable. Neighboring period rooms at the Met are intriguing, but a short viewing suffices for me, in part because I know them to be the confections of talented curators rather than a space teleported from the past. The Gubbio Room is nothing short of that. We see it more or less (apart from the floor and light) as the Duke would have. Time travel is part of the seduction, as well. We can read about the Renaissance, but in this room we can step back into it. The years of effort on the part of the Met's conservation department to reassemble this massive jigsaw puzzle was a quiet and contemplative time for Antoine M. Wilmering, who devoted a decade to its complete restoration. It repays repeat visits, and you will never again look at *intarsia* (inlaid) furniture and ornament the same way. This is the baseline. Good luck to anyone, then or since, who attempted to meet or exceed it.

STUDIOLO FROM THE DUCAL PALACE IN GUBBIO, CA. 1478-82. ITALIAN. DESIGNED BY FRANCESCO DI GIORGIO MARTINI (1439-1501) AND EXECUTED UNDER HIS SUPERVISION IN THE WORKSHOP OF GIULIANO DA MAIANO (NAPLES) AND BENEDETTO DI MAIANO (FLORENCE). WALNUT, BEECH, ROSEWOOD, OAK AND FRUITWOODS IN WALNUT BASE. H 485 CM., W 518 CM., D 384 CM. THE METROPOLITAN MUSEUM OF ART, ROGERS FUND, 1939 (39.153). IMAGE © THE METROPOLITAN MUSEUM OF ART.

DISLOCATED ART CAN BE JUST AS MEMORABLE

Sometimes a displaced context or artwork makes a connection with us that is wholly unexpected, and can add new insights. Early in the spring of 1982, I made my way to West Berlin as a courier for "The Horses of San Marco," a loan exhibition sponsored by Olivetti that traveled around the world. At the time, the Soviet Union's puppet regime in East Germany did not permit cargo flights over their airspace into the modest Berlin-Tegel airport. So art shipments had to land in Frankfurt and be transferred onto smaller planes heading into West Berlin. The extra aggravation and handling of art works were a disincentive to lend, but they were essential to reach audiences in West Berlin.

The exhibition was a celebration of the depiction of the horse in classical antiquity, and all that it symbolized to Greek and Roman civilization. Viewing 2,000-year-old depictions of horses in any modern exhibition requires a kind of detoxification program, stripping away the received experiences of modern transport, industrialization, and the noise and speed of contemporary life.

But as the truck and police escort pulled up to the exhibition hall, I recognized the need for even more detox. Until its partial destruction during World War II, the hall was the home of the Kunstgewerbemuseum, or Museum of Arts and Crafts. Martin Gropius was the architect, a pupil of the great classical architect Karl Friedrich Schinkel, and the uncle of the Bauhaus master, Walter Gropius.

As I watched over the unloading of the crates at the Martin-Gropius Bau, it was hard not to look up and see the Berlin Wall, crudely attached to this exhibition hall's own century-old wall, covered with spray paint and crowned with razor wire, an apparently abandoned building looming on the other side of the wall in East Germany. How could one look at images of horses from two millennia ago while this monstrous monument to tyranny had literally run smack into the humanistic values of the building and its contents?

I was struck by the resilience of the Berliners who went about their daily lives as they lived on an island in the midst of Soviet-dominated East Germany. Drinking in these masterworks of classical sculpture in the midst of an urban scene so powerful as this could only be a very contingent, limited experience, I assumed.

The Greeks had invented democracy. The Nazis and Soviets had sought to extinguish it. Here in a building by an heir of the classical tradition, there was real

MARTIN GROPIUS BAU, BERLIN, GERMANY. © HOME.EDGE.NET.

poignancy in championing the accomplishments of pre-Nazi Germany by reclaiming this building, compromised as it had been by warfare and its aftermath.

FINDING QUALITY IN THE INSCRUTABLE

Even in the world's greatest museums, you often have to work to find art experiences offering what literary critic Stephen Greenblatt called a combined reaction of "resonance and wonder." The Louvre's galleries of Near Eastern Art are normally empty of visitors, but are always filled with an enormous array of pottery, stone sculpture, and statuettes made of bronze, copper, and even silver. They are among the greatest treasures of the world's greatest art museum, but are inscrutable to most. Part of the reason is that there is precious little written record remaining to lay bare the mysteries of Ugarit, Babylonian, or Mesopotamian culture, apart from a paucity of surviving texts and inscriptions on tablets and monuments.

While we know the names, attributes, and exploits of dozens of ancient Near Eastern gods, the absence of a successor culture that reanimated these protagonists

has relegated them to the consciousness of experts alone. There is no Near Eastern cultural inheritance to spawn the equivalent of a Parc Asterix, the French theme park lionizing the popular cartoon recounting the adventures of the Gauls in the time of Julius Caesar.

Among ancient cultures bearing literature replete with absorbing and memorable tales of heroism and derring-do, and human protagonists with whom we can identify, the textures of life and belief in the Near East are notably wanting.

But even without compelling legends that resonate today, the works can speak to the viewer with an open imagination. Spindly torsos, huge eye sockets, and stiff frontal poses are what strike us first. It's as if the makers of figurative sculpture found a formula that worked for them and saw no reason to set off in new directions—for the better part of 1,500 years. Our twittering present renders such force of habit unimaginable. Even my Romans retired artistic conventions as often as they changed consuls—roughly speaking, after one term of a U.S. president.

Near Eastern and Egyptian artists shared a superficially inflexible appreciation of tradition that classical artists eschewed. So in order to seek out the best in their stylistic conventions, we have to suspend our native restlessness and empathize with their veneration of what they deemed to be successful figurative typologies.

To attempt this, we can practice examining and appreciating other visual conventions that are superficially similar but not identical. When we take in images of Warhol silkscreened portraits, we make room for the shared pop sensibility—fluorescent colors, deadpan character, rectangular cropping and, most helpfully, repetitiveness of the art form. Yet we still manage to remain fascinated by the people they depict, even if unknown to us.

By channeling Warhol when confronting the legions of expressionless Near Eastern statuettes in art museums, we can learn to make certain helpful allowances. But in this case, instead of demanding individualization among the gods and goddesses depicted, look for technical differences. Are the features incised (cold-worked) and detailed, or muddy? Even though they are unnaturally attenuated, are the proportions pleasing to the eye, or ungainly? Do you have the impulse to cradle a work in your hands, or are you indifferent to it?

In other words, experiment with the long-lost point of view of a faithful adherent to the cult of Baal. Give in to the otherness of his worldview and project yourself

into a long-lost setting marked by incense, leather skirts, guttural speech, and mud-brick architecture. Imagine how an adherent to the cult of one or another divinity would have turned to the little bronze effigy as a talisman against the ravages of nature, foreign enemies, or other forces seen or imagined in the universe.

Bombarded as we are by representations of the human form today, it is challenging to project ourselves back to a time and place when such figurative art in precious metals, even on a small scale, was the rarest of the rare.

Making the effort to suspend our Western visual habits and see art through the eyes of a long-lost culture can pay substantial dividends. Even if we are traveling back in time without a map, compass, or Google translator, we can at least attempt to unlearn certain received ideas and pretend to be foreign emissaries to the Near East—uncomprehending but alert to our new surroundings.

SNAP JUDGMENTS ABOUT ART WITHOUT A PASSPORT

I've already revealed my past as a basement archaeologist, salvaging neglected treasures from shelves, shower curtains, and far-flung hills. One of the most rewarding of such discoveries involves three statues in a glossy black stone known as *bigio morato*.

I first saw them in 1988 leaning up against a brick wall in a modest storeroom in Rome. In the dim light and below their grime, I thought that these could be masterworks, and neglected ones at that. The works were made, we now believe, in the first century A.D. for the Palatine Hill—and likely the same Palace of the Emperors that provided some marble elements found today at the Metropolitan.

The statues are under life-size but pack a punch. They are as sleek and sensuous as any depiction of the female form, despite the fact that they taper from a womanly chest to a squared-off base at the waist. That makes them herms, so-called, named after road markers in the form of the messenger god Hermes that lined the roads of ancient Greece like our highway signs today.

These female herms are inky black, flawlessly carved, and highly unusual. Little like them survives from the Roman world. If I had first seen them on the art market, and not in a museum basement, I might have questioned their authenticity, just as Ernst Langlotz had condemned the Italic Maiden at the Met. But they haunt me to this day, and deserve a more prominent place in the literature of ancient art than fate has so far handed them.

Another sculpture came to light around the same time with a different result. Much ink has been spilled about the Getty Kouros, a marble statue once thought to date to the early fifth century B.C., and now considered by many to be a modern forgery. It was renowned not just because of the dustup when the Getty began to question its authenticity. A parade of specialists in ancient art was brought to see it in the museum's storeroom in Malibu, and I was one of those who had an early glimpse.

The writer Malcolm Gladwell captured some of why the work screamed "fake" to so many, myself included, in his 2005 book *Blink: The Power of Thinking Without Thinking*. My instant reaction to the work was that it was a combination of mechanically accurate, improbably preserved, and stylistically forgettable. I had the opposite of a sustained connection—I was instantly dubious about it, and saw it as a too-perfect copy. The radar you can develop after prolonged looking at types of art is what we are after in this book, and like any other work that is wrought by hand or by the human imagination, there are a multitude of signals that we receive subliminally at first glance.

MONEY DOESN'T NECESSARILY BUY QUALITY

While Gladwell shows us how such revelations can be instantaneous, the converse is also true. Protracted study can provide clues that direct us to otherwise negligible features of a work of art. In 1982 The Metropolitan Museum staged an exhibition titled "Curator's Choice." We were challenged by the director to offer up works we had purchased for $5,000 or less that could withstand the scrutiny of our peers and the public. I selected the cheek piece from a Roman helmet that I had recently purchased for the museum. It's basically a metal flap that folds down from the helmet to protect the cheekbone from the blow of a weapon. While not a great work of art, it was a rarity—the practical Romans took to melting down damaged armor to reuse it, while the more spiritually inclined Greeks used to bury armor with the deceased. That's why there are so few examples of Roman armor surviving, in contrast to the relative abundance of ancient Greek helmets in tombs—and therefore in museums.

The experience of "Curator's Choice" offered a welcome filter to highlight works of art that were not big-ticket purchases. But it also provided another platform for curatorial braggadocio: the more you could buy for less, the better eye you had.

UKIYO-E PRINTS AS WINDOWS TO THEIR TIME AND PLACE

Sometimes the subject of an artwork gives it a leg up in sustaining a connection, as when it captures something instantly familiar or of abiding interest, projecting us into a faraway time and place. Such is the case with genre scenes, which are abundant in the history of art. By genre scene we mean pictures of daily life unencumbered by recognizable historical events. Genre scenes that float to the top of our awareness are marked by how well they reflect the tone of a time and place—how successful they are at drawing us into the scene. Few are more successful than Japanese Ukiyo-e, which may be translated as "pictures of the floating world."

Produced between the seventeenth and twentieth centuries, these woodblock prints were not only highly prized in Japan, but are credited with inspiring several European artists of the nineteenth century, including Van Gogh, Degas, and Toulouse-Lautrec. These prints opened a world of understanding between East and West, and fostered appreciation of forms of perspective that had not been seen in

KATSUSHIKA HOKUSAI, JAPANESE (1760-1849), *FINE WIND, CLEAR MORNING (GAITU KAISEI)* FROM THE SERIES *THIRTY-SIX VIEWS OF MT. FUJI (FUGAKU SANJUROKKEI)*, ABOUT 1800-1849, COLOR WOODBLOCK PRINT, 10-1/8 X 15 IN., 60.12, INDIANAPOLIS MUSEUM OF ART, CARL H. LIEBER FUND.

Europe since the advent of one-point perspective, pioneered during the Italian Renaissance. It is clear that Ukiyo-e had an impact on European painters, and bound up with it is the rethinking of slavish adherence to both one-point perspective and the conceit that we can see into a painting as if into a window. Manet and other pioneering artists affected by *Japonisme* began to look outward, to the viewer, and to put aside longstanding conventions in Western art.

The Ukiyo-e tradition imparted its prefiguration of Modernism upon the cultural landscape of Japan. Through this woodblock print technology, art ended up in the hands of people of more modest means who could not afford one-off paintings or other works of art. The late-sixteenth-century move to cities in Japan fostered the development of several forms of creative expression that had heretofore been limited to imperial courts. The Ukiyo-e tradition reshaped Japanese popular culture. Reciprocal influences between East and West in the course of the nineteenth century were profound, and contributed to major changes in the pictorial traditions of both Japan and Europe. Among the most notable of these connections was the abnegation of conventional approaches to perspective. Series such as Katsushika Hokusai's *Thirty-Six Views of Mount Fuji* from the 1830s left a lasting impression not only on art lovers, but also on Monet's approach to landscapes a few decades later.

All of us flip through forgettable films or shows on our TVs until we find one that holds our attention. Art that makes a sustained connection does so for many reasons, some of them personal and hard to verbalize. But if a work of art hits none of your neural networks or senses, and leaves only the slightest trace of memory, it's very possible that the artist missed the mark. And you have every reason to flip to the next artwork.

NOTES

"Physiological correlates of aesthetic perception of artworks in a museum," Tschacher, Wolfgang; Greenwood, Steven; Kirchberg, Volker; Wintzerith, Stéphanie; van den Berg, Karen; Tröndle, Martin in *Psychology of Aesthetics, Creativity, and the Arts,* July 18, 2011.

CHAPTER IX : Finding Quality in the Art of Our Time

There is no more widespread conviction about modern art than that it is fraudulent.

People feel the same way about "serious" modern music. Atonal music is the product of composers who are committed to breaking free from "theme and variation." Insight and patience are required if we wish to make room for it in our lives. Most people, however, dismiss it, just as they reject contemporary art.

Before labeling such opinions the province of philistines, let's review who the historic Philistines were and why they got such a bad rap. Philistines were, in the parlance of the Old Testament, pagan inhabitants of the coastal cities in the southwest of Canaan. Both neighbors and enemies of the Hebrews, their adoptive name is actually Hebrew: *pelishtim*, or the people of Pelesheth (Philistia in Greek). In Germany in the course of the seventeenth century, the term philistine fell into common usage as the modern equivalent of "townies." As a modern derisive term, philistinism began with this very particular application. Over time, it took on a more general meaning opposite to "bohemianism," and flourishes to this day to denote an intolerant, unevolved observer of contemporary culture. Jonathan Swift would use it in the eighteenth century, and other authors followed, including Matthew Arnold in *Culture and Anarchy* (1882). There he connected philistinism with the vulgar pursuit of money for its own sake:

MARK HANSEN AND BEN RUBIN. *LISTENING POST*. (2001-2003). SHOWN HERE AT THE WHITNEY MUSEUM OF AMERICAN ART. NEW YORK. DECEMBER 2003. PHOTO BY DAVID ALISON.

"The people who believe most that our greatness and welfare are proved by our being very rich, and who most give their lives and thoughts to becoming rich, are just the very people whom we call Philistines. Culture says: 'Consider these people, then, their way of life, their habits, their manners, the very tones of their voice; look at them attentively; observe the literature they read, the things which give them pleasure, the words which come forth out of their mouths, the thoughts which make the furniture of their minds; would any amount of wealth be worth having with the condition that one was to become just like these people by having it?'"

Arnold's formulation bears examination, since the use of the term today to signify the uneducated is connected with a general sloppiness in etymology, vocabulary, and syntax. His formulation allows for a reading far different from common usage. It suggests that it is not the common man, but some of the overzealous deep-pocketed bidders at contemporary art sales that are today's philistines.

Contemporary culture is inevitably the most contentious slice of human creative history. This has always been so, because agreeing on what's important in our time is a lot harder than agreeing on the best of what came before. The past has already been examined, with conflicting views laid bare, and we get to choose from a tasting menu. The art of the present is still in the kitchen as the dealers, curators, critics and collectors clamor for it at their tables.

CONTROVERSY CAN OCCLUDE OUR QUALITY RADAR

Suspicion of modern art stems not from an aversion to experimentation, but from a skeptical view by those who hold that art should refer to something easily apprehended. Much of the suspicion people feel when entering art museum galleries has to do with abstraction, rather than contemporaneity. There is also the perception that unreasonable value is assigned to works of art that have no discernable preciousness about them. That is why philistinism, if we begin using the term in this connection, is an overwhelmingly American phenomenon. If the modestly compensated Turner Prize elicits widespread controversy in England, it is because the visual arts are believed there to have an enduring controversial value. The merits of its finalists and recipients are hotly debated by cab drivers, doormen, bankers, and academics alike.

In the United States, by contrast, works of art and artists are only noticed by

mass media and by the general public when colossal amounts of money or a scandal is involved. The theft of a valuable work triggers interest, as does vandalism, because these involve an assault on the value held by an interested party. The other strain in contemporary American culture, an abiding Puritanism, is evident when a work of art or an artist is accused of being "controversial," by which the media or amateur critics intend being topical. If modern or contemporary art in America is neither abstract nor topical, it has a greater chance of being well received in the popular consciousness, as the Corcoran Gallery's 2003 exhibition of Seward Johnson's three-dimensional recreations of Impressionist paintings demonstrated.

Or Johnson's more recent *Forever Marilyn* statue of the subway-grate-breeze-enhanced icon disporting herself in Chicago. This is our latter-day Colossus of Chicago, but we could take liberty and paraphrase Bede by saying *Quandiu stabit Marilyn, declinet Chicago* ("So long as Marilyn stands, Chicago sinks"). Johnson has mastered the derivative gesture, and here he hitches an unwelcome ride on the truly innovative gigantism of Claes Oldenburg.

WHEN DUCHAMP CHANGED THE RULES OF ART

Marcel Duchamp (1887-1968) recognized twin strains in public reception of modern art: the attachment of art to money, and the aversion to and fascination with visual metaphors that challenge the hegemony of a safe public space. He called attention to these strains in displaying a urinal, first exhibited in 1917 and titled *Fountain*. It is easy to underestimate the original shocking power of this gesture. Proposed for exhibition by the Society for Independent Artists, the urinal was his most significant "ready-made," as he would call manufactured objects that could, from his vantage point, take their place among works of art. Purchased directly from J.L. Mott Iron Works, a plumbing manufacturer and supplier, the ur-urinal was rotated 90 degrees from its intended orientation, and inscribed "R. Mutt 1917" eliding the manufacturer's name with that of the contemporary comic strip "Mutt and Jeff." The original version, long lost, was recreated in a signed edition of eight by Milan's Galleria Schwarz, authorized by the artist in 1964.

It is hard to say what rankles people most about the Duchampian strain in contemporary art. Most likely it can be distilled to the resentment at what is imagined to be "pulling the wool" over the eyes of onlookers. Duchamp's playful

up-ending of received traditions in the visual arts was quickly confused with non-objective, or abstract painting and sculpture, such as that by Kandinsky, Malevich, and Mondrian, and later by Abstract Expressionists, including Ad Reinhardt, whose painterly efforts are so nuanced as to be all but invisible without very close and lengthy inspection, and proto-Pop artist Robert Rauschenberg, whose Duchampian "Erased Drawing" took a work by senior artist Willem DeKooning and erased it, declaring his own (patricidal) accomplishment.

Pop Artists, including Andy Warhol, continued in this vein, challenging the remaining boundaries between high art and popular culture to great effect. The ensuing proliferation of art-making methods and styles in the 1960s, including Conceptual, Minimalist, Performance, Anti-Form, and Earth Art, ratcheted up debates about boundaries between art and life, and tested prior assumptions about the market value of art.

I take a very, very long view about the state of play in contemporary art. The hue and cry is a modern one. The porous boundaries between art and life, art and popular culture, art and low valuations, art and humor, art and pornography, and art and irony date back to ancient art. The creation of a membrane separating art from life began in the seventeenth century. On balance, it was an unhealthy effort, notwithstanding all the glories that triumphed in spite of it. That membrane was, as considered earlier, the Academy, born in Paris at that time. The academy's eclipse began in the mid-nineteenth century, and it has taken this long for its death rattle to be nearly silenced.

There are still apoplectic critics who decry the end of quality in art—such as conservative pundits like the late Hilton Kramer, who never made peace with the 60s. And there are other litigants, including artist-turned-critic Jerry Saltz, whose now televised snap judgments have made him a high priest in the art market. But art critics are, like movie critics, of waning influence. Intelligent observers are increasingly making themselves at home with personal art judgments. Like moviegoers who rely on advertising, word of mouth, and box office performance, museum-goers can make their minds up about what to see—and what to like—from a rapidly expanding variety of sources.

ART CRITICISM'S LONG SLIDE

The nascent breed of self-confident museum-goers, collectors, and observers for whom the adjudication of quality in art is not indexed to the opinions of critics is now in the majority. The art market offers one filter that art admirers can review for evidence of artistic achievement. But the evolution of social media is putting evaluation in the hands of millions who can turn to blogs, websites, and other evanescent arenas for evaluation and ranking. What was formerly kept to ourselves is now shared, and opinions that once seemed risky to venture are now easily tweeted, float for a while, and sink into the uninterrupted flow of assertions and rebuttals that constitute the Internet's conversation.

The austerity of Ad Reinhardt's works had intrigued me since high school. His daughter Anna was my classmate at The Dalton School. She was a discreet, tall brunette who steered clear of the antics indulged in by me and my classmates. Her father's paintings were even more mysterious than his teenage daughter; they achieved a Zen austerity that built on the adventurous early twentieth-century works of Kasimir Malevich, and reward patient looking. Barely discernable cruciform patterns and geometries are evident beneath the first glimpse of an all-over monochromatic canvas.

Reinhardt, like his successor mining the territory of whiteness, Robert Ryman, delved deeply into the absence of form and color to reveal the essence of a painterly gesture. For many who struggle with the austerity of these artists, the question is one of finding artistry in absence.

I often turn to Japanese rock gardens in trying to explain the rewards of absence in art. The sound of raking tiny white stones is as bound up with the success of a rock garden as is the absence of unruly vegetation. The process of manicuring these magical spaces and the resulting stillness is where a reward is to be found, not in ornament, color, geometry—or realistic representation.

Mark Rothko's abstract paintings are as much about the absence of form as about soft fields of color. In 1998, the National Gallery's comprehensive survey of Rothko's works arrived in crates at the Whitney. I had long admired his work, but got to know it in greater depth by seeing individual paintings in individual collections. The chance to hang so many side-by-side is what drives curators to put in years of effort behind special exhibitions. By dropping in frequently, I had the

opportunity to watch the exhibition being installed in something like time-lapse photography. The comparisons made within the exhibition were on the one hand obvious—the painter made certain works in his studio near each other in time, and so they resemble one another. But on the other hand, the act of reuniting these works, in some cases dispersed for nearly half a century, revealed much about Rothko's evolving approach to painting shapes.

The opening dinner was a triumph—apart from the overzealous caterers, whose rectangular Rothko-like appetizers elicited a grumble from some of his family members—and was, as always, a challenging time to see the exhibition. After the crowds had thinned I returned to the Whitney's fourth floor to take in the result. So much of Rothko's experimentation was evident in paired and serial hangings, yielding favorites and also-rans. While the selection by the National Gallery's curator

Jeffrey Weiss was superb, what the exhibition drove home for me was that an artist so dedicated to an overarching approach set himself up for invidious comparisons. The risk was potentially no greater or lesser than artists who hop from technique to technique or subject to subject. In Rothko's case, the subtle abnegation of subject separated him from other artists of his time.

SITTING IN THE JURY BOX OF CONTEMPORARY ART

For six years I watched over the nation's most influential survey of contemporary art—the Whitney Biennial—and emerged with tactics to pass along in the quest for quality among works that are a month old.

No one can lay claim to certainty about quality in the art of our time. But the three Biennials in which I had a hand taught me a great deal about the process of adjudication, as each exhibition relied on a different set of curator-judges, and each had a different point of departure and a very different destination. It was a sobering effort in 1999, because I assembled a curatorial team of six leading lights; most of them had not worked with one another before. When the show opened, some critics were livid—an occupational hazard of choosing and exhibiting contemporary art. One critic, however, pointed out something else that may have been going on:

"The point is that no matter what this Biennial did, the local heavies wouldn't want to like it. The source of the pique is not really the art. It's the meta-narrative: This bad guy from beyond…came galloping into town, stormed the fortress, routed the rightful occupants, and hijacked the Biennial. Even more unforgivable, he reinvented it in the image of the show we always wished it was…" (Kim Levin, *The Village Voice*, April 11, 2000)

The process of judging the art of our time differs from judging artworks of the past in one key respect: we have no time to savor it or to see if it can maintain a sustained connection. Artists who have buzz—because they land on a clever or topical approach—may not find a long career ahead. There are artists who toil for decades in relative isolation, because they have never gotten the break that others more fortunate have gotten.

There are many works made over the last decade that hit all the marks I've lined up for our consideration. Mark Hansen and Ben Rubin's *Listening Post* (2002) (p.

192), which we showed at the Whitney by itself, draws from the interconnectedness of contemporary society through digital technology. Few works have risen above the din of digital innovation in the way that this does; a work at turns sublime, voyeuristic, and unsettling. With over two hundred supermarket checkout monitors displayed in a wire-mounted, curving grid, the artists channeled a live feed of Internet "chat rooms" (the antecedent to Facebook) robotically mined in real time. Semi-private conversations become very public. The work was made years before social networking sites came of age, and it anticipated by several years the voyeuristic fire hose of Twitter comments. It was most certainly born of an original idea, was riveting to watch, harnessed the very latest technology of its time seamlessly, was an unblinking review of an emerging global conversation, and was beautiful to apprehend in a darkened room. It passed our five quality features with flying colors.

In 1999, when I proposed to create an award for an artist in each Whitney Biennial, the art patron and Whitney trustee Melva Bucksbaum took to the idea, and endowed the program. Now in its second decade, the Bucksbaum Award is chosen by a jury that changes each time. The judgments handed down by a group of curators and experts are often, in my view, more trustworthy than those conferred by a single person. This is the case not only for curators, but for critics, as well. The passions that rise and fall with the mention of a name, or the review of a work or a body of work, are subject to everything from groupthink to biases introduced from without.

The 2002 Bucksbaum Award was conferred on an unlikely choice, Israeli-born film-video artist Irit Batsry. At first there was much consternation among art world observers, for whom the artist was both unknown and a devotee of film as a medium, both damning flaws, in some eyes. But with time, even the tough *New York Times* critic Roberta Smith came around, conceding the quality of Batsry's work and stating that in her original condemnation, "I doubt that I'm the only one who stands corrected." (Roberta Smith, *The New York Times*, January 9, 2004).

Some artists are reduced to ignominy after a short burst of attention. The leavening effect of time—even a mere 18 months—can alter perceptions as some enthusiasms deflate, and some rise in a slow-baking oven of critical review.

In June 2001, I juried the annual art exhibition of the Cambridge Art Association. The slide sets of yore had by then given way to digital files, which allowed me to sift through hundreds of entries and find my way to the works that

IRIT BATSRY, SET, 2003, WHITNEY MUSEUM OF AMERICAN ART. PARTIAL INSTALLATION VIEW: MAKE: MEASURE, 2003. DIGITAL VIDEO PROJECTION, COLOR, SILENT: 2:13 MIN., LOOPED. DIMENSIONS VARIABLE. © IRIT BATSRY. PHOTO BY SAHAR BATSRY. COURTESY OF IRIT BATSRY STUDIO (NYC), SHOSHANA WAYNE GALLERY (LA), BENDANA-PINEL ART CONTEMPORAIN (PARIS) AND AUT AUT ARTECONTEMPORANEA (RIO).

made me stop and linger. In all such juried competitions, there is a range from quietly authoritative to stridently dependent on the ideas of others. And it is in many ways a thankless task to ferret out those works that, in the eyes of one person, make the cut. The awarding of prizes in art is of course a ritual reaching back thousands of years, and by virtue of the changing bases of judgment is no more objective than medals for wine or pies at a country fair. If the judge or jury arrives on the scene with a predilection for painting over photography, the deck is stacked.

One more reason why it is always best that we put prizes in their proper context, and develop our own quality instinct.

THE ART WORLD'S TOP DOGS

Leaving written opinions of critics aside, there is a more clinical trial to consider. The expression "art follows money" is never truer than in the field of contemporary art. Reputations today are born and flame out in a matter of months, based on the vagaries of the marketplace. An artist today has little chance of making an impact without the blessing of an influential dealer. In the past this was also the case. But in the past there were myriad ways of supporting artists through commissions. These could be for the Church, for noble patrons, affluent burghers, or civic projects. Today, the chances of obtaining a major commission without pressure from a dealer are few, and most emerging artists cannot rely on enlightened patronage to further their careers. They need the imprimatur of commercial success. Only then are others prepared to line up behind them.

Who decides which contemporary art is worth seeing? "The contemporary art world" is a familiar locution, but on closer inspection it is impossible to generalize about its attributes. There are various stakeholders whose opinions shape the perception of contemporary art. As outlined towards the beginning of this book, these are chiefly artists, curators, dealers, collectors, critics, and the public. Within these six interlocking groups are opinions across a vast spectrum—at its extremes stretching from those who mistake art for fashion to those who await the judgment of the art market to measure achievement. In between are those whose opinions are in various degrees informed by a good eye, knowledge of art history, and openness to creative risk.

Artists are at the core of the contemporary art world. They are for the most part generous with each other. With a cocked eyebrow at museums and the marketplace and with no guarantees, they go about making work. Their support of each other is critical as they try to survive lukewarm reception, being passed over for shows, and other disappointments in the quest for critical and commercial success.

While director of the Whitney, I tried to reserve Friday afternoons for studio visits, whenever possible. When my office called to set up a provisional time for a visit, the nerves and expectations of the artist were set in motion, and I could do little to put them at ease until I arrived. While the curators who worked for me were the primary decision-makers as to what to purchase and what to exhibit, a well-placed word from me would certainly guarantee a closer look by a curator.

Contemporary curators are often caught in a bind of seeking to reward innovation while having to cope with competitive colleagues and risk-averse directors. I have had the benefit of working with exceptional curators over the years, each bringing a bias and energy into the perpetual debate over what to favor from a sea of potential protagonists. The best contemporary curators keep an open mind until they actually see the work over which they might exercise influence, and are then clear and declarative about their appetites and allegiances. There are many in the field who become personally involved with artists as friends, which can be fatal to their duties as an objective judge of quality. The pressure to embrace an artist's newest work is almost irresistible, coming as it does from all quarters—the artist himself, his dealer, and the collectors who want to see their investment safeguarded.

Dealers are inherently committed to the artists they represent, and interested, but by necessity less invested, in those they don't. There are many dealers in the contemporary art world for whom the profession is one of advocacy, with the business side being integral to their work but not its driving force. For these dealers, the gallery provides an opportunity to launch an emerging artist's career or to revive the career of an artist whose best work is presumed by most to be behind her. Their shows might have limited sales, but they can provide an essential imprimatur for the careers of the artists they represent. Some dealers are willing to take real risks in acquiring inventory that will likely go unsold. It is a way of keeping the artist solvent and feeling appreciated.

Dealers who are somewhat more businesspeople than advocates may feel compelled to sacrifice the best interests of the artists in their stable for the bottom line, sometimes with disastrous results for an artist who got out of the gate too soon.

Collectors struggle to identify work that they enjoy spending time with, but some, understandably, are willing to rely on other people's judgments to sharpen their own eye. Since the contemporary art boom in the 90s, more people collect photography than any other art form, since it is an affordable medium. One collector who should have known better described his appetites as gravitating to "big, color, Chelsea," as shorthand for the work important to him. In each category, the marketplace is paramount. I have nothing against big color photographs by artists represented in Chelsea, but it is extremely misguided to think that a novel medium by itself is a guarantor of quality, let alone value.

ANDREW BORDWIN. *HOUSE 1 (FROM THE INCUBATOR SERIES)*. 2000. GELATIN SILVER PRINT. 30 X 40 IN.

PHOTOGRAPHY'S METEORIC IMPACT

Photography is seductive for many collectors because it is deemed "accessible." That's a way of saying that it notionally requires less work to interpret than do works visibly inflected by the human hand, and are, more often than not, other than representational. But most artists who use photography despair of being considered lightweights because the digital medium they use is the province of average consumers. In fact, the emergence of digital photography led to a crisis of confidence among artists who previously developed and printed their own work. As aspiring collectors hope to find value through the editioned work of mid-career artists, these same artists are struggling to find their voice in a miasma of digital media. Over time there will be a shakeout, as the boundaries separating photography's use for art, advertising, illustration, commemoration, and souvenirs dissipate in a common binary language that cannot be adduced to be art or non-art.

Judging quality in contemporary photography is the hardest job in the art profession today—not simply because there is so much to be examined, but because everyone considers himself an expert. Absent the artisanal touch, the grounds for attributing ascendancy to one photographer over another in this creative maelstrom are almost impossibly subjective. Dealers are desperate to anoint a couple of dozen names each generation as the primary exponents of photographic art, because without a compass of this kind—without agreed-upon stars who can be chased by one gallery or another—the chaotic ferment of digital representations of the world around us would consume the art market in an incomprehensibly vast sea of offerings.

Unlike other art forms before it, such as painting, photography can be effortlessly practiced by everyone from high school students to retirees, with evocative results. The reality is that photography is not the end of art—but it is the end of a certain kind of commercial paradigm in the art market. Throughout the history of art, it is recognizable archetypes that have predominated. These included statues of Venus, icons of the Madonna and Child, and sun dappled Impressionist landscapes. What are the most recognizable archetypes in photography? Are they Cartier-Bresson's artful candids of Parisian street life, or sports figures and politicians licensed by Getty Images? The ubiquity of digital images and the ubiquity of authorship of digital images will be a one-two punch to the old system of anointing art stars in this medium. The images that capture our imagination will come not only from artists, but also from rank amateurs who find themselves in the right place at the right time.

The first mature generation of artists to react to photography, the turn-of-the-century French post-Impressionists known as *Les Nabis*, mined it for what it taught us about the vagaries of human perception. Successive waves of creative souls grappled with photography's assault on art's traditional role as the playground for individual genius. But it took a revolution in technology—the advent of the digital camera—to put high-resolution images in the hands of amateurs. Until its widespread adoption in the early years of this century, it was possible to maintain that the best work was being made through traditional analog technology.

One after another, the titans of contemporary art abandoned the darkroom for the computer screen, and as go they, so goes the art market. The artificial distinction of creating an edition of five or ten digital prints signed by the artist will begin

to seem as obsolete as selling music on CDs. If the images are powerful, beautiful, or lasting, and if there is simply no rationale for limiting their editions, apart from an attempt to corner the market, some artists will break ranks from the gallery system if they can find a way to reach the consumer directly. Multimedia and installation artist Tony Oursler was in the vanguard of thinking about this possibility, burning a CD-ROM in the late 1990s to bypass his gallery and get art directly in the hands of anyone who wanted it.

Not being beholden to the marketplace, I am very excited about this up-ending of the artificial constraints on the circulation of compelling images. Once "big, color, Chelsea" is affordable for every consumer, a new kind of currency will invent itself, and ownership of the greatest contemporary art will not be limited to speculators.

THE CRITICAL DILEMMA

Critics are forced to sift through an almost infinite sea of aspiration and achievement on a deadline, and often as not lay waste to exhibitions that fail to meet a highly subjective and pre-ordained set of criteria. Many critics are artists who simply gave up trying, and began to write about the work of their friends and rivals. These critics can become entangled in a very problematic dynamic, continually settling old scores. Assaulting the accomplishments of an artist who has achieved renown simply because she has "made it" isn't fulfilling; it ends up only exacerbating the critic's vitriol. The quality of the work under consideration becomes less important than making a point of one kind or another.

The market is the only tangible source of information that cleanly and unhesitatingly separates the coveted from the overlooked. And the market exerts a powerful influence on critics. This category of judge has the least to lose by introducing snap judgments or purely subjective, unsupported, shoot-from-the-hip assertions. Lacking a personal connection to the market value of works—unless they are in some way rewarded for a positive review, such as being invited to the right parties— some critics simply settle scores from graduate school or from presumed snubs. It's why I take much art criticism with a bath of salt, and pay heed only to those writers who, like Ken Johnson at *The New York Times*, don't seem to have an ax to grind. With so many competing agendas, it's obviously misleading to suggest that the factions of "the contemporary art world" comprise anything but a loose confederation.

These struggles, disconnected as they are, all benefit the public. Because "the public"—meaning everyone not in the art world—is free to find its way through the endless offerings of museums, commercial galleries, and online and print publications, and can make up its mind while discounting the puffery of museum advertisements and the tirades of select critics.

Anyone who discounts the opinions of those not inducted into the contemporary art world does so at his or her peril. The "art world insiders" alone cannot determine an artist's passage from the contemporary world into ignominy or art history. As the great public intellectual Max Lerner put it, history is written by the survivors. The public is of course inchoate; by the public I intend those devoted art addicts who fuel the kind of rising tide that Malcolm Gladwell describes in *The Tipping Point*. Enough traction from a few influential figures with access to the media can be enough to capture the attention of one of the key constituencies above, and launch an artist's career.

TECHNOLOGY IS CHANGING THE RULES OF ART

Sometimes a work of art speaks to you. Literally. Tony Oursler's works starting in the late 1980s consisted of blank puppets with faces projected on them, and the artist's recorded voice offering bland pronouncements. Novel as they were in technical terms, their real power was in disrupting the time-honored divide between the observer and the observed. Ourlser's playful conceit can be deeply disorienting. Just as when an animal at the zoo locks his eyes on ours, something is awry, and we look away. In that case, there is a pang of guilt over our complicity in a fiercely independent creature's incarceration for our amusement. When Oursler's works speak to us, we make the intellectual assumption that the puppet doesn't recognize us. Or so we hope.

Oursler's works operate mysteriously, knocking us off balance, making us think about the ways we try to categorize and give order to works of art. His puppet-works hit all the marks for artworks of high quality. They leave us feeling differently about the experience of art, haunt us for days afterwards, are wholly original, utterly simple technologically, and challenge received wisdom about sculpture. Most importantly, they are expressive, powerful, and unexpected.

In 2000, I curated a small display of Oursler's work titled "Tony Oursler: The Darkest Color Infinitely Amplified." The installation involved high-definition

THE DARKEST COLOR INFINITELY AMPLIFIED, 2000. TONY
OURSLER. INSTALLATION VIEW AND DETAIL. © TONY OURSLER.

volumetric display technology, yielding video images that appear to float, with no
visible projection source. It was an up-to-date *camera obscura*, the pinhole camera,
for which antecedents date back to antiquity. The most remarkable feature of the
projected work was a floating image of a glass statuette of the devil: Oursler's com-
mentary on the threatening character of magic and manipulated perception.

My lifelong interest in how technology is changing our lives prompted me
to invite the artist to explore a means of working new to him, and I was excited
by its promise and results. Yet there could be no way for the work to have a sus-
tained connection to the viewer—one of the hallmarks of quality that I advocate.
Once the laser projection source was stilled, and the display packed up, there was
no way to recreate the experience offered fleetingly in the Whitney Museum's
Ehrenkranz Gallery.

Even noting its fugitive character, I believe the experiment was noteworthy. My hunch is that future attempts at three-dimensional projections in space—the ultimate in *trompe l'oeil*—are inevitable, and that Oursler's installation was ahead of its time.

Being ahead of your time or being on time are both highly desirable features in works of art. When Barnett Newman laid down masking tape and painted a background and what he called a "zip" line, he made a statement so bold and original that others were condemned to repeat him. The breakthrough for Newman was to think of the painted surface with less sanctimony, and the ironic result is a series of abstract works that convey a spiritual depth that we anachronistically apply to them. For artists experimenting with video, there were no rules to start with, other than the freedom to innovate in a medium akin to film, but as malleable as film is finite. It is often the case that artists like strictures and limits, because without them, the vastness of creative potential can overwhelm the most talented person. For painters, the paint dries. For marble carvers, the stone is unpredictable. For draughtsman, the first mark on a page cannot be easily removed.

That's why assessing quality in art made since the 1960s is in many ways a treacherous proposition. But as time marches on, certain artists and certain works from that day forward have kept our attention. This is hard to explain unless some new filter of quality is at work. The marketplace has its own logic on this front, but the marketplace is subject to the whims of collectors or artists dumping too much on the market in a short period, or a monographic show at an influential museum, or the independent judgment of a single renowned collector.

It is clear that time will sort things out. Looking at the art of our time, we are poorly equipped to sort out the best from the good from the bad. In the same way that it is hard to recognize recent forgeries but relatively easy to pick out old ones, our eyes don't see the forest for the trees. That is, we see the world with contemporary eyes, and they are fickle. What looked cheesy only a few years ago becomes retro and cool—almost overnight, it seems, as happened with mid-century modern style. And so it is with works of art. Examples abound. The Pre-Raphaelites and other academic painters have gone through cycles of appreciation, as have countless artists of recent generations. It is up to us to take the time to look patiently, and try to remove our contemporary glasses to see art in a more timeless context.

OVEREXPOSING PUBLIC ART

Public art lives in its own world. Outside the safer confines of an art museum, all bets are off. The creative expressions of artists, designers, and architects are instantly judged by city planners, self-ordained art consultants, community activists, journalists, bloggers, and the newspaper commentariat, consisting of readers emboldened by permission to post anonymously. This may be the ultimate proving ground for quality, as everyone has an opinion about works of art that are not in a museum or private residence, but in a shared, public space, one normally supported by public funds.

The anxiety felt by artist, curator, and commissioning authority when a work of public art is floated before a community hearing is palpable. Because it takes only one vocal opponent to set off a firestorm of criticism, as happened with Fred Wilson's remarkable work, *E Pluribus Unum*.

My senior curator of contemporary art at the Indianapolis Museum of Art, Lisa Freiman, proposed the artist for the Indianapolis Cultural Trail, and Fred was invited to create a work. His talent is often brightest when he shows the racial selectivity of public monuments, and his idea was a simple but brilliant one: to replicate the freed slave from the city's Soldiers and Sailors Monument and portray him as a man with no connections to slavery, but instead holding a flag with emblems of the African diaspora. The misunderstanding of Wilson's benign intentions and the meaning of his work was deafening. Opposition was led by at a small group of disgruntled members of the public. Little could be done to sway the project's opponents.

E Pluribus Unum was, even as a replica, born of a highly original idea. The form and subject are arresting. It was to be made with sensitivity and great technical skill. Its warring identity as a former slave and a symbol of present freedoms was complicated and powerful, born of Wilson's sure-footedness as an artist. And its composition and powerful form were as good as any work of public art I've seen in a decade or two. In other words, it hits all five marks we've set for ourselves in judging artistic quality.

But the public outcry led to the monument's displacement from its intended location across from the City-County Building. Then in December 2011, the project was cancelled.

Which goes to show that opinions about artistic quality are not best undertaken

FRED WILSON, *E PLURIBUS UNUM*, 2011. PROPOSED RENDERING. MIXED MEDIA: INDIANA LIMESTONE, BRONZE, FABRIC (FLAG). PROJECT PROPOSAL FOR THE INDIANAPOLIS CULTURAL TRAIL: A LEGACY OF GENE & MARILYN GLICK. RENDERING PROVIDED BY THE CENTRAL INDIANA COMMUNITY FOUNDATION WITH PERMISSION OF THE ARTIST.

by means of a plebiscite. The best judge is the solitary viewer equipped with an open mind and a set of reliable criteria for determining what is exceptional and enduring in the work. And those criteria are… (drumroll, please): *original* in its approach, *crafted* with technical skill, *confident* in its theme, *coherent* in its composition, and *memorable* for the viewer.

In other words, after journeying with me through the pages of this book, graciously indulging me my anecdotes and biases, and armed now with some techniques to advance from looking to seeing, the best judge of quality—even with the most bleeding-edge art—is you.

NOTES
Matthew Arnold, *Culture and Anarchy* (1882), Chapter i, p. 13.

CHAPTER X : Conclusion: Art and Muscle

The modest demands of high school physical education, or the greater demands of training for a college sport, are familiar to most of us. Shotokan karate was my sport in college, and Kazumi Tabata was my instructor. An eighth-degree Grand Master, he was captain of the U.S. Karate Team for two decades. When he tapped me for the varsity team, I was already deep into art history, and the parallels between these two disciplines were clear to me from the start. The arena of competition was twofold: a *kata*, or rehearsed performance of a series of blows akin to memorizing a gymnastic routine, was followed by open combat with an opponent, called a *kumite*.

The *kata* was how I developed muscle memory and good form. It was like learning the basics of art history. Memorizing the physical forms—the sensation of my fist sailing forward, twisting and snapping, and the roundhouse kick swinging around and connecting the ball of my foot with a target—felt somehow comparable to memorizing artists' names, dates, subjects, and collections. With varying degrees of drudgery and satisfaction, the process of memorization gives us all greater confidence.

The muscle memory of the *kata* was what I drew upon when battling an opponent during a *kumite*. The *kumite* was like venturing into the uncharted challenges of recognizing the hand of an artist. When exam time rolled around, I summoned the reflexes from memorizing artists' most influential works, and put those memories to work.

MARK ROTHKO (1903-1970), *NO. 11/NO. 20*, 1949, OIL ON CANVAS, 93-3/4 IN. X 53 IN. COLLECTION CHRISTOPHER ROTHKO. PHOTO BY CHRISTOPHER BURKE. ART RESOURCE NY.

The competitive performances on the gym floor and in the classroom were not so different. I relished "getting it right" in both instances. The rewards were dissimilar, of course, but the impulse to master something basic and put it to use kept me on track in both instances.

I'm not suggesting that you start swatting something (even if the adrenaline released from the odd round with a punching bag can feel great). I am encouraging you to draw from the discipline you have in *any* life pursuit and liken it to your quest for a quality instinct. If you tinker with cars, you've shown an aptitude for knowing parts and how they function, and can recognize what's under a hood in an instant. If you're a gardener, you know what it takes to get the best of the topsoil in your locality. If you're a cook, you may be able to pick out the seasonings in someone else's casserole.

Picking out the best artwork on the wall demands the same attention to learning the rules, putting them in practice, and honing your skills.

The life experiences you have had are the training ground for aesthetic muscle memory. We are innately drawn to the best in everything, whether consciously or not. My plunge into the Metropolitan Museum's galleries and basements gave me an unfair advantage, but you have had comparable experiences in honing judgment about what is better made, longer-lasting, and more gratifying in infinite categories of manmade objects, from smartphones to bathroom fixtures.

If travel is in your future, you can forge a road map to experience works of art, architecture, and design that are today unfamiliar or known to you only in books. The preparation for such a journey can involve advance work in plotting exposure to the best of what that place has to offer, whether a neighboring city or a far-flung retreat in an exotic locale. Using the tactics laid out in this book, you can aspire to enlarging your frame of visual reference on the next trip. When on the road, you can test ways of seeing that will contribute to training your visual muscle memory. These are the building blocks to differentiating a lesser example of creative intention from a better one.

Even on a business trip, you know the instant you walk into a hotel room what you're in for. The furniture, carpet, drapery, fixtures, décor and appliances have an instant story to tell, on the spectrum of functional to luxurious. A sprayed on "cottage cheese" ceiling instead of a smooth plaster one says expediency got the better

of aesthetics. Exposed sprinkler heads without caps is a blow to the room's sense of calm. A riotously patterned bedspread to shield stains should make you think twice about lying down on it. Plastic cups instead of drinking glasses shout convenience over style. And a shower curtain instead of a glass door likely signals a preference for cheap and disposable to cut the labor cost of cleaning yet another surface.

The room's aesthetics might invite you to savor a languorous soak in an elegant bathroom—or propel you downstairs to the hotel bar. The people who designed your room operated from a budget and a sensibility that led them to choices you've decoded the moment you rolled your bag across the threshold. Next time you check in, prepare to sharpen your skills of observation by consciously separating each aesthetic experience into the five features we are seeking in manmade things. Those things may be purely functional, or, as we've covered, things that function primarily as storytelling artworks on the wall. They are the baseline for future quality inquiries. If your trip allows for a side excursion to a museum, art gallery, or architectural landmark, limber up your aesthetic antennae in the hotel room and lobby before heading there.

The **originality** of a gesture or artifact may not be plain to you at first. Much of what we see may appear original but in fact be derivative. It will become apparent which is which after you've spent enough time looking, reading, and absorbing. Those generic fabric or paper-framed abstractions on hotel walls are normally the equivalent of elevator music—an empty gesture to simulate an aesthetic experience. You're far more likely to find originality in the minibar selection.

In an art museum, a row of landscapes may yield only one that leaps out and draws you in, as when a Charles Demuth painting of an industrial setting admixes a highly original veneration of modern industrial design, a crisp palette with precise brushwork, a bold composition likening grain silos to Egyptian pyramids, and harmonious geometry, all of which combine to produce an instantly recognizable and memorable result.

Fine craftsmanship—whether by hand or by machine—is something that we never take for granted in our consumer culture. As the elements of our lives deteriorate or survive intact, we can take cues about technical skill from the longevity of something, but more important, from the clear evidence that it was thoughtfully conceived and made with care. A soapily carved statue next to an uncompromisingly

detailed one may not be evidence of lesser quality, but the artist had better have the other four attributes of a great work of art in abundance. Rodin's surfaces in marble intentionally shift from polished to raw, but you learn to love that variation in his talented hands. Lesser followers may rely on hydraulic tools to tame a block of marble, but the results are mixed. Besides, fine craftsmanship alone isn't enough. It has to be accompanied by the other four attributes to stand the test of time.

By **confident in its theme** we mean that an object or work of art clearly reflects the maker's intent. In the contemporary art world, that intention can favor the accidental—as when an artist lets nature or chance decide the contours and character of a creative act. The late Felix Gonzalez-Torres made several installations of wrapped candy in piles or formations, teasing the viewer into becoming a participant, and yielding to the impulse to indulge in the ingredients of his installation.

The originality of that way of making a visual set piece was bold, unproven, and brazen. Those who would follow in the artist's wake do so at their peril, and risk being judged as derivative. A more conventional work of art may radiate confidence in more overt ways, such as in its improbably large (Richard Serra) or small scale (a sixteenth-century rosary bead) appropriate to the artist's intent. A socially charged photograph of abject Depression-era poverty by Dorothea Lange may reveal a confident point of view seeking a reaction from us. A sexually suggestive sculpture by Jeff Koons can still retain an air of mystery or humor rather than being gratuitously titillating. Other works of art are made from powerful or rigorous impulses that stop us in our tracks.

By **coherent** I mean an artwork or object that has harmony or dissonance in what feels to be an appropriate measure. The artist Sarah Sze crafts improbable, Dr. Seuss-like confections out of humble remnants of daily life that hang or climb in the air with seemingly effortless grace. She perfected this way of working over a decade ago. At the other end of the spectrum, a Byzantine icon is ruthlessly geometric and spare in form, but enjoys an enduring harmony because of it.

And finally we seek artworks that are **memorable**, that stick with you after you've moved on. The temptation to return may not be so strong as to elicit the kind of pilgrimage I make to the National Gallery to see my favorite Raphael, but the next time you see something in the genre of a memorable artwork, you may recall that first exposure. It is never quite erased from your visual DVR.

Original, crafted, confident, coherent, and memorable. If you're unable to find all five in a work of art, or in that hotel room, the odds decrease that it will stand the test of time, or resonate in ways that others will pick up on. And the threshing exercise of walking and looking, whether next door or halfway around the world, stands to continuously improve your skills in recognizing these five features.

In the preceding chapters, I've suggested some exercises to sharpen your reflexes in seeking out the best. You can return to these whenever you wish. There are lots of cues to help you begin sorting wheat from chaff in museum galleries and city streets, if you take the time to pick them out.

If I were to sit down at your desk at work and confront your file folders, email inbox, and blinking voice mail system, I would be completely baffled about where to start. But the good news about museums is this: when you enter *my* workplace—an art gallery—you're likely to have a map, a handbook, labels, a human guide or maybe an app or an audio tour to get you going. There is no shame in trying out any or all of these tools in your quest to build visual muscle memory.

Just as when you learned to swim, you gradually developed the self-confidence to shed an instructor, or a float, or the comforting grip of the side of the pool. So it is with looking at art. There will come a time when you will feel better equipped to tread water or push forward at your own pace. There is no "right" type of museum visit. Lingering in front of a few works can be more satisfying than sprinting to glance at every possible object on display.

Our end game is to feel more at ease when setting out to scale new heights in exploring art. My hope is that you have found some grappling hooks for the climb.

With this initial journey behind us, the next step is yours. I suggest striving to make more informed, self-assured judgments about the fruits of visual creativity, while worrying less about being judged by others. You've seen how tastemakers in the art world are not always right, and often spectacularly wrong. You've followed the experiences of one museum director who began with an appetite to learn, and proceeded to devote decades to appraising not the monetary value of art, but its impact and significance.

You've read that art world jargon is often just a way of avoiding being caught flat-footed, that museums are filled with objects that deserve attention even without household names attached, and that many with household names are not much

better than others by lesser-known or unknown artists.

And most of all, you've discovered by now that those in positions of authority in museums are eager to share what we know, open to being challenged, and curious about what makes our visitors tick. So the next time you visit us don't begin with the assumption that art museums are formal places. Begin by accepting your responsibility to learn about and convey the lessons of art for the daily lives of family, friends, and future generations. Pass on to them this basic premise: with a bit of effort, anyone can develop a quality instinct.

INDEX

A

Abstract Expressionism, 154, 196
academics, 3, 6
academies, 37
Academy of Fine Arts, 37
Academy of Painting and Sculpture, 37
Adam, Robert, 170, 180, 181
aesthetic experience, 42
aesthetics, 38, 40, 41, 44, 215
 history of, 40–45
Aesthetics and Psychobiology, 44
African art, 136–137
Agnelli, Gianni, 155–156
Agrippa, 154
The Alba Madonna, 150, 162–163
Alexander the Great, 35
ancient art, 34
 Western art and, 27, 29
Anderson, Maxwell
 education, 23–29
 Dartmouth years, 23–26
 Harvard years, 27–29
 grandfather, 15, 18
 Manhattan apartment, 14, 18–19, 23

summer house, 15–18
travel, 19–21, 29
upbringing, 14–29
The Angel Appearing to the Shepherds, 77
antique shops, 64
The Apology, 40
appreciation, 7
Aquinas, Thomas, 45–46
Archaic period, Greek, 34–35
 Ripe Archaic period, 35
architecture, 135
 Roman villas, 157
Aristotle, quality, 41
armor, Roman cheek piece, 189
Arnett, William, 99, 101
Arnold, Matthew, 193–194
art
 defining, 43
 intention, 46
 life vs, 196
 outside museums, 58–59
 viewing, 49, 58
The Art Critic, 5
art critics. *See* critics
art history and historians, 4, 6, 30
artistic quality
 defining, 45–47

features, 50–52
artistic technique, 50–51, 107–128
artists
 getting acquainted, 13–14
 intentions, 46
 self-taught, 97–102
 signing their works, 148, 152
 terms, 108
art market. *See* market
art world
 factions, 3–4
 insiders, 207
 today, 39
Ashcan School, 165
Ashcroft, John, 123
Augustine, St., 42
Augustus, 141, 154
authorities, 75
avant-garde art, 39
awards, 66, 200–201
Aztecs, 42

B

The Bar at the Folies-Bergère, 95–97
Bardini, Stefano, 126–127
Batsry, Irit, 200, 201

Baudelaire, Charles, 43

Bauhaus style, 30

Beardsley, Dr. Hezekiah, 109

beauty, defined, 39

Beazley, John Davidson, 132–133

Beck, James, 127

Becket, Thomas, 146

Becket Chasse, 144, 146–147

Bede the Venerable, St., 172

Bell, Clive, 38

Berlin, Isaiah, 136–137

Berlyne, Daniel E., 44

Bernier, Rosamond, 73

Bernini, Francesco, 148

Bernini, Gian Lorenzo, 147–149

Bethea, Bob, 12

bigio morato, 188

The Birth of Tragedy, 43

Black Paintings (View No. 2), 198

Black Room, 153, 154–155

Blink: The Power of Thinking Without Thinking, 189

Blond Bather, 88

The Boating Party, 90

Boas, Franz, 136

book learning vs art learning, 64–65

Bordwin, Andrew, 204

Bosch, Hieronymus, 151

Boscoreale, 153

Boscotrecase, 153–154, 156

boulevardier, 97

Bramante, Donato, 177

Brandt, Kathleen Weil-Garris, 127

bread and circuses, 172

Breuer, Marcel, 164, 165, 166, 168

Brisley, Denny, 143

Bronze Age, 34–35, 92

Bucksbaum, Melva, 165, 200

Bucksbaum Award, 200

Bull, David, 164

C

Capitoline Museums, 67, 86

Carlos, Michael C., 134

Carter, Sonny, 93

Castelli, Leo, 66

casts, 85–86
 Segal and, 86–87

Catholic doctrine, artistic quality and, 42

caveat emptor, 75

celebrity, 89, 97

Cellini Cup, imitation, 97

censorship, 40

Cesnola, Luigi Palma di, 115

Chalcolithic Period, 91–92, 137

Chambers, Anne Cox, 73

checklists
 kitchen cabinets, 61
 logos, 61
 paintings, 60–61
 product packaging, 61

Childs, Liz, 9

Chinese painting, 148

Christ the Redeemer, Rio de Janeiro vs Christ, Santiago di Compostela, 110–111

Clark, Sterling, 50

Clark, T. J., 38

Classical period, Greek, 34–35, 121

Coat-of-Arms with a Skull, 55

coherent composition, 50–51, 216, 217
 Lavinium statue, 122

Cohon, Robert, 132

Colalucci, Gianluigi, 177, 179

collectors, 4, 38, 58–59, 67, 203
 stolen art, 69–72

Colosseum, 172

Colossus, 172

Commendatore dell'Ordine al Merito della Repubblica Italiana (Commander of the Order of Merit), 66

competitiveness, 112–113, 203

composition
 coherence, 151–168

dissonance, 164–168
 harmony, 162–164
 Roman, 152–158

compulsion, 179

Conan Doyle, Arthur, 133

confidence, in subject or theme, 50–51, 131–149, 216, 217
 Lavinium statue, 121–122

Conflict, Arousal and Curiosity, 44

connoisseurship, 6, 26–27, 29

contemporary art and culture, 193–211

context, 22, 93–97, 180–183
 displaced, 185–186

controversy, 194–195

conviction, 179

copies, 172–173

craftsmanship, 50–51, 107–128, 215–216, 217
 Lavinium statue , 121

critics, 3, 48–49, 55, 197–199, 206–207
 The Art Critic, 5
 formalist, 38
 perspective, 6
 theory, 38

Critique of Judgment, 42

crowds, museum visitors and, 79–80

Culture and Anarchy, 193

cultures, visual languages, 135

Cuneiform tablet with an account of rations, 93
 in space, 93–95

cup, 98

D

da Carpi, Ugo, 26

damaged works of art, 30

Dancers, 111

The Darkest Color Infinitely Amplified, 207–208

Daumier, Honoré, 5, 55

Da Vinci Code, 46, 144

dealers, 3, 6, 23, 38, 47, 203
 photography, 204

De Architectura, 152
Deconstructionism, 65
Defence Medal, 22
Degas, Edgar, 24, 25, 111
Le Déjeuner sur l'Herbe, 97
DeKooning, Willem, 153, 196
Demuth, Charles, 215
Dial, Thornton, 101–102, 103, 105
Diaz, Bernal, 42
Dirksz, Adam, 107, 112
di San Giuliano, Benedetto, 175
disegno, 36
disinterestedness, 43
displaced context or artwork, 185–186
dissonance, 151
Domitian, 140–141
Don't Matter How Raggly the Flag, It Still Got to Tie Us Together, 103
Dorman, Peter, 131
Douris, 8, 13
Drake, Frank, 173
Draper, Jim, 123–124, 126, 127, 128
Duchamp, Marcel, 41, 44, 46, 195–196
Dürer, Albrecht, 55, 179
The Dying Gaul, 86

E

ear, 132, 133
École des Beaux-Arts, 35, 36
Egyptian art, 131–132
Einstein Tower, 105
Eisenman, Peter, 166
energy, 164
Enlightenment, quality debate, 42–45
Enquiry Concerning the Principles of Morals, 43
entertainment, art exhibitions and, 73–74
E Pluribus Unum, 210–211
Erased Drawing, 196

ergon, 41, 45
essence, 41
Etruscan kore, forgery, 115–120
Euphronios, 113
Eusebius, 161
Euthymides, 113
experts, 59–60
extrinsic quality, 41

F

Faison, Lane, 24
familiar artworks, making them fresh, 80–83
fashion, 43
feeling, subjective, 42
Ferragamo, Fiamma, 102
Ferragamo, Salvatore, 102–104
fiber art, 101
 see also quilts
fibula, dragon-shaped *corsini*, 34
Fioravanti, Alfredo, 117
First Style, Roman, 153
First World War, 44
Flavian period, 139, 140
 reliefs, 153
flaws, 72
flea markets, Italy, 62
 metal ornaments, 63
Forever Marilyn, 195
forgeries
 Etruscan *kore*, 115–120
 Getty *Kouros*, 189
 Greek vase, 12–13
Foster, Norman, 166
Foucault, Michel, 65
Fountain, 195
Francesco di Giorgio Martini, 184
Francis of Assisi, St., 45–46
Freedberg, Sydney, 162
Freiman, Lisa, 210
French, Carroll, 16–17, 18
French Academy, 37
French Embassy, sculpture, 124–127

French language, 37
fresco technique, 152, 154
frescoes, 152–158
 restoration, 156
Freud, Sigmund, 133
Fry, Roger, 38–39, 44
function, 41, 45

F

gallery-goers, 55, 78–79, 174
Gauser, Richard, 117, 118
George III, 182
George Segal: American Still Life, 87
German Archeological Institute, Rome, 67, 68
 Fototeca (photographic archive), 68–69
Getty *Kouros*, 189
Ginzburg, Carlo, 133
giornata technique, 152
Glackens, William, 165
Gladwell, Malcolm, 189, 207
Gluckman, Richard, 166
Golden Mean, 35
Gonzalez-Torres, Felix, 216
Gran Nicoya culture, 134
Graves, Michael, 164–165
Greek art, ancient, 9–12, 34–36
 workshops, competitiveness and, 37, 112–113
Greenberg, Clement, 38, 39
Greenblatt, Stephen, 186
Gregory XV, Pope, sculpture, 147–149
Gropius, Martin, 185
 Bau, 185, 186
Gubbio Studiolo, 183, 184
guilds and workshops, 36, 37

H

Hansen, Mark, 193, 199–200
harmony, 151, 158
Hawes, Harriet Boyd, 114
Hegel, G.W.F., 40, 43

Hellenistic period, 35, 36
Henri, Robert, 165
Henry II, 146
Henry VIII, 146
Hercules Chasing Avarice from the Temple of the Muses, 26
herms, 188
Hirshhorn, Thomas, 179
Holl, Steven, 166
House 1, 204
Houseman, John, 16
human figure, 35
 ear, 132, 133
 nudes, 110
Hume, David, 43
Huntley, D.J., 118

I

Idea, 43
ideals, 35, 43
Ife sculpture, 137, 138
images, glut of, 48–49
imitation, 50
Imperial Palace, Flavian, 140–141
Impression, Sunrise, 1
Impressionists, 27, 29
 first exhibition, 1
 photography and, 205
Indianapolis Museum of Art, Obama campaign and, 143–144
individual liberties, 40
industrial revolution, 30
innovation, 48, 97, 203
 Roman painting, 154
inscrutability, 186–188
interpretation, 183
 semiotic, 6–7
Invisibile sandal, 104, 105
Israel Museum, 90–91

J

jaguar vessel, 131, 134–135
Jerusalem, 90

Johns, Jasper, 66, 101
Johnson, Ken, 206
Johnson, Seward, 195
The Judaean Desert Treasure, 91–93
Judd, Donald, 108
judging artworks, 199–201
 Twitter and, 89
 making, 217
Julia Mammaea, 159–162
Julius II, Pope, 177
Juvenal, 172

K

Kant, Immanuel, 4, 38, 42, 43
Kantor, Morris, 16
karate, 213–214
Katsushika Hokusai, 190, 191
Kelly, Ellsworth, 99–100
Kennedy, Caroline, 30
Kimmelman, Michael, 99
Kinkade, Thomas, 140
Knott, George and Pam, 21–22
Koolhaas, Rem, 164, 166–168
Koons, Jeff, 216
Kramer, Hilton, 196
kumite, 213

L

Lange, Dorothea, 216
Langlotz, Ernst, 117, 118, 188
language, shared, 105
Lansdowne House, dining room, 170, 180, 181, 182
Lansdowne Tyche, 180, 182
La Rocca, Eugenio, 67
Last Supper, 152
Lavin, Irving, 147–148
Lavinium statue, 117–120
 quality hallmarks, 120–123
learning to see, 75–76
Lectures on Aesthetics, 43
Lenya, Lotte, 16
Leonardo da Vinci, 47, 152

Lerner, Max, 207
Leroy, Louis, 1
Levi-Strauss, Claude, 136
Levin, Kim, 199
LeWitt, Sol, 179
life experiences, 214
lighting, 73
Lin, Maya, 166
Listening Post, 193, 199–200
Litchfield, Mrs. Edward S. ("Bambi"), 159
Loewy, Emmanuel, 114
longevity, artistic, 172–174
Louis XIV, 37
Luks, George, 165

M

Machado & Silvetti, 166
Madonna and Child, 151, 162–163
Madonna with the Christ Child, 151
Maeder, Edward F., 104
Maidulf, 144, 146
Make: Measure, 201
Malmesbury Chasse, 144–147
Man at a Table, 86
Manet, Edouard, 95–97, 110
Mapplethorpe, Robert, 40
Marcus Aurelius, 161
market, 6–7, 69, 197, 206
 quality and, 38, 47–48
marketing, museums, 73–75
Marshall, John, 114, 115, 139
Martindale, Colin, 44
Marx, Karl, 40
Marzio, Peter, 99
Maserati, 51
Mask of the Oni Obalufon, 138
Masler, Steve, 74
mass appeal, distraction of, 89
mass entertainment, art museums and, 78
mass production, 142
Matisse, Henri, 109, 110

Maximinus Thrax, 161
McDonald, John, 90, 91, 131
Medici family, 74
Mei Moses Art Index, 6
Mellon, Paul, 164
memorability, 50–51, 171–191, 216, 217
 Lavinium statue, 122–123
Mendelsohn, Erich, 105
Meredith, Burgess, 16
Metropolitan Museum of Art
 internship program, 9–12
 storage, 85–86, 113–114, 137, 139
Michelangelo, 36, 125–127, 152, 177–179
Middle Ages, 36, 42
mimesis, 50
modality, 42
modern art, 193–211
Modernism, prefigured, 191
Mona Lisa, 46–47
 theft, 95
Monet, Claude, 1
money, art and, 47–48, 189, 195, 202
Montefeltro, Federico da, 183
Morelli, Giovanni, 132–134, 158
Morgan, J. Pierpont, 139
multiculturalism, 136–137
Munna, John, 66
muscle memory, 213
Muse, 28
museum, 6–7, 218
 culture, 65
 education, 65, 78
 experience, 78
 mass entertainment and, 78
 people, 4, 6, 38
 purchases, 47–48
 visiting, 57–58, 217
 visitors, 55, 78–79, 174
Musso, Luisa, 67

L
Les Nabis, 205
narrative art, 36–37

NASA spacecraft, 93, 173
National Endowment of the Arts, 40
Nero, 141, 172
Neutra, Richard, 105
NEWhitney, 166–168
Newman, Barnett, 209
Nietzsche, 43
nineteenth century art, 35
No. 11/No. 20, 213
notoriety, quality and, 95–97
Nouvel, Jean, 166
nudes, 110

O
Oberhuber, Konrad, 133–134
Object in Space, 93
objective pluralism, 136–137
objects, looking at vs assessing, 75
Oldenburg, Claes, 195
Oliver, Bernard, 173
Olympia, 110
originality, 50–51, 85–105, 215, 216, 217
 experts and, 113–120
 Lavinium statue, 120–121
 today, 89
Oursler, Tony, 206, 207–209
ownership, 30

P
paintings, function, 45
Palatine Hill, 140–141
Parmigianino, 151
passion, 179
patterns
 shared, 143–144
 as subject, 137, 139–143
perception, Hegel, 43
Periclean Athens, 35
philistines, 193, 194
photography, 204–207
 digital, 204, 205

physiological response to art, 171
Piano, Renzo, 165–166
Pilgrim, Jim, 91
Plato, 43, 50
 quality, 39–40
poetry, 40
political correctness, 38
Pompeian painting, 152–153
Poor, Annie and Henry Varnum, 16
Pop Art, 101, 196
 vs fine art, 89
portrait heads, Roman, 64–65, 159–162, 180
portraits, limner vs self-, 109–110
postmodernist argument, 45
pottery, 131, 134–135
Praxiteles, 36
prayer bead, 107, 112
Pre-Columbian art, 131, 134–135, 137
pre-industrial world, 142–143
prints, reproductions vs originals, 63
psychology, 44
public art, overexposing, 210–211
public experience, 78
purpose, 41

Q
quality, 42, 64
 academic view, 33
 ancient art, 34
 Aristotle, 41
 debate, 38–39
 defined, 33, 38
 hallmarks, 110
 judging, 37
 market, 33
 measurement, 33, 35
 Plato, 39–40
 popular view, 34
 the word, 37–39
quality instinct, 4
 developing, 31

quantity, 42
quilts, Gee's Bend, Alabama, 98–101, 105

R

Rabirius, 141
Rafferty, Emily, 156
Raphael, 150, 151, 162–163, 164
Rauschenberg, Robert, 66, 101, 196
reality, defined, 43
reconstructions, 182
reflection, 78
Reinhardt, Ad, 154, 196, 197, 198
Reinhardt, Anna, 197
relation, 42
Rembrandt van Rijn, 77
Renaissance, 35, 36, 42, 74
 ancient art vs, 124, 126
 Italian, 162–164
 room, 183, 184
Renoir, Auguste, 88, 89–90
representational art, 38–39
Republic, 39–40
responsibility, 218
reviewers, 48
Richelieu, Cardinal de, 37
Richter, Gisela Marie Augusta, 114–115
Robinson, Edward, 114, 115
Robinson, Franklin W., 23
Robus, Hugo, 16
Rodin, Auguste, 111
Rogers Fund, 115
Roman Empire, 35–36
 architectural elements, 139–143
 copy of Greek statue, 28
 portrait heads, 64–65, 67, 159–162, 180
 stolen, 69–72
 wall painting, 152–158
 styles, 153–154
Romulus, 141
Rosenberg, Harold, 38
Rothko, Mark, 154, 197–199, 213

Rothko Chapel, 45, 46
Rubin, Ben, 193, 199–200
Russell, John, 73–74
Ryman, Robert, 197
Ryther, Martha, 16

S

Sagan, Carl, 173
Sagan, Linda Salzman, 173
Saltz, Jerry, 196
Schinkel, Karl Friedrich, 185
Scholastics, 42
science, 44
sculpture, 114, 137
 architectural, 139–143
 artists' tracks, 111
 Etruscan, 116–120
 plaster, 85–86
 Roman portrait heads, 64–65, 67–72, 159–162, 180
secco technique, 152, 154
Second Style, Roman, 153, 154
secondary works by great artists, 148
Segal, George, 85, 86–87
Self Portrait with Panama Hat, 110
self-taught artists, 97–102
senses
 dispassionate, 42
 memory, sharpening, 174–176
sensory shift, 81
sensuality, 110, 122–123
Sermek, Gordana, 81
Serra, Richard, 99–100, 216
Sesame Street, 29–30
Severe Style, 35, 121
Severus, Septimius, 159, 161
Severus Alexander, 159
shared attributes, 158
Shinn, Everett, 165
shoes, 102–104
sight, sense of, 176
Sistine Chapel, 177–179

skeptics, 48–49
Sloan, John French, 165
Smith, Roberta, 200
Socrates, 39, 40
sounds, 176
spacecraft
 Discovery, 93
 Pioneer 10 and 11, 173
 Voyager, 173
sports, 172
Springer, Mrs., 10, 12
St. John the Baptist, 151
Statue of a Young Woman, 116–120
stolen art, 69–72, 185, 195
Stone Age, 92, 93
Structuralism, 65
subject, pattern as, 137, 139–143
surveillance, consumer, 76
suspension of disbelief, 58
Swift, Jonathan, 193
symmetry, 152
Sze, Sarah, 216

T

Tabata, Kazumi, 213
table fountain, 33, 45
Table Lamp, 81
Tanenbaum, Joseph M. and Toby, 147, 148
Taniguchi, Yoshio, 166
taste, 65
 acquisition of, 59–60
 disinterested judgment of , 42
 sense of, 174–175
tastemakers, 59–60
Taylor, Lisa Suter, 104
technical skill, 50–51, 107–128
 breakthrough, Segal, 86–87
 points of departure, 107–111
technology, 207–209
Teitelbaum, Matthew, 148
The Tipping Point, 207
The True History of the Conquest of New Spain, 42

theory, 38

thermo-luminescence dating, 118

Thibadeau, Bill and Carol, 134

Third Style, Roman, 153–154, 157

Thirty-six Views of Mt. Fuji, 190, 191

Thomson, Kenneth, 144

Thorvaldsen, Bertel, 30

Thurber, James, 2

Timaeus, 42

time machine, yours, 177, 179

Titus, 172

tondo, 162, 164

touch, sense of, 175–176

Tournachon, Gaspard-Félix, 1

training
 for the eyes, 60–61
 to disengage from distractions, 79–80
 to see, 79–83

Trajanic period, 139

travel, 29, 214–215
 England, 20, 21
 France, 19–20

trophy hunting, 65–72

Tunick, David, 23–24, 26

Turner Prize, 194

Twitter, 89

U

Ukiyo-e prints, 190–191

University of Munich, 86

urinal, as art, 195

V

values pluralism, 136–137

vandalism, 195

Vanderbilt, Cornelius, 165

Victoria and Albert Museum, 56

videos, art exhibitions and, 74

visual connections, 3

visual languages, divergent cultures, 135

visual literacy, 1, 4, 12

visual metaphors, 195

Vitruvius, 152

von Blanckenhagen, Peter H., 139, 140, 142, 153

von Bothmer, Dietrich, 9, 10–13, 27, 29, 114, 118, 119–120, 132–133

voyeurism, 97

vulgarity, 175

W

Walk, Don't Walk, 85

wall painting, Roman, 152–158

Warhol, Andy, 196

Weill, Kurt, 16

Weiss, Jeffrey, 199

Western aesthetics, 39

Western art, and the ancient world, 27, 29

White House, 143

Whitney, Gertrude Vanderbilt, 165

Whitney Biennial, 199–201
 award, 200

Whitney Museum, 164–168
 NEWhitney, 166–168

Wiencke, Matthew, 10

Williams, Irene, 100

Williams Mafia, 24

Wilmering, Antoine M., 183

Wilson, Fred, 210–211

Winckelmann, Johann Joachim, 68

Wintle, A.G., 118

Woman Combing Her Hair, 25

Women Woolworking, 8

wonder, 186–188

Y

You Who Have Dreams, 18

Young Archer, 125–127

Z

Zeuxis, 36